# CURATING NOW: IMAGINATIVE PRACTICE/PUBLIC RESPONSIBILITY

OCT
14-15
2000

D1376728

**Paula Marincola**
**Robert Storr**
Symposium Co-organizers

**Philadelphia Exhibitions Initiative**
Funded by The Pew Charitable Trusts
Administered by The University of the Arts

The Philadelphia Exhibitions Initiative is a granting program funded by The Pew Charitable Trusts and administered by The University of the Arts, Philadelphia, that supports exhibitions and accompanying publications. "Curating Now: Imaginative Practice/Public Responsibility" has been supported in part by the Pew Fellowships in the Arts' Artists and Scholars Program.

Philadelphia Exhibitions Initiative
230 South Broad Street, Suite 1003
Philadelphia, PA 19102
215-985-1254
philexin@bellatlantic.net
www.philexin.org

**Book design:** Gallini Hemmann, Inc., Philadelphia
**Copy editing:** Gerald Zeigerman
**Printing:** CRW Graphics
**Photography:** Michael O'Reilly
**Symposium and publication coordination:** Alex Baker

# CONTENTS

# PREFACE

"Curating Now: Imaginative Practice/Public Responsibility," the symposium sponsored by the Philadelphia Exhibitions Initiative that is documented in this report, forayed into some infrequently occupied territory in the Philadelphia region's visual arts community. It brought together a large segment of that community, along with gifted national and international arts leaders, to think and talk collectively about matters of deep and, sometimes, problematic importance to their field. Perhaps such encounters ought to be business as usual, but in fact, they are far from standard practice here. Yet, critical and open dialogue is essential to the health of this or any arts discipline.

The Pew Charitable Trusts created the Philadelphia Exhibitions Initiative in close collaboration with its director, Paula Marincola, based upon an extensive investigation of the needs and priorities of the region's visual arts organizations. PEI is one of seven regional artistic initiatives established by the Trusts. The others are Dance Advance; the Heritage Investment Program, focusing on historic sites; the Pew Fellowships in the Arts, which provides substantial unrestricted stipends to artists across a broad array of disciplines; the Philadelphia History Exhibitions Initiative; the Philadelphia Music Project; and the Philadelphia Theatre Initiative. All were developed both to respond to the strengths of these specific components of the local cultural landscape and to assist them in addressing the challenges and difficulties they face. Over time, the design of each of these initiatives has been developed and refined to include, in addition to grants for exhibitions, performing arts productions, and other forms of public programming, multiple and flexible means of supporting the professional and artistic development of the individual practitioners involved. Additionally, with increasing frequency, these initiatives have generated collective conversations and experiences (including "field trips" to cities from New York to Toronto to London), with the purposes of supporting peer learning and building intra- and interdisciplinary collaboration. As a consequence, the extraordinary community of artists and arts practitioners who infuse the life of this city and region with such creativity is becoming more self-aware and more knowledgeable about the aesthetic and critical context of its own contributions.

"Curating Now" has upped the ante considerably in this process, and, as such, has set a standard of critical dialogue that will challenge the other disciplines to create similar opportunities for artistic discourse that reaches both into the Philadelphia region and beyond it. We are all deeply indebted to Paula

Marincola for her leadership in convening this symposium as well as her contributions to the arts community.

Robert Storr, in his keynote address for this symposium, included a number of memorable quotes among his remarks. One that struck me strongly was his reference to a statement by Gramsci, the Italian Marxist, that he was "a pessimist of the intellect and an optimist of the will." As you will see when you read his wonderful speech, Storr parsed this comment as a reaffirmation of all those who, like artists and like curators, may wonder why they keep getting up in the morning to do their job, but somehow keep doing so as an act of faith. Two days later, at a conference in Minneapolis, Garrison Keillor, in *his* keynote address, said, in talking about writing and writers, "If you're an 'author,' you look at books as trophies; if you're a writer, you get up in the morning and write."

Those of us who are not artists or arts practitioners, but who work to facilitate the creation and presentation of the arts, stand eternally in awe of the courage it takes for artists simply to get up each morning and make work, when the prospect of that work's making its way into the world, and being met with engagement and with pleasure, can, sometimes, be remote. I hope that the Philadelphia Exhibitions Initiative and the other Philadelphia cultural initiatives created by The Pew Charitable Trusts make it easier for artists and curators of all stripes to engage in this daily act of faith. I know that Philadelphia's community of artists has gained a strengthened sense of shared purpose, and that our region's audiences have benefited mightily from the remarkable exhibitions and programs that this and our other initiatives have been privileged to support.

MARIAN A. GODFREY
*Director*
Culture Program
The Pew Charitable Trusts

# INTRODUCTION AND ACKNOWLEDGMENTS

The Philadelphia Exhibitions Initiative (PEI) is a granting program initiated and funded by The Pew Charitable Trusts—a major philanthropy based in Philadelphia—and administered by The University of the Arts, a multidisciplinary educational institution unique in this country. PEI was founded, in 1997, to support visual arts exhibitions and publications; as one of several different disciplinary artistic development initiatives of the Trusts, it is designed to foster excellence and enhance the cultural life of our region. Similar programs to PEI exist in dance, music, and theater, for instance, and The Pew Charitable Trusts support a fellowships program for individual artists as well. In PEI's first four years, we have invested more than $3.1 million in twenty-four exhibitions for projects of international scope (see page 159 for a list of PEI grantee exhibitions from 1998 to 2001).

One of The Pew Charitable Trusts' challenges to those of us who direct their artistic development initiatives is to attempt to identify and analyze exemplary standards of practice in the fields we serve, and to do this within the context of offering our community significant professional development opportunities that ultimately benefit our understanding and our work. In response to this challenge, "Curating Now: Imaginative Practice/Public Responsibility" was conceptualized and produced as a weekend long event in October 2000. It convened a group of peers to assess the current state of curatorial practice, to articulate our professional values, and to test the assumptions implicit in them. The proceedings were divided thematically into separate but integrally related discussions of curating in both its private ("imaginative practice") and public ("public responsibility") aspects. Underlying both themes were questions regarding curatorial power and authorship as well as inquiries into how external pressures and challenges impact upon and shape exhibition-making in what critic Michael Brenson characterized recently as "the era of the curator."

The response in the field to "Curating Now" was immediate and tremendously gratifying. It was subscribed to capacity (and even necessitated a waiting list), and resulted in a gathering of colleagues from all across the country as well as abroad (see attendees list, page 155). This symposium made apparent an urgent need felt in the field for opportunities for curators to come together to discuss the philosophical and pragmatic aspects of practice; feedback from attendees after the weekend confirmed this assessment. PEI hopes to recognize this need by sponsoring other such conferences in a timely manner, and to work with

colleagues around the country, where appropriate, on similar events.

"Curating Now" was made possible through PEI's professional development program and also with additional funds provided by the Pew Fellowships in the Arts' Artists and Scholars Program. I am deeply grateful to my colleague Melissa Franklin, who directs the Fellowships, for her unfailing support throughout the realization of this symposium. At The Pew Charitable Trusts, the inspired leadership and constant encouragement of Marian Godfrey, director of the Culture Program, and Gregory T. Rowe, program officer in Culture, were, as always, enormously sustaining.

Many other talented and dedicated individuals were also instrumental in the success of this event. Alex Baker, the symposium and publication coordinator, was involved in every aspect of producing both the conference and the record of the proceedings. I am extremely grateful for his dedication, excellent ideas, and meticulous work. Gordon Wong, PEI program assistant, worked with his usual capable good humor on most of the key organizational components of the program, as well as serving as a tactful and sympathetic gatekeeper to the attendees. Both Alex and Gordon's joint efforts ensured the smooth operation of a complicated and interlocking series of events over the course of the weekend. In addition, my thanks go to Michael O'Reilly, our videographer, Doug Smullens, our audio engineer, and Amie Scally, Laurie Switzer, and Yane Calovski, all of whom contributed to the symposium's successful realization. Gerald Zeigerman served as this publication's expert editor, Nick Muellner ably shepherded the manuscript through to publication, and Gallini Hemmann, Inc., is responsible for the vibrant graphic design of all the printed materials associated with the symposium.

Robert Storr, Senior Curator, Department of Painting and Sculpture, Museum of Modern Art, New York, was the co-organizer of "Curating Now" and instrumental in the articulation of the event's focus and the selection of its participants. In addition, he presented a cogent keynote address and moderated both of Saturday's panels. This yeoman service was delivered with his singular mix of intellectual discernment and agility. It was my great pleasure to work closely with him on this symposium.

My profound gratitude is also extended to the other distinguished participants in both days' events. Kathy Halbreich, Director of the Walker Art Center, in Minneapolis, offered strong and visionary leadership in her stimulating afternoon address. The panelists—Anne d'Harnoncourt, the George D. Widener Director of the Philadelphia Museum of Art; Thelma Golden, Deputy Director for Exhibitions, The Studio Museum in Harlem, New York; Hans-Ulrich Obrist, Curator, Musée d'Art Moderne de la Ville de Paris; Mari-Carmen Ramirez, Curator of Latin American Art, Museum of Fine Arts, Houston (formerly Curator of Latin American Art, Jack S. Blanton Museum of Art, University of

Texas, Austin); Ned Rifkin, Director, The Menil Collection and Foundation, Houston; Paul Schimmel, Chief Curator, Museum of Contemporary Art, Los Angeles; Nicholas Serota, Director, Tate, London—responded in kind with candor and consideration. They generated a dialogue among themselves and with an audience of peers that was searching, passionate, and substantive. On Sunday, critic and curator Dave Hickey brilliantly responded to Saturday's proceedings, calling into question, in a most salutary and often humorous manner, many of curating's currently espoused orthodoxies. I deeply appreciate the generosity of this extraordinary group to the field and to PEI's constituencies in particular. It was indeed my privilege to convene and work with them, and to offer this record as evidence of their insight and commitment.

PAULA MARINCOLA
*Director*
Philadelphia Exhibitions Initiative

# HOW WE DO WHAT WE DO. AND HOW WE DON'T

**Robert Storr** > *Senior Curator, Department of Painting and Sculpture, Museum of Modern Art, New York*

Under any circumstances, the idea of addressing a conference of one's curatorial colleagues is daunting. The reality is even more so, especially from where I am now standing, since, by glancing out into the room, I can see how much of the field is actually represented here today. With that in mind, I want to begin by encouraging you to believe that this really is the occasion for serious conversations among us, and not a pro forma event with lengthy speeches and pre-scripted panels. There will, of course, be presentations, but I sincerely hope that people will take advantage of the opportunity to speak from the floor and not feel inhibited in raising difficult questions or in bringing their particular experiences to bear on the topics being discussed. If we cannot manage to make the best of this chance for free and open exchange, then the state of curatorial thinking and practice will have proven itself to be a sorry one indeed.

In a sense, I am the straight man in this situation. I was reminded of how true that was by walking over here with Dave Hickey, who was cracking wise and wisely all the way. He'll get to tell the jokes at the end; my job is to set things up.

In accordance with my way of thinking, I am going to speak historically. Our primary subject is contemporary art and the places it is shown: ICAs and MCAs (institutes and museums of contemporary art), colleges and university museums, big, mainstream venues, and alternative spaces. However new the art they concern themselves with may be, these spaces and their prototypes have histories. My understanding of how they do what they do—and sometimes fail to do it enough, or do it well—is rooted in an awareness of their origins. So, if you'll permit me, I am going to take some leaps backward, in order, I hope, to get to the present and stay there.

The first leap is to a phrase from a wonderful text by Larry Rivers and Frank O'Hara entitled "How To Proceed in the Arts." It dates from 1961, when, as they say in the text, "Expressionism has moved to the suburbs." And, not long after, Pop, of which Rivers's work was a precursor, moved into the museums. It was the moment, in other words, when avant-garde met the general public on common ground in a way that had never happened before, and when the full impact of this new reality was just beginning to dawn on artists. Luckily, many from Rivers's and O'Hara's generation regarded this situation with a sense of

humor rather than responding with the anguish and resentment that were typical of the reactions of many of their elders, though some younger artists also took matters awfully hard. Among the numerous ironies Rivers and O'Hara noted was this: "Youth wants to burn the museums. We are in them—now what?"

The truth is that this paradox or contradiction had been a factor all through the history of modernism. Modern art was made in defiance of institutions because the institutions were not interested in it, or because those that professed to love new art loved it badly or in ways that distorted what the artists were trying to accomplish in their work. For me, the problems inherent in this situation become increasingly important and increasingly acute as I get older. In the past, as a critic, I wrote some pretty severe attacks on big institutions, including the one for which I now work. I might add, at this point, that not only was Rivers's work prominently embraced by the Museum of Modern Art around the time he made the remarks just quoted, O'Hara himself ended up as a curator there. So, I guess anyone can find themselves caught up in such a reversal of positions.

My experience is typical to the extent that a lot of us—particularly among sixties- and seventies-era "baby boomers" (although the generational spread here today is quite wide)—entered the art world protesting what the museums did and the way the art world habitually went about its business. Ten, twenty, or thirty years later, depending on when we made our entrance, we discover that, to a greater or lesser degree, we are the establishment. If the museums don't function properly, if the art world is unresponsive to the needs and achievements of artists, there are all kinds of people to blame for that, but, mostly, we must blame ourselves. I might also say that this unexpected set of circumstances gives great pleasure to critics—especially conservative critics—who think that the vandals have taken over the sanctuaries of art. If they had their way, they would get rid of both the vandals—us—and the art we have championed, which they have never liked—and it's worth emphasizing how little contemporary art they ever have liked. In any event, with or without this vengeful edge, we are constantly being reminded in the press that, once upon a time, so-and-so was throwing stones at glass houses, and now he, or she, is inside wearing a suit. Well, it happens. To my amazement, it's happened to me, and I figure the only thing to do is to wear it well, or as well as one can.

It's also true that younger generations of curators, critics, and artists are on the rise, and they have posed multiple challenges to the way museums operate. If we take our own oppositional stances of the past seriously, then I think we have to take these new critiques very seriously as well. In effect, they are coming from people who are now what we were a decade or two ago. The way in which they see us creating problems or failing to solve problems that have been on the table for a long time—in fact, since the time of our own greater radicality—speaks to

a life experience and a perspective that we have to appreciate is, in many respects, very different from what ours is or was; for precisely that reason, we must reach out to those representing it with both candor and curiosity. Inasmuch as we can't answer all the questions they raise, and, in some cases may remain in firm disagreement with the assumptions behind their arguments or proposed solution to a given problem—unless, that is, we want to become an establishment that behaves like one—now's the time to make sure that dialogue is engaged and that it is initiated by us rather than waiting for the citadel to be stormed while we seek cover. There are too many historical examples of former young turks becoming a self-protective old guard for this possibility to be treated lightly.

Moreover, having finally chosen to work inside rather than outside institutions, and having occupied the position I have for the past ten years—a position roughly comparable to those many of you in this room hold or look forward to holding—I have abiding doubts about many aspects of the relation of modern and contemporary art to the museums and other venues devoted to them. Those doubts become specific when I consider the ways in which what I, in all good will, do as a curator may qualify or denature what the artist has tried to do. This is not a simple problem, and walking away from it won't help matters. All things considered, I would rather be in a position where I can test certain options, in the service of what I believe in and what I think the artist believes in, and use my intuition and expertise to try to minimize the mistakes that can be made in presenting their work than to stand back and let someone else run those risks and indulge myself in the luxury of being right about how they were wrong. The fact is, I have been responsible for having "framed" or contextualized art in ways that subtly, albeit unintentionally, altered its meaning or diminished its impact. As a practicing curator, one has to be straightforward not only about the potential for but the likelihood of doing this in a given circumstance.

I also teach a good deal—at the Bard Center for Curatorial Studies, at the Graduate Center at CUNY, at Harvard, and, on a hit-and-run or occasional basis, at a number of other places—and lots of you teach as well. All of us work directly with younger colleagues coming up through the ranks as interns and assistants, younger colleagues facing great uncertainties about the profession and their place in it, and not a few wonder whether there is a tolerable future in museums at all. Some want to know, better than we can probably tell them, what the trade-offs are going to be, and they want to know, having made those trade-offs, if, at the end, there really will be an opportunity to work in a museum context on the terms that allow them to do what they do best in a manner consonant with their convictions. Having learned what I have learned on the job, I take their doubts and discomforts very, very seriously.

Before I go any further, though, I want to offer some visual evidence.

Customarily, when I give talks, I try to do it without slides, or with as few slides as I can get away with. I am an object person, and I believe what counts in actual works of art doesn't translate well, if at all, into slides. Nevertheless, I often use slides as wallpaper so that people listening to me in the dark will have something to look at, something visual to get lost in if they wish. Here are some slides that might best be thought of as wallpaper about the museum profession. They're from a children's book I recently found in a secondhand shop. It was published around 1980, for kids around the age of my youngest daughter. The images stand for what some educator thought the museum world looked like back then. Not much commentary is needed; the pictures speak for themselves. As you will quickly see, they portray a reality that no longer exists—we hope—in which certain relationships among museum workers and the lack of certain people— women, African Americans, and others—in certain job classifications are conspicuously out of date. I will run through the slides without further remarks, but, in addition to the amusement the slides may provide, they are a reminder that in a relatively short period of time a good deal has changed for the better.

Another purpose for showing the slides is that, for all their limitations, they do constitute a useful cross section of the museum world. It is pretty widely thought that, in that setting, curators have the glamour jobs, and curators are often resented for that very reason. Some, I am afraid, conduct themselves in a fashion that fully earns them such hostility. Many, if not most of us, however, recognize that we belong to just one profession among many other professions that are essential to our institutions and to the proper presentation of the art they house and exhibit. As museums grow in scale and complexity, and as those working in them become increasingly specialized, it becomes ever more crucial not to lose sight of this basic reality; and it becomes ever more important that curators, who zip around to exciting places and have contact with exciting people, remember their place among other workers, which, though it may be at the center of a network of decision-making, is not at the top of an imaginary social or intellectual pyramid. If museums are to succeed at their task, and grow coherently with the times, there has to be active dialogue between curators and other professionals who contribute to the system—and in many cases contribute much more in time, effort, and ingenuity than they are specifically paid for. As you are well aware, MoMA has just been through a very difficult strike. One of the most painful aspects of the situation was that the people on opposite sides of the picket line understood that the issues that separated them did not altogether follow the pattern of a traditional labor dispute, but rather represented a disagreement within a group of colleagues who normally work extraordinarily long hours together to accomplish the same overall purpose.

On another level, this slide portfolio is a symbol of something called "The

Museum," about which there is a lot of critical discussion in art schools, and academic journals, and on panels. "The Museum" is also the focus of a great deal of public attention. On the one hand, people seem to have almost too much respect for what is usually meant by this term, as if the museum were a religious order—a cloister with its priests. On the other hand, there is a backlash against this conception, a populist feeling that culture is being handed down from on high from a single source, "The Museum," which is merely replicated in different sizes in different locales.

Contrary to this belief, however, museums are extremely various, and, of course, there are many art spaces that serve some of the museum's functions, and yet are not museums at all. As the system made up of these diverse institutions evolves, we have to be more precise—and, perhaps, therefore, less theoretical—in our description and analysis of what the actual working connections among these distinct institutions are. First, we must carefully reexamine their differences; second, we must teach the public about what those differences are if we ever hope to dispel the phantom "Museum" that hovers over us all as cumbersome myth and easy target. All of the institutions for which we work, in effect, suffer from a form of ideological and social typecasting that adequately describes none of them.

Think, to open a brief parenthesis, of the number of institutions that can properly be called museums, as well as those—like the Drawing Center—that regularly mount museum-quality shows. Each has its own specific origins, its distinct mission or mandate, and its history of activity, of personnel, of relations with the public, and of patronage. The Guggenheim, for instance, was founded to promote nonobjective art, whereas MoMA was, almost from the start, an omnibus museum dedicated to whatever was thought to be modern—abstract or figurative—in whatever medium the artist chose to work: painting, sculpture, photography, film, architecture and hybrid forms. Meanwhile, the Whitney was created in response to the perceived neglect of American artists by MoMA and the Metropolitan Museum of Art, which was otherwise dedicated to art from all cultures and all periods. Then, there is the Asia Society, the former Museum of Primitive Art that was eventually enfolded into the Metropolitan, the Studio Museum in Harlem, the Museo del Barrio, and so on. In a very real sense, these museums came into being to address areas the existing museums did not attend to, or didn't attend to sufficiently; it's what they don't have in common that defines them, at least as much as what they do have in common.

I say all of this not because I want to maintain or reinforce distinctions in the abstract but to explore them in particular, and consider the ways in which they have changed, or come to overlap, in certain respects, without becoming the same thing. If the Drawing Center, which was originally devoted to showing the work of young, usually unrepresented artists, is doing historical shows that are the

envy of the large museums, one has to revise earlier ideas about the purposes of alternative spaces, but that doesn't necessarily reinvent the Drawing Center as a branch of "The Museum."

To be sure, there are gross distinctions to be made between kunsthalles and collecting museums, and these, too, are sometimes evolving distinctions. The New Museum of Contemporary Art has a collecting policy, according to which everything that has been in the collection for more than ten years must be deaccessioned, no matter how hard it may be to part with the best of the work that meets that criterion. What many people don't know, or may have forgotten, is that MoMA once had a similar policy for art that was over fifty years old, a policy that, fortunately enough, never went into full effect. The considerations that prompted Alfred Barr to contemplate that policy were close in spirit to the reasons Marcia Tucker imposed her ten-year limit—to make sure an institution dedicated to the new didn't become overly freighted with the formerly new. So, when people talk about the Modern as a grand old monolith, they should remember that it began as a kunsthalle—with no collection—and then operated for a while with the intention of periodically cutting its ties to the past—and only later turned into what it now is, a repository for the history of modern art in all its breadth and depth. Those shifts in emphasis, that gradual development is essential to grasping what kind of a museum MoMA is and the part it has played, and currently plays, in the wider network of museums of modern and contemporary art.

In this connection, it is important to mention that along with differences of this developmental sort go differences in curatorial practice—differences in the range of materials shown, the ways they are shown, and the speed with which they are shown. With that in mind, curators looking for work need to pay close attention to what's out there for them, not simply in terms of securing an entry-level job or moving up a given career ladder—although frankly, that may be the primary concern of many in a crowded, if not overcrowded, field—but especially in terms of which institutions—prestigious or not, in the middle of the art world or away from it—will offer them a situation sympathetic to the kind of work they ideally hope to do. For instance, think of what Ellen Johnson accomplished at Oberlin in the sixties or what Suzanne Ghez has done at the Renaissance Society, at the University of Chicago, in recent years; when these women made their commitments, neither situation would have seemed promising to most professionals. In some circumstances, meanwhile, it's a question of realizing that an institution is undergoing fundamental changes, and noticing that what once seemed impossible to do in a given place is not only possible but welcomed, in which case one may become the agent of transformation in a museum, even though it has a widespread reputation for sticking to old ways.

Thinking historically about the nature of institutions is fundamentally important; thinking creatively rather than reactively about them is equally so. On this score, I would say that in spite of the vogue for talking about curators as artists, I would strongly insist that they are not. I've been a painter, an unsuccessful painter, and I know the difference between that and being a fairly successful curator. The conflicts, the pain, and the satisfactions of being the former are categorically different from those of being the latter. Notwithstanding that conviction, I do think curators have a medium, and if they retain some humility and master their craft, their relation to that medium and to art itself is like that of a good editor to a good novelist. Although it's not the same thing as being a novelist, being an editor involves a deep identification with a living aesthetic. That aesthetic vantage point is as important or, in many respects, more important than what we usually call "ideas" about art. As a curator, you can work through problems by working with materials and working with artists who are working with materials, instead of always approaching things as if a curator was primarily an explainer or educator.

If there is a plurality of institutions, and a plurality of types of curatorial practice that are distributed unevenly around the various institutions, there might also be, in any one institution, big or small, a plurality of curatorial views represented. The great institutions—and, by that, I do not mean just the big ones—are those that foster internal differences, those that do not operate according to a uniform aesthetic ideology, and do not, in the currently fashionable way, think of themselves as a "brand" with a consistent product, although they may have an overall "style" or a primary focus on certain kinds of material. Instead, they are the ones that encourage a multiplicity of ways of framing and interpreting the material with which they are concerned. Gertrude Stein famously said that you can be modern or you can be a museum, but you can't be both. She was only half right, though, in the sense that being modern, or postmodern, and also being a museum, depends on constantly rethinking and recontextualizing the work that people come to see so that it stays fresh. It is not the work that grows stale in museums of modern art—or, at any rate, not the great work—but the way in which it is presented, the view that one has of it in relation to others' works, and the range of connections established by curators who may see the same work from very different angles. It is, doubtless, comforting for people to come back and find their favorite objects in the same place over and over again, but it stirs their imaginations more to discover what they know in a setting they do not expect, and thus discover previously ignored aspects of that work. Doing this well—which is distinct from simply recycling, or, to use a stock-market term, churning collections—means having curators with fully developed but dissimilar, even conflicting, ways of approaching the problem. The big institutions, and the

small ones that do their job best, recognize and take advantage of the fact that they have many voices rather than one. Since I work in an institution where profound disagreements exist and get aired on a fairly regular basis, I can assure you that it is possible to hold an institution together and to maintain a degree of collegiality and still have those disagreements show to beneficial effect in the way exhibitions are organized and collections are built. It is necessary that this happen because modern art itself, and postmodern art, too—though I take the long view and think that the latter is actually a middle chapter of the former—has been a debate about what art should be or become. The streamlined installation that presents a seamless unfolding of history, with elements as different as such con-temporaneous movements as Surrealism and de Stijl, is, in reality, a gross distor-tion of history. In those situations where debates about modern art's essence have been most intense, the tensions should be palpable in the galleries, and if they are, they will contribute considerably to extending the "shelf life" of modern art beyond the fifty-year limit Duchamp once claimed was applicable. As curators, our task is to make those tensions clearer, more articulate, and more acute, and to do it both on behalf of the art and on behalf of the public, since there is absolutely no purpose in inviting people to come and see something that was intended to stir them up and have them soothed or lulled by it instead.

What I am trying to emphasize, if it is not already self-evident, is that we should work out of the contradictions inherent in our institutions, out of the ambivalences we may feel toward them and toward the larger art world, and out of our disputes with each other over matters of substance, in order to create an entity—an institution or an exhibition—that accurately reflects the dynamics of the art that we are responsible for presenting and preserving. In some cases that means taking the museum itself as our focus. In recent years, there have been a number of exhibitions devoted to the relation between artists and museums. I am thinking in particular of Kynaston McShine's show "The Museum as Muse," which, though I am not well-disposed to the idea of an auteur theory of curator-ial practice in general, was, in the best possible way, an auteur exhibition, in the sense that it summarized Kynaston's thirty-year involvement with MoMA and his equally long-standing involvement with conceptual artists who have made challenging the museum a primary focus of their work. It was the reflection or meditation on art of a dedicated museum man that questioned the basic assumptions of the institution to which he had devoted himself, an institution into which he had, during his long tenure, consistently introduced work that tested that institution's limits.

On that score, a couple of other historical details are in order. In 1928, Lincoln Kirstein and two of his friends created the Harvard Society for Contemporary Art, which was, in many respects, the prototype or model for

what Alfred Barr set out to do when he created the Museum of Modern Art a few years later. The statement Kirstein wrote to announce the founding of his society declared that it was dedicated to "art that was decidedly debatable." That, it seems to me, is a very good definition of what museums and institutes of contemporary art, and of modern art, should be doing.

It is easy to stir up phony controversies while, at the same time, suppressing or contributing to circumstances that suppress real, substantive debate of the kind that has any chance of significantly opening or changing minds. One of our principal tasks as curators and museum professionals is to see to it that what we do does not dampen spontaneous reactions to issues that are undecided. It is not our place to settle these matters among ourselves and pass our conclusions along to the public but, rather, in Brechtian fashion, to articulate the disagreements that may exist among us as fully and as well as we can, and then present our ideas about all the things the work might possibly represent and might possibly mean so that the public can make up its own mind, and add its own thoughts.

I also remember another thing that was told me by Rona Roob, who was, until recently, MoMA's archivist and, before that, Barr's assistant. She recalled him saying one day that the desk of the director of the Museum of Modern Art should be like the desk of a big city newspaper editor—that things should be moving across it all the time, that the director should be constantly aware of new events at the same time as he or she was tracking long stories, and that the whole surface of that desk should constantly be changing, as a reflection of the changes in the world being reported on. It's a wonderful image, but things are different now. Given the scale of the museum's operations, it's impossible to work things that way anymore. We who work in big museums can no longer move that fast, which affects our relations with other, smaller institutions in the field—and I do not just mean P.S. 1. Even though you cannot really coordinate the activities of museums on a broad basis, there should be some ways in which all the major museums, and all the smaller institutions, keep each other in mind as they do their separate programs so that, collectively, they manage to express the zeitgeist in its actual complexity, variety and detail. It's a matter of doing art history as it happens—which, given the periodic return and revision of old ideas, also means doing art history retrospectively from the present, revisiting and rethinking certain eras, or movements, or artists who suddenly seem relevant in ways that they had not been before, or, at least not for a while. I see nothing at all ironic in the fact that institutions that were known for presenting the canonical version of modern art—the Janson text of modernism, if you will—are currently engaged in reorganizing their collections around revisionist versions of that canon. That is what they should be doing, and should have been doing all along. The institution that Barr set up was designed for doing that, it was what he imagined—a place of

constant turnover rather than a place of fixed values and ideas. The museum he improvised into existence—the original Modern—is, in essence, what many people now think of as a postmodern museum, in that it was a multidisciplinary, truly international institution that "made itself up as it went along," which is to say followed art history as artists "make it up as they go along."

Another way to look at the problem is by analogy. Although there are certainly differences, it is useful to think of museums as being like libraries—libraries or public reading rooms of visual culture. They ought to be places where people who have dedicated interests or tastes, or merely an active curiosity, can, so to speak, be seduced by a book they find on the shelf while browsing—and the next book, and the next—or, to shift back to the world of galleries, the next painting, the next object, and the ones that come after. (They ought, like libraries, to be free, but that is another story.) In this respect, the function of museums is very different from that of kunsthalles, in that museums have collections where this pursuit of interests or tastes or curiosity can be played out over a lifetime, and over generations. Indeed, one of the nicest things you hear working at the Modern are complaints; they come from artists and repeat visitors when they discover that we have taken down a favorite picture. We hear from them right away; and they want it back up again right away—because, in a way, it's theirs. One of the ironies of this situation, by the way, is that one of the most missed and requested pictures is Pavel Tchelitchev's *Hide and Seek*, which is one of the curatorial staff's least favorite works. Even so, it gets seen often enough.

Putting these things together, it seems to me that in a context where you are a resource for the at-will inventorying of art history, and a forum where tensions that modern art generates can be heard and discussed, it is quite possible to be both modern and a museum.

If you will accept the notion that the museum offers curators a medium, then within the scope of their use of that medium are distinct genres. One of the most discouraging aspects of much that one reads in the art press is the failure to understand or take note of the formal distinctions between different kinds of shows. Just as all museums tend to be spoken of as "The Museum," all shows tend to be described in the same terms. In the area of contemporary or modern art, the most common is the monographic or retrospective exhibition, followed by the large-format show devoted to a movement or ism. Then, there is the focus exhibition—a miniversion of the first kinds, and the projects exhibition that zeros in on one artist, but is often commissioned rather than borrowed work.

It is useful, perhaps, to compare each of these formats to its writerly equivalent. Think of the larger ones as treatises on a period or style or individual, the medium-size ones as profiles that characterize an artist with a certain degree of economy or essays that push an idea strongly in a particular direction, and the last

as a report on new developments in the field. Then, there are the large-scale group exhibitions of new or relatively new art. These, too, have writerly equivalents—travelogue, field report, polemic, and, too often, the Ph.D. thesis proposal. Frankly, some of these shows are casting calls or quick takes on the scene. To the best of their abilities, curators can, for instance, make big group shows that are essentially shapeless but that, nevertheless, manage to capture the excitement of something happening in the world, as they render an accurate, albeit messy account of the breaking stories of art. Art as well as the public can be served by making such exhibitions; the best ones have the most friction and throw the most sparks. Another kind of show is the well-considered survey, either a contemporary one or an historical one, a show where the curator is really trying to make sense of a theme or moment in art. One of the things American museums need more of at this time is shows of this sort; there is a lot of sorting out that needs doing, a lot of education both inside and outside museums about what has really happened in contemporary art within recent decades, as well as about what has happened in other parts of the world, that have been overlooked too long by the museums.

Some of the difficulties we have faced during the culture wars of recent years are a consequence of the fact that people in this country are unfamiliar with much that has happened in contemporary art in the last twenty-five years because of a tendency to cover the same artists and movements over and over again at the expense of introducing others to the general audience. Whether the public likes this thing or that thing is less important than whether they understand that it is an integral part of the larger picture—if they are altogether unaware of something challenging or foreign, it is easier for them to accept the idea, foisted on them by hostile critics, that it really isn't something to concern themselves with. Museums need to devote more attention to historical movements that are anarchic or improvisational, like Fluxus—Elizabeth Armstrong and Joan Rothfuss's 1993 exhibition was a model of how this can be done—which will make it seem less surprising, less arbitrary for the ordinary museumgoer when contemporary artists do work in a similar vein. Again, it's not so important that people like the stuff; they will understand, as a result of repeated exposure, that such aesthetic ideas or practices weren't invented yesterday, and weren't invented simply to get their goat.

In any event, museum programs should reflect the full range of these approaches and integrate them in a way that incrementally builds an appreciation in the audience of the differences of approach being taken, and the correspondences that also exist. In reality, however, an awful lot of these distinctions get lost in the shuffle, both from a lack of planning and coordination on our part and from careless or inattentive reporting on what we do.

I have chosen literary metaphors—treatise, essay, polemic, etc.—because, having been a critic before becoming a curator, that is the way I think about things. For me, in fact, the motive for making exhibitions is very close to my motive for writing. The impetus usually comes from something I do not know about a certain body of work or am not sure of when I start out, rather than a clear-cut idea of how it will add up and how the show will look. The art I wrote about for *Art in America* and other magazines has often been art that gave me trouble. If one begins from that point, one can both present the information one has gathered and the puzzlement or mixed feelings that one has felt as an essential part of the text, instead of going about the task as if one had in advance a definitive point to prove and everything said was directed at that effort. Indeed, one serves the public best when you—like them—don't know where you're going to come out at the end. This means that the essays one writes or the exhibitions one makes won't be perfect, but they won't be canned either. The hardest cases are those in which you are working with artists who have been shown or written about many times. I am not suggesting that the first thing to be done in such cases is to strike an obviously revisionist stance, or to pretend that you don't have formed opinions about the work, but, rather, to clear your mind and start to work as if you didn't know what you thought, as if you were seeing the work for the first time. The result of turning off the ready-made ideas and responses is that you do see things in fresh terms. I am not going to do a Jasper Johns show anytime soon, but I often think about what it might be like to go back to that work and try to start from scratch. In this regard, the craft of making the exhibition is in allowing this process of being uncertain to show, in letting certain obvious correlations go unstated, in letting the work be seen in a suspended environment that the viewer can explore with greater freedom than didactic or strictly chronological exhibitions generally allow for, of leaving loose ends on purpose rather than building to a conclusion or a visual crescendo that definitively punctuates the whole experience they have had.

That said, curators need to be in full control of everything that bears on the presentation and interpretation of the work they're dealing with. Increasingly, in museums, there is a tendency to divvy up the labor. As institutions get bigger and more complex, all kinds of people with all kinds of expertise are being brought in to share the load. This is necessary and inevitable. But specialization and compartmentalization can make for serious problems when it comes to mounting shows. Ultimately, the way the public sees what's on the walls, or on the floor, is connected to everything, from the manner in which they are installed, to the press release, the wall labels—or absence of wall labels—the catalog, and the brochure. At each point of contact between the public and the work, or its interpretation by the museum, there is a different level of engagement—as, for example,

between those who read only the brochure and those who buy the catalog. All these aspects must be coordinated in the service of the work that is being shown. You want to make sure that the catalog is not just written for scholars, and you also want to make sure that the brochure doesn't talk down to the hypothetical "average" reader. Everything that shapes an exhibition, including the graphics, the color of the walls, the articulation of the rooms—all of this is part of the interpretation of the work, all of it bears on how the exhibition is "phrased." Even though this is a period of text-driven art, these spatial dynamics, this visual phrasing of the exhibition, are as crucial to people's experience and appreciation of art as anything that gets said in words. In many cases, this perceptual positioning of the work, the clues one leaves in how things are laid out and discovered, is a way of commenting on, raising questions about, even contradicting the conventional wisdom about what the work is, the preconceived ideas or "text" that people bring with them in their heads.

The pressures working against this concept of exhibition-making are considerable. The relations among curators and the architects, designers, educators, publishers, and other professionals who work in museums is an inherently delicate one. On the one hand, curators may have to fight for control of their projects within bureaucracies that have their own vested interests. On the other hand, curators must recognize their dependence upon the skill and goodwill of people who may know much better than they do how to realize the conception that the curator has devised. The ability to explain that conception and a realistic grasp of one's own strengths and weaknesses in any given aspect of the overall production of an exhibition are fundamental. Especially the ability to explain. Given current realities in small institutions as well as big ones, the curator's role as educator is not confined to finding ways to make what they do make sense to people outside the museum but to do so inside the museum as well. This means articulating one's needs, motives, enthusiasms and ways of problem-solving to curatorial colleagues, other staff members at all levels, administrators, and patrons. At the Modern, for instance, we have regularly scheduled tours of new exhibitions for anyone on staff who wants to come, and it is the exhibition curator who leads them. Everyone, from librarians to fund-raisers to guards, is invited, and they come in considerable numbers. These tours help in many ways. If fellow workers understand the logic of a particular show, it is easier for them to understand your reasons for saying "yes" or "no" to their suggested solutions to your problems in the next show; and it's easier for them to accept the response as something that does not just come from upper or middle management but from someone with whom they share a common interest in art.

Of course, increased scale of operations in the museum and increased specialization has stirred many new tensions or fears. One is the fear that

fund-raising imperatives will override curatorial prerogatives. This need not be true. At MoMA, we have a wonderful director of development, Mike Margatich, who came to the museum with virtually no background in modern art. My first reaction was, "How are we going to find a way to talk about shows? What hoops am I going to have to jump through to keep the quest for money from dictating or limiting my options?" I needn't have worried. Mike has been clear from the beginning about the separation of powers inherent in our relationship. He knows how to raise money very effectively—something that has always been part of my job but never easy; however, when it comes to aesthetic questions, he calls me in to speak with donors or to clarify the issues for him. Out of those contacts, he and I have had some very interesting informal discussions about art we both like. It's been a pleasure to work with him, and it's reassuring to know that it's possible to build up such a relationship without having our relative difference in uniforms—my downtown uniform and his uptown uniform—create barriers.

The opportunity to have that kind of exchange with museum colleagues, and the chance to feel out the misunderstandings that may arise, also represents an opportunity to imagine where similar misunderstandings and a similar basis for exchange with the general public might exist. Not only has Abstract Expressionism moved to the suburbs, people who live in the suburbs work in museums. Museums no longer are, if they ever were, a club.

The cultural differences and cultural prejudices that often divide museums and their audience also appear within the museum, and the prejudices exist on both sides of that divide. A curator's ability and willingness to talk with his or her in-house constituency—or the failure to do so—is a fair test of how that curator will deal with the larger public. What one learns from engaging in such dialogue can be much more helpful than reading surveys that describe that public in the abstract, or try to summarize what and how it thinks about art based on stereotypical profiles.

Nonetheless, one cannot underestimate the cultural fragmentation that has yet to be overcome. How we go about addressing that fragmentation and the hostility to art that does exist is sometimes part of the problem. One of the downsides to the way museums function in America derives from the country's discomfort with things that probe too deeply under the surface of common-sense living and from a corresponding Puritan distaste for the purely aesthetic. Too often, art is explained and justified on the grounds that it is "good"—that is, not just of unimpeachable quality, which, by the way, we may not all agree is true in a given instance—but that it is also "good for you." But some art is not really good for you. Some art does not love the art lover back. There is, in fact, a lot of art that respects the art lover, that treats him or her as an equal, as someone capable of interpreting complex ideas and feelings, but that also treats them roughly and addresses them

only on the condition that the art can be nasty, that it can ask them things they don't want asked, or make them think about things they aren't in the habit of thinking about. Conservative critics have exploited this. They have characterized the art public as virtually innocent, that is to say touchy, basically immature and unsophisticated, and, therefore, unable to absorb shock or make up their minds about art for themselves. Systematically and deliberately underestimating their fellow citizens, these critics act as if the museums were forcing something tainted onto the tender and unsuspecting. But that's not really the case, although a lot of the material may be disturbing. Here, after all, is a public that goes to Hollywood movies full of sex and violence, watches the same on TV, reads newspapers, reads crime stories and scandal sheets, and is prepared for almost anything, and, yet, that public is being encouraged to believe that the visual arts are only valuable if they are affirming and positive in their outlook.

A prime example of someone who corrects this false perspective is Bruce Nauman. Nauman speaks the languages of video, of neon, of signage, generally, languages the public is completely fluent in. They get him right away—because right away they can feel the urgency with which he tries to speak to them, and because they recognize immediately that the message he is trying to deliver is unlike anything delivered by those mass mediums in their ordinary applications. I remember that when Kathy Halbreich and Neal Benezra's Nauman show came to MoMA, we were concerned about its being attacked, since it was a time when there was a furor in Washington over the use of government money to pay for shows that might be judged "obscene" by conservatives. We also were worried that, given the aggressive use of new media, people might simply stay away in droves. In reality, though, it was one of the most highly attended contemporary shows we have had.

During the exhibition, I spent a lot of time in the galleries watching how people behaved. You could see them ping-ponging off all these unexpected works and absorbing the shock without difficulty. The show also demonstrated how people can connect with very contemporary art in ways that they don't always do with historical modernism. In fact, it's probably harder for most people to get Marcel Duchamp or even much of Picasso than it is for them to get Nauman. Which means that it's time to rethink the museological habit of explaining the present by the past in an academic way, as if the only way into new art was to know its lineage. During the Nauman show, most people didn't give a damn whether he came out of Duchamp or not; they were involved in what was right there in front of them. But having drawn them in, it is possible to switch the flow of ideas around and get them interested in Duchamp. Indeed, one thing museums ought to be thinking about more and more is the question of presenting art history in reverse, working from "now" back to "then" rather

than from "then" forward to "now."

I have one other thing to say about the timidity that sometimes sets in as a result of underestimating the public. It has to do with where you exhibit the most challenging, most contemporary work in the overall scheme of things. In this connection, I remember, about five years ago, when Feri Daftari did a Project exhibition with Paul McCarthy called "The Painter." In several ways, the Projects gallery was a pretty terrible piece of museum real estate—in size and configuration—but it had one big advantage: It was right at the corner of the main lobby as people passed by the ticket collectors. Everybody who came to see an exhibition or the collection had to go by it—on their way to Monet or Matisse or whatever. It was around that time that we were getting ready to do the late de Kooning show, which Gary Garrels had organized in San Francisco. When it went up, McCarthy's piece featured a painter in a strawberry blonde wig who humps a painting, has collectors sniff his behind, and does all sorts of rude things while drooling the name "de Kooooning." On top of that, it was Glenn Lowry's first season as director. A junior curator, who might have been very vulnerable, had done the show and was quite nervous. I tried to reassure her that if anyone was going to get fired, it would be me, not her, since I ran the program. But I honestly didn't think there was much chance of that. I went to Glenn, and said, "I just think you should be aware of what's going to be on view in this centrally located gallery." He said, "Fine, that's what we're here to do." He made the point that I have also made, which is that it was really important that McCarthy's work be right there where people would see it before heading up to the *Waterlilies*. And in the end, everything was fine; the public readily accepted the McCarthy piece.

As I said at the beginning, there are many types of museums rather than one. They vary in accordance with the different reasons they were founded and the different emphasis they give to their multiple functions. For many, the primary mission is educational. It is a mission that all must take seriously, in ways I have already tried to sketch. There is an old maxim in French literature, coming from Racine, I think, that says the purpose of art is to please and instruct. In America, we tend to privilege the idea of instruction, and, at this particularly didactic moment in the history of our culture and of criticism especially, we have taken that tendency pretty far. Acknowledging that, we should also recognize that the tone a teacher takes makes a good deal of difference. For instance, one can use Foucault's ideas quite effectively without sounding like you're in a university seminar. Don't forget—for all the daunting intricacies of his thought and language, Foucault himself placed a premium on pleasure.

How highly one values pleasure, and how one uses it—painful pleasure as well as positive or pleasant pleasure—to draw people in is not a secondary issue but a primary one. On the whole, people have much less resistance to aesthetic

or sensory information than to strictly conceptual or analytic ways of addressing the same questions. If you can engage them by those means—and Nauman, once again, is a crucial example, but so, too, is Felix Gonzalez-Torres—they will open themselves to possibilities they may or may not welcome but will find they can't ignore.

In this connection, there is a term Virginia Woolf used that I find very helpful: "the common reader." When she used it, she meant the people who are not specialists in anything but who have books around, and who, though they may read haphazardly, read avidly. They may also read infrequently or, at least, irregularly, but they compose a dedicated public that continues to dive into books—detective stories as well as Jane Austen—and to try new things. The general audience for museums is composed in large part of people very much like them. Statistics tell us how often they come to museums, and, more important, prove that they keep coming back, but, so far, they don't really tell us why. They are not counted as part of the "art world"—at any rate, critics of museums tend to ignore their existence—and we ourselves tend to underestimate their importance when we talk to each other about what we do and who we are doing it for. It's easy to overlook them, to lose them in the larger crowd. But these common readers are essential to the future of museums, not just in terms of attendance but in terms of understanding. They represent the demographic and cultural threshold where the ideas cultivated by artists, critics, and museum people begin to become general knowledge.

There's always a lot of discussion about what the "field" is doing and who is doing it, who is making waves. On that score, I would say that, for all the competition among us and our institutions, there is less raw rivalry than is usually thought to be the case by outsiders who listen to secondhand gossip about the scene—but, altogether, we should, perhaps, be less concerned with staking out professional territory in the name of the new than in thinking about how the news of the new gets to the public at large. After all, most of us work for public institutions, or for private institutions designed to serve the public. It is our job to introduce that public to the art of its day, and to help it to see that that art is not just our concern but its concern as well. We want to make it possible for them to explore it for their own reasons and at their own pace—like someone opening a magazine and reading at their own discretion. Not everyone knows what we, who have the tickets to travel from city to city to see each other's shows, know. Out of the whole population of the art public only a small fraction is on "the circuit." In any given place—big town or small—a given artist entirely familiar, maybe overfamiliar to us will be unfamiliar to the rest of the population—never before seen or not seen in a generation. It makes no difference to the person paying ten dollars to come to the museum that the "hot" young artist whose

work is on view has already been widely exhibited in art galleries that he or she never goes to or in towns they have never visited.

How you inform people in this situation is also crucial. You must never talk over their heads—as if they should already be aware of what you, the expert, are aware of—nor down to them—as if they are being given a remedial course. Just as you need to take care to phrase exhibitions in spatial terms, you must choose your words carefully, so that this common reader can enter into what you are saying on their own terms. On that score, I would cite another literary example, that of Virgil Thomson, the avant-garde composer and collaborator of Gertrude Stein, who, for many years, wrote music criticism for a New York daily newspaper. In that role, he was writing for a mass audience about something he understood far better than most critics; he was writing about modern and classical music for people riding the subways. His rule of thumb, which curators as well as critics should heed, is never overestimate the information your reader has and never underestimate their intelligence. If you condescend to people or treat them as if they are somehow incapable of more than rudimentary understanding, they will pick it up right away, and you will have lost them. Instead, one must assume that, in varying degrees and mixtures, they have much the same combination of general education, responsiveness, and appetite that we have, minus the opportunity to devote themselves full-time to developing those resources. In that sense, the common viewer—like the common reader—is not so much defined by their "commonness" as by their individual status as "amateurs" in a area where we are lucky to be experts, but where it is neither in their interests nor ours to take that discrepancy for granted, much less abuse it.

If you're inclined to think that your true public consists of the happy few who speak the language of the guild to which we belong, and you're prone to thinking that serious art writing must imitate serious texts in such other disciplines as philosophy and the social sciences, texts that demonstrate their seriousness by striking an anti-aesthetic tone, I recommend a careful review of Roland Barthes's *The Pleasures of the Text,* in which he says, "The text you write must prove that it desires me." If the text does not desire the reader, there's no reason in the world that the reader—or museumgoer—should simply submit to its authority for their own good.

What we do as curators is a more or less sophisticated version of Show and Tell. One component is to impart information about things, the other to present the things themselves. There is a philosophical dimension to the latter that distinguishes it from mere display, and also from theatrically staged spectacle. It is a question of making it possible for correspondences to emerge in the mind of the viewer. There is a text by Wittgenstein that is particularly enlightening in this connection. It was his contention that certain areas of human experience fell

outside the scope of philosophical analysis because they did not give rise to statements about them that were subject to objective verification, statements that could be proven true or false. Those areas were religion, ethics, and aesthetics. But that did not mean that these areas should be disregarded. Instead, he maintained, one could arrive at an understanding of them, not through logically consistent means but by what could be *shown*, and how what was shown registered in the person who experienced it and weighed its possible significance. Yet, again, Nauman's work is exhibit A. Although he is a conceptual artist, he does not write syllogisms or argue points with the viewer; rather, he is an artist who has found ingenious ways of showing us things, putting us in situations where we can see or hear or feel things that belong to these most hard-to-pin-down, indeed never-to-be-pinned-down areas of our consciousness. We, as curators, are faced with the responsibility of finding appropriate ways to show those artists who have this rare capacity to show things within this fluid realm.

I am going to end with that thought. I want to invite the other participants up on stage to make their statements, and to open the more general conversation among us. I'd simply like to add that, as a practicing curator, whose job it is both to please and to instruct—and I try to do the teaching part well—if forced to make a choice between the two, I would favor the party of pleasure over that of instruction. By the same token, I would choose the party of the imagination in preference to the party of ideas. I value ideas enormously, but I think museums and art are about something besides ideas—and something more than ideas. We all are alert to the economic, social, political, and other "real world" pressures that overshadow and qualify what we do; during the course of the next two days, we will doubtless hear a lot about them. But, as we confront those factors—and are sometimes worn down by them—holding to the conviction that art has intrinsic value may become an act of faith. Given all that we have learned about the contradictions of the activity to which we are committed, all that institutional critique has taught us, all that the accurate diagnoses of our current cultural malaise have made us see, taking the position that what you do you do for the sake of the imagination, for pleasure, for all these intangible things, seems corny. Or just plain naive. And I suppose it is. But, basically, if you hope to sustain the effort it takes to be a curator, you must proceed despite such skepticism, despite the probability that, in part or in whole, you will fail in the endeavor of showing art as it should be shown. Even so, even if you assume that the art system is locked in and incapable of fundamental change, one must remember that that system or structure is not a monolith. There are cracks in it, and within those cracks and crevices possibilities exist. Antonio Gramsci, the Italian Marxist, described himself as a pessimist of the intellect and an optimist of the will. So am I. It is the only reasonable, or at any rate, the only livable position. This

combination of pessimism and optimism seems to me the only point at which our situation as curators can truly be correlated with that of artists. We wonder, sometimes, why artists get up in the morning to make the things they make, considering how much of a long shot it is that they will fulfill their ambition of creating something that matters or has any chance of being recognized. Curators who get up in the morning and go to work in the hope of doing their job well face comparably long odds. The fact that they go to work anyway is a leap of faith of a comparable kind.

NOTE: *This text has been edited from a transcript of comments made at the opening of "Curating Now" and amended in certain sections from notes made in preparation for that occasion. Rather than rewrite it in essay form, I have tried to retain the tone of the original, spontaneously delivered talk.* —RS

NOTE: *All of the following texts have been edited by the participants from transcripts of the proceedings. In every case possible, we have tried to keep the informal and conversational tenor of the event.* —PM

# PANEL STATEMENTS AND DISCUSSION

**Paul Schimmel >** *Chief Curator,*
*Los Angeles Museum of Contemporary Art*

Good morning to all of you. I appreciate that on such a beautiful day you should all come here and discuss curatorial practice— something that has undergone enormous changes since I first joined the profession some twenty-five years ago, in Houston, Texas. Perhaps the thing that brings us all together is our love of objects and our passion about working with artists. That remains the same, beyond other issues such as trustees and globalism. It keeps curators very much on a track and helps make the work satisfying and productive.

When I first began, there was a sense that curators came from art history; you went from being an assistant curator to an associate curator, to a curator, to a chief curator, etc. But, in the last twenty years, our whole sense of what a curator is has been blown apart. There used to be a clear distinction, for instance, between people who worked at galleries and people who worked at museums. I look at Kathy Halbreich sitting there in the audience, smiling, because she did something rather brilliant several years ago when she brought Richard Flood from a commercial gallery into the museum profession. It's something that twenty-five years ago wouldn't have even been considered; it was just against the rules. And yet, he is a terrific writer, someone very close to artists, and has done some amazingly important exhibitions.

Now, there are curators for private collections. When I first started hearing about this, I thought: That's not a curator at all—that's more a kind of registrar. But, then again, collectors like Kent Logan are buying not just dozens of pieces but hundreds. [Logan has bought nine hundred works in the last ten years.] That is a very empowered position for a curator, enabling them to have an impact on what is being made, what is being shown, and, finally, what is being collected today.

The most important change in curatorial practice today is, I think, the role of the independent curator—a kind of journeyman curator or wandering global nomad who doesn't have the shell of the museum to protect them, to carry around day to day, week to week. This has done the most to invigorate the museum. Although I share Rob Storr's concern about the curator as a star auteur, I'm also encouraged that curators are able to bring a personal vision and passion into the discipline. Many of these independent curators have raised the bar for those

of us who work in more traditional museum fields.

Another recent tendency—and you see it more often in larger institutions—is the curator as a collective entity. This is very promising, on the one hand, because it creates a great deal of dialogue, a multiplicity of viewpoints within the institution. On the other hand, it also has the effect of making you wonder: Who really made this? Or where is this exhibition coming from? You can't get your arms around these group practices sometimes, or you're not even sure what the point is that's being made. Early on in MOCA's history, there was a large-scale, thematic exhibition called "The Automobile and Culture." It seemed a wonderful place for MOCA to begin, because it established us in doing complex, thematic exhibitions. There were three or four or five curators, but, finally, when the show opened, there wasn't a single person around. No one knew who was supposed to show up for what; it was like a child with no parents. So, much as I am encouraged by this kind of collective exercise, I'm a little bit concerned that there isn't the same sense of responsibility.

It's been a great privilege to work at MOCA. The curatorial staff there has enormous opportunities. The space that we have is extraordinary—or, should I say, the *spaces* that we have are extraordinary; however, I admit I was a little upset when I read a wonderful and very positive review that Roberta Smith, of the *New York Times,* did of the "Out of Actions" exhibition, in which she said, "Real estate is destiny." My first reaction was, no, no, it's not that; it was my vision, my dedication, my tenacity that made it all happen. But the more I thought about it, the more I realized that, in fact, she was right, to the degree that I don't think I ever could have imagined doing that kind of project without real estate. I don't mean real estate just in terms of physical space—I mean the real estate of possibilities that trustees and, most important, artists give you as a curator at an institution. It allows you to make something you feel very strong and very passionate about.

As we succeed, however, I wonder if we can, in fact, do more; this question applies especially to an institution like the Museum of Modern Art. As we build larger audiences and do the kinds of exhibitions other institutions can't do, are we, in fact, limiting where we can go? After our successes, can we, as curators, afford to fail? It's very important for a curator to be able to say, I want to try something and it could very well be one of the biggest disasters of my career. Can I go on? Will I be fired? Could I get another job? The truth is that after twenty-five years of relative success, there isn't a single big show I do that I don't wonder if it could finally be the last one. Thank you.

**Mari-Carmen Ramirez >** *Curator of Latin American Art\*,*
*Museum of Fine Arts, Houston*

I want to thank Rob for his wonderful overview of how we do or
don't do things in our curatorial profession. In my comments,
however, I would like to step outside the institution of the muse-
um and, instead, focus on the transformation of curatorial practices over the last
ten or fifteen years. At the same time, I want to point out some of the creative
and ethical challenges that, in my view, our profession confronts now.

First, however, I wish to address the general context that holds curatorial
practices in place. It is impossible to consider the status of curatorship now with-
out taking into account the broad and deep reorganization of the public, private,
and symbolic spheres of culture brought about by the so-called new global order.
This reorganization, in turn, has propitiated an intermingling of public and pri-
vate interests that makes for some very strange bedfellows in our profession and
in our institutions. There is no doubt that the new conditions have deeply
impacted the way that contemporary art has come to be perceived in our society.
When you have private entities taking over the public sphere for their own inter-
est, or governments and private interests coming together to facilitate different
forms of cultural endeavor, contemporary art becomes not so much the com-
modity it has always been but something else. In this context, art has increasingly
come to function as a dynamic form of *symbolic capital*. One of the points that I
want to make here is that curators are indeed playing a key role as mediators in
that type of symbolic exchange. That's why I have referred elsewhere to the cura-
tor as a *broker*, but I will get back to that point later.

Less evident, perhaps, is the extent to which the artistic and cultural field in
which curators operate has been altered and then absorbed into the dynamics of
this new economic order—a phenomenon that generally lacks artistic reasons.
Thus, the second contextual factor I wish to highlight concerns the unprece-
dented expansion since the late sixties of "The Art Institution." I cannot think of
any other period when more museums, galleries, or exhibition spaces have been
built or more collections expanded as in the last thirty years. This phenomenon,
as you all know, has even led to the franchising of museums beyond their local or
national communities. The self-preservation of this almighty Institution has, in
turn, become the straitjacket under which curators—whether independent or
institutionally affiliated—are forced to operate. Within this system, not only are
curators under constant pressure to deliver easily consumable and entertaining
products but the imaginative and creative dimension of curatorial practice, that
which Rob described for us this morning, is sacrificed to plain bureaucratic or
corporate interests. This is a fundamental threat that must be stressed here. In this

\**At the time of the symposium, Mari-Carmen Ramirez was Curator of Latin American Art at
the Jack S. Blanton Museum, University of Texas, Austin.*     **25**

uncontrollable context—as Saskia Sassen describes it—the *unstable status* of our relatively young profession, as well as our concern for autonomy, oscillates between power and powerlessness.

The main point I am trying to make, however, is that the aforementioned conditions have brought about a fundamental shift in the understanding and practice of the contemporary art curator. In other words, curators, as we understand them today, have been produced by these economic and social circumstances. The visibility that curators have today, for instance, was not there twenty or thirty years ago. Back then, it was the art critic or the intellectual functioning as cultural ambassador that had the spotlight. The curator's job was a "behind-the-scenes" job. By contrast, the *centrality* accorded to contemporary art curators in the new system is evident in the multiplicity of extra-artistic roles and the diversity of performative arenas that have come to define our current practice. As we all know, curators now have to function as aestheticians, art historians, and educators, as well as cultural diplomats, politicians, community organizers, and fund-raisers, among many other roles. The adaptability and skill of contemporary curators to manipulate ethically all these functions and contexts is no longer a desirable qualification but has, indeed, become an intrinsic feature of what Michael Brenson has recently called "the curator's moment."

Within the present system, the curator's allure stems from his/her potential to actively *mediate, broker,* or even *translate* the distance between those worlds. As a *broker,* his/her function depends on the ability to negotiate openly the financial or symbolic status of everything from concrete artworks and artistic manifestations to the intangible identities of emergent cultures and new social movements. As a *translator,* the curator's role is to decodify and interpret cultural and artistic values from one context to another. More important, the future success of curatorial efforts in this area will be largely dependent on the mediator's adaptability and engagement of the processes dictated by these combined forces—to put it simply—in an ethical approach.

Despite the restrictions I have outlined so far, or *precisely because of the challenge they represent,* curatorial practices, broadly understood, have come to embody one of the most dynamic forms of cultural agency available today. This *fluid space* allows us, as curators, to affect a series of interdependent areas in ways not accessible to other more restricted modes of cultural practice. Such a task involves everything from how to invent the spaces for art to how to reinvent the art institution itself, something that we have not yet touched upon in this discussion. Rob, indeed, seems resigned to the fact that we have to accept the art institution as an *act of faith* and operate within it with a "reformist attitude." I tend to think, however, that we have to, at least, pry it open and discuss it, fully aware that we are entering a new century and that that transition requires that we reinvent

ourselves, our practice, and our spheres of action.

Despite the positive gains in visibility and influence, the downside of the already mentioned shift lies in the ongoing erosion of the creative potential of curatorial practice and its intellectual reduction to the instrumental role of strictly facilitating and/or promoting private or institutional interests. As Olivier Debroise has pointed out, ours is a practice involving mostly *the production of meaning* by means of exhibitions or other creative endeavors—meanings that are not only critical for the continued nourishment and development of art but for its positive impact in a democratic society. In my view, it is in this particular area that the gains and losses of the new curatorial roles must be duly assessed and their future potential must be mapped.

Finally, I believe that, in effect, curatorial practice entails a *creative* and *imaginative dimension* that is somewhat parallel to that of the artist and even closer to that of the critic. This is not to say that the curator should take the artist's place, as some recent detractors have naively suggested; instead, it implies acknowledging that curatorship involves a *propositional discourse* that invariably results in some form of scenic enunciation, whether by means of an exhibition or other concrete manifestations of the curatorial proposal.

**Hans-Ulrich Obrist** > *Curator,*
*Musée d'Art Moderne de la Ville de Paris*

I'd like to say a few things first about curatorial notions and then about changes that I see at the moment.

*1. Connective Possibilities*

Classical exhibition history emphasized order and stability. In contrast, we see now fluctuations and instability: the unpredictable. In nonequilibrium physics, you find different notions of unstable systems and the dynamics of unstable environments. Combining uncertainty and the unpredictable with the organization seems an important issue. Instead of certitude, the exhibition expresses connective possibilities. The question of evolutionary displays. An ongoing life of exhibitions. Exhibitions as complex, dynamic learning systems with feedback loops, basically to renounce the unclosed, paralyzing homogeneity of exhibition master plans. To question the obsolete idea of the curator as a master planner. As you begin the process of interrogation, the exhibition is only emerging. Exhibitions under permanent construction, the emergence of an exhibition within the exhibition. This idea of renouncing or questioning a master plan also means that, very often, organizing an exhibition is to invite many shows within the shows, almost like a

kind of Russian Matroyshka doll. Every exhibition can hide another exhibition (temporary autonomous zones).

At a moment when collaboration between museums and different exhibitions is driven more and more by economic reasons and the rentability of globally shipped and packaged traveling shows, I see an urgency and necessity to think about nonprofit-driven, but art-oriented, interconnectedness. As Indian economist Amaryta Sen points out, there is a necessity for empirical connections that link freedoms of different kinds. This also means that, rather than further enhancing bigger and bigger museum conglomerates, which become more and more homogeneous, I see a necessity for collaboration between different models, which enhances differences and allows disparate conditions "to thrive through both protection and exposure," as Cedric Price reminds us.

### 2. On the Move

This whole notion of the evolving display—that there is an ongoing life of exhibitions—becomes important. I've tried to develop this with "Cities on the Move," together with Hou Hanru. It's been a small sketch of something that has to be further thought about and further continued: the idea that complex and evolving exhibitions can, on the one hand, follow the ever-increasing exigency to develop traveling shows, because of economies of scale, global logistics, and budgets, etc.; on the other hand, exhibitions should avoid the kind of big problems traveling shows always include, such as the energy loss in the process of mounting the tour. An exhibition travels to the second venue and the third venue, and that, very often, is the end. An interesting alternative might be to invert and make the third venue the most exciting—make it a kind of ever-growing, evolving model that resists the fly-in and fly-out mentality of much current exhibition practice. Rather than a product, it is important to think about the possibilities of the museum and its exhibitions as a process, as a laboratory condition. This means that exhibitions are no longer switched on and off but that there is an almost organic, lifelike aspect where seeds grow—where sedimentation of display can occur—rather than the current condition of tabula rasa, where one display is always followed by the next display, and the memory of the previous display is not cared about enough.

With "Cities on the Move," the traveling exhibition on Asian cities, there has been an ongoing, three-year dialogue. Little by little, very interesting things started to occur. Artists started to collaborate with other artists. Lots of things were triggered that also happened beyond the exhibition. The exhibition, in this sense, truly became "on the move." On the one hand, it was very fast; on the other hand, the exhibition catalyzed a very slow process of emerging dialogues, of emerging collaborations.

"Cities on the Move" kept changing throughout its tour. An empty court-yard in Vienna—the exhibition's first venue—was designed by architect Yung Ho Cheong. In London, Rem Koolhaas and Ole Scheeren designed what they called an "accelerated Merzbau" for the Hayward Gallery. They tried to be "economical with their imagination" and recycled the exhibition architecture of Zaha Hadid, who had designed the previous exhibition at the Hayward, "Addressing the Century: 100 Years of Art and Fashion." This and other previous Hayward–designed exhibitions were recycled and reassembled by Koolhaas and Scheeren. In a form of interior urbanism, the show became a process of sedimentation.

After London, "Cities on the Move" continued its evolutionary process. There has never been a fixed artist list. With "Cities on the Move," Hou Hanru and I basically tried to trigger positive feedback loops. It was designed as a learn-ing system, where knowledge was acquired and shared depending on the various urban contexts of the exhibition sites. The exhibition went to Helsinki, where it was designed by Shigeru Ban, the Japanese architect, who used paper tubes in different forms of appearance, creating an homage to Alvar Aalto.

*3. Interior Complexity: Learning from Sir John Soane's Museum*
Patricia Falguières refers to interior complexity while linking Sir John Soane's Museum to the Merzbau. She notes that the temporality of Schwitters's marathon visits through the Merzbau were nurtured less by objects than by events/intensities. The exhibition is conceived not so much as an envelope but as a process of sedimentation that is never stabilized. Intricate and uneven structural elements unfold in a manner similar to Piranesi's Carceri, with staircases mirrored into infinity, opening connections in all directions. Nonlinearity requires self-navigation, where the viewer discovers his own path.

*4. Time—Time—Time*
The time-marathon visits of the Merzbau lead us to the question of time-based exhibitions, which is something I'm very interested in. The time-based museum or the time-based exhibition is also important in relation to the time of the viewer and the time the viewer spends in the museum. The changes that are necessitated in terms of time are relative to the sum presence of film and video in exhibitions.

Many changes that I see at the moment are related not only to space but also to time—the whole question of the invention or reinvention of the time of the exhibition in order to create new temporalities. Toni Negri and Michael Hardt discuss in *Empire*—one of the most brilliant interpretations of globalization to date—their concept of "multitude," whereby new spaces establish new residencies. Here, autonomous movement is what defines the proper place of

"multitude." "Multitude" fights the homogenization of globalization; "multitude" constructs new temporalities—immanent processes of constitution.

Following up on Negri and Hardt's emphasis on different temporalities, I want to continue this discussion based on a drawing by Cedric Price, a great, visionary English architect and urbanist who participated in different versions of "Cities on the Move." He once noted that time is the fourth dimension of an exhibition. In the Bangkok exhibition of "Cities on the Move," time was the key, because the whole nature, not the presentation of materials and ideas but the actual consumption of ideas and images, exists in time. The value of doing the show is an immediacy—an awareness of time that isn't in a place like London or, indeed, Manhattan. In his *Fun Palace*, a project from 1961, Price proposed a building that would not last forever, or have to be renovated, but that would disappear after a limited life span of ten to twenty years. The *Fun Palace*, which Price developed out of dialogues with Joan Littlewood and Buckminster Fuller, was to be a flexible multipurpose complex in a large, mechanized shipyard, in which, according to changing situations, many structures can be built on top of one another. Price's key idea is that the building can be altered while it is occupied. This loose social pattern would allow, according to Price, "the user to be free in what he or she would do next." The *Fun Palace*, as a responsive building, responds to the necessity to connect disciplines and different practicioners within changing parameters. Price developed these ideas further in a vision for a cultural center for the twenty-first century that utilizes uncertainty and conscious incompleteness to produce a catalyst for invigorating change, while always producing the "harvest of the quiet eye."

*5. Against the Amnesia about the Laboratory Years of Exhibitions*

If one observes the Bilbao effect and the whole focus on exterior spectacle in relation to museums, one will notice that there is a comparatively very strong amnesia about the interior complexity of experimental exhibitions as were mounted by Bayer, Duchamp, Gropius, Kiesler, El Lissitzky, Moholy-Nagy, Lily Reich, and Mies van der Rohe. Mary Anne Staniszewski, author of the excellent book *The Power of Display*, reveals a kind of amnesia, whereby the importance of the diverse set of exhibition and institutional practices that mediate our experience with art are often forgotten. She writes: "Seeing the importance of exhibition design provides an approach to art history that does acknowledge the vitality, historicity, and the time-and-site-bound character of all aspects of culture." In a recent interview I conducted with the artist Richard Hamilton, he pointed out that most of the great exhibitions since 1851 have produced some display features of historic importance, a manipulation of interior spaces that commands respect to this day.

*C H. 2*

### 6. Against the Amnesia of Curatorial History

Amnesia not only obscures our understanding of experimental exhibition history it also affects innovative curatorial practice. I wish to mention a few pioneering examples of curatorial positions I find relevant at present and that are possible cures for the amnesia that haunts our profession. They not only contributed to the mutation of existing museums and exhibition structures but also pushed the boundaries toward the invention of new interdisciplinary structures.

In the early twentieth century, Félix Fénéon bridged different fields and continuously sought new forms of display and mediation. He made projects with daily newspapers, as they temporarily seemed the most appropriate space. He also founded his own magazines, published books, and organized exhibitions. Fénéon defined the curator as a *passerelle* (pedestrian bridge) between the artist and the world. Harry Graf Kessler also pursued mobile strategies of display and mediation. He was a junction-maker between artists, architects, and writers. From time to time, he organized exhibitions to put the art of his salons into a larger social and political context. Kessler also pursued publishing activities parallel to his exhibition-organizing. Herwarth Walden was a similarly open mediator between the disciplines. He founded the art school Der Sturm, his own publishing house, and ran an exhibition space as an open, hybrid laboratory for small exhibitions. In 1913, Walden organized the First German Salon of Autumn, with more than 360 works by eighty of the most important artists of the time.

I could discuss Sandberg, the former director of the Stedelijk Museum, in Amsterdam, at greater length since he was so influential on twentieth-century curatorial practice. As there is a lack of material on the history of curating, I have begun an oral history project on the subject, conducting a series of interviews with curators who are from the generation of Walter Hopps and Pontus Hulten. It has been very interesting to learn how many paths seem to lead back to Sandberg.

— NEED TO CROSS DISC PLINES

### 7. Bridges between the Disciplines

"We cannot understand the forces which are effective in the visual production of today if we do not have a look at other fields of modern life." (Alexander Dorner)

Another crucial issue is the necessity to go beyond the boundaries of disciplines. This transdisciplinary drive can be observed right now in all kinds of productions. It is evident not only among artists but architects and designers. Exhibitions should reflect this, too, as curators also practice a kind of transdisciplinarity. This is an issue of some urgency.

### 8. Slowness / Silence

I also want to say something about what has not changed, because all of this is about change. Something that has not changed is that the collection remains the

backbone of museums. The museum's main function as a site for "time-storage" is unchanged. Pontus Hulten, in an interview with me, said that this collection/backbone element is very important as a kind of a shelter into which to retreat, and a source of energy. I think the collection is a source of energy both for the curator and the visitor.

To have moments of silence and slowness are an integral part of a museum visit. At a time when the fast lane and noise dominate over the slow lane and silence, it is important to think about how to reinject slowness and silence into current museum conditions. In an interview I conducted with Rem Koolhaas, he discusses this idea in reference to his museum and library projects: "I don't think you can have a laboratory visited by two million people a year, and that is why, in both our libraries and our museums, what we are trying to do is to organize the coexistence of urban noise experiences, and, at the same time, experiences that enable focus and slowness. This is, for me, the most exciting way of thinking today, the incredible surrender to frivolity and how it could actually be somehow compatible with the seduction of focus and stillness. The issue of mass visitors and the core experience of stillness and slowness, taken together with the work, are what is at issue in these projects."

**Thelma Golden** > *Deputy Director for Exhibitions*
*The Studio Museum in Harlem, New York*

In my twelve or thirteen years in this field, I've worked in a major institution, I've worked in an alternative space, I've worked as a curator for a private collection; I now work in a culturally specific institution. According to Paul's model, I just have the auction house left.

**Paul Schimmel :** We'll probably all end up there.

**T.G.:** I've had titles that have ranged from curatorial assistant to assistant curator, to visual arts director, to curator for special projects—to, now, something called deputy director for exhibitions and public programs, whatever that means. When I think about the nature of the change in this field, it is in relation to this idea that curatorial work, at this moment, is so defined by context. My own work has been defined very much by context. In some ways, I feel like a relic, because I've chosen to work most of my career in institutions in one way or another. In the age of the independent curator, or the curator working in the in-between spaces, as Hans-Ulrich has described but also exemplifies in the best way, I still believe that there is a need for deep institutional change. That has to happen through this

connection to the institution in some form of permanence. I know better than others that there's no such thing as permanence. I say that in terms of perma-nence in the sense of the field, in the sense of where one chooses to exist. I also think, however, in the way Rob talked about different kinds of exhibitions, that there are very different kinds of curatorial practice. The challenge becomes, as one understands their context, defining what kind of curator one can or might be.

A couple of years ago, when I was working on this exhibition at the institu-tion I was working at at the time—I've learned how to do that very well, right?

**P.S.:** And no one got it!

**T.G.:** I was interviewed by the architecture critic for the *New Yorker,* Paul Goldberger. He was writing a piece, and his hook, at least when he started the piece, was the idea that there was a kind of "branded curator," that there was this "star" curator notion—that one defined curatorial practice by who one was, and then other people would come along and try and be that kind of curator. In discussing this, he forced me to come up with some analogies so that he could write about this. This was a "Talk of the Town" piece, so it was meant to be buzzy. In trying to come up with an analogy of how that then plays out—what are the different kinds of curators—he used architects, of course, as the example, and how one understands them in the world through their practice.

I couldn't come up with an analogy for him, except one that was prompted by being in my doctor's office and waiting for her interminably. They always put you in a room and make you take your clothes off, and then no one comes for forty minutes. I'm sitting in there, and there was this chart about eating habits or diet types. It started with vegan, then it explained what a vegan was, then it went to, like, ovo-lacto vegetarian; then, there was some other kind of vegetarian that was not ovo-lacto. Then, there was something before carnivore that was chicken, fish, but no red meat, then there was the straight carnivore. There was this other interesting thing—the situational eater. They described situational eating as some-thing that didn't happen so much in the developed Western world, necessarily, but developed in other parts of the globe where access to different foods was not necessarily a matter of choice, like in the supermarket. When I was talking to Mr. Goldberger, it made me realize that, in some ways, curatorial practice can be like that. Some of us have the luxury of being able to live out our lives as vegans: to focus on one thing and know that's the one thing we do and be very pure about it, and never get swayed by a piece of dairy that might be lurking on the edge of the plate. Others of us, of course, have become, for one reason or another, situational eaters: You get to an institution, and this is what the institution does, and this is what you become. Most of us are probably some form of omnivore

33

that tries to develop what we do around a wide palate, but picks and chooses, and certainly has its favorites. We might like lamb better than veal. We come up with some way to understand ourselves as curators through a wider plane. For me, particularly now, as I look back over the time that I've worked, it is this notion of figuring out what our practice is, then finding a way for that practice to exist within an institution that might be something else. It's like being in a relationship. It's like you're a carnivore and you marry a vegan. In some ways that probably isn't going to work. But there are other ways. The combination of one's practice, the way one sees oneself, and the world in which one decides to work in as a curator—by bringing that into an institution, one finds a way for the institution to adapt and transform.

I also think that nothing makes us understand ourselves or what we do or "how we do it or how we don't do it" as actually looking for a job. One of the changes in this field, of course, is the way in which that does define this field, not only the elasticity that Paul has described, of people moving back and forth, but the nature of change in time, in institutions, that often requires this kind of redefinition over and over again, as one might try and make a career around the desire to make certain kinds of projects in different kinds of places. The change, now, that at least emboldens me is the idea that context, as we understand all of the things that face institutions at this time—whether it be money and space or audience or any of them—is really a context in which we define ourselves. As Rob implied, I have this funny job where one foot is in the director's office and one foot is somewhere else, which we hope is the curatorial department, by being a deputy director. This insistence on administration is real, whether it's made plain, as it is in my case, or it's a little bit more subsumed, as it can often be in the title "chief curator." Rob has indicated in his talk one way that it is, which is to see oneself as a curator within the very complex ecosystem of an institution rather than set aside from it. Another way is to transform radically the notion of the administration that we all know is necessary to run institutions no matter how big or small. That's the thing I've learned; the size of an institution doesn't matter, administration is there, no matter what. We must inform it with the same passions that go into making an exhibition or engaging with an artist.

The biggest change—at least that faces me and that, I imagine, faces some curators of my generation, as we constantly negotiate these choices between independent and institutional, between directorial administration and a purely curatorial position, as we negotiate the changes between different spaces in the institutions—is the notion of not to tell a curator what can exist in an institution, or even outside of it as an independent, but how a curator can exist in the world, and how our practice can engage with our audiences outside of the institution, and how the curatorial voice becomes less a voice speaking to each other and

ourselves but can speak in a larger context that allows our vision to move in a significant way out into the world. Thank you.

## PANEL DISCUSSION

**Robert Storr:** I'm going to ask some general questions. I invite anybody to interrupt, mix it up, scrap, or do whatever is necessary along the way; I just want to get the ball rolling. Then, at a certain point, we'll open it up to the floor. If you can't contain yourself, speak up, but if you can contain yourself a little, let them speak.

Mari-Carmen, you were talking about new curatorial spaces and so on—and that seemed to overlap with Hans-Ulrich. Could you spell out in more detail what you actually are trying to describe, practically speaking? Where is one the broker for these things? Do we invent the occasion or does the occasion exist in the interstices of something that we all know?

**Mari-Carmen Ramirez:** I think it's both. To the extent that the curator can have the power to manipulate any kind of situation, he or she should be able to invent the spaces, whether it's inside a museum, trying to open up the museum, create a special gallery, for instance, or make an exhibition outside in the courtyard or some other place. Or try to take over a part of your city to do an exhibition, and not only to do an exhibition, in the traditional sense of taking the artwork there, but making certain elements of that city or that community come together to discuss a particular issue that may pertain to art, but may also pertain to how that art functions within that particular urban context. A site can also be a publication. It does not necessarily have to be an art object or an exhibition with art objects; it may be the case where you can effectively communicate a number of ideas that relate to artists you're working with, or particular objects in a publication, without necessarily having to do an exhibition. Sometimes, the conditions don't allow you to do the exhibition, so you have to resort to the publication. In each case, this is a very broad way of looking at curatorial practice, but it enables us to come out of these categories that we've been dealing with, as well as these institutions and structures that are holding us in place. You don't necessarily have to be the peripatetic curator to be able to engage in some of those activities. I don't know if that answers your question.

**Paul Schimmel:** We're not really considering the impact that architecture is

having on our programs in general. Some of the most successful museums to come on the scene in the last decade, in fact, continue this legacy of larger, more monolithic structures, designed by one or two individuals, that, for the most part, have very consistent spaces and, therefore, almost demand a certain kind of program. Museums are not really keeping up with the various interests of artists. What both of you are talking about is trying to go outside the museum, because, in fact, the space within the museum doesn't exist.

The hope that I've had is that a museum could be much more like a campus of a university, with different kinds of opportunities—not just physical opportunities in terms of different kinds of spaces. Obviously, I think about having two very different types of spaces. I couldn't see the Gober installation being in the Izosaki building. I couldn't see the Reinhardt exhibition being in the Temporary Contemporary. It needs to go far beyond a warehouse and a clean, well-lighted box. That includes places where artists can create and play in, it includes nontraditional sites that are of a temporal or time-based nature—that a museum should have something that looks like the newsroom at CNN, on one hand, and a contemplation garden from Kyoto, on the other hand. As we start thinking about taking museums into the future, we better start thinking about design and architecture, which reflects all the programs that we, as curators, want to see artists realize within our facilities. If we don't, they will surely go elsewhere, as they ought.

**Hans-Ulrich Obrist:** The big change right now is to develop a complexity where all these different experiences are made possible within one building. That, at the moment, is the big change for the twenty-first century for museum architecture.

To come back to your question of different spaces—for me, what has been very, very fundamental has been discussions with Felix Gonzales-Torres about this issue, at the very beginning of the nineties. He always pointed out that it is not about an opposition, it is not about doing a billboard project because of leaving the museum, but actually by doing the billboard exhibition—and not only that, but that a museum is the key to maybe doing the billboard. So, it is "both/and" instead of "either/or," instead of "nor, nor." Somehow, there is a very huge potential for that—that museums can open up new spaces. At the moment, they are all over Asia, and they are starting to be in more and more places, such as New York and several European cities—these large-scale, electronic billboards. They are mostly used for advertising, but I see a possibility and necessity to make them public. At the same time, it's very, very interesting to connect billboards to museums, to connect them to what happens within exhibition spaces. Exhibitions become sort of network conditions.

**R.S.:** Do you think we've built ourselves into corners we can't get out of, or do

we have to hire a whole set of architecture people to deconstruct the museum, literally in some cases, to make those spaces, since we've got another set right now?

**P.S.:** In the most extreme case, the program inside the institution almost seems irrelevant to the public. It will come to see the facility for its grandeur, for its entertainment, for its sense of bringing people together, all of which are very positive things; what's going on inside the institutions is slightly irrelevant. Artists recognize that, and, to some degree, don't want to participate in that kind of venue, and will, instead, say, I prefer to create and work on something for three, four, five years. I'd like to find someplace where it can exist and be appreciated by a significantly smaller audience that's really focusing in on what the artist has created. So, I do see it as a critical problem. And I think we're going in the wrong direction, in that respect.

**R.S.:** I want to talk about the global issue. A lot's been said about the global culture and its commercial, political side. I don't know how long it will last, but, in a positive sense, the international culture of art is much more fluent and more truly international than it was for a time. I wonder how you see the particular institutions you're involved in as related to that more free-floating thing. You're working with a particular community, a particular ethnic group, for the most part. You're working essentially with Latin Americans. But it's all connected. Whereas we're working—I'm working—in a big monolithic institution that, in theory, is connected, but maybe isn't as connected as it ought to be. Somewhere between those extremes is a world of activity.

**Thelma Golden:** One of the first things that Lowery Sims, my director, and I did at the Studio Museum was to rewrite immediately our mission to acknowledge the global as primary to what we did. It was an important act, but one fraught with a lot of political implications. Because, basically, I work now in an institution that was founded around the idea of African-American art in a context that was specifically American, and American only. In rewriting our mission to say that we now present, preserve, collect, and interpret African-American art and artists of African descent, locally, nationally, and internationally, acknowledges, not just in political terms, the presence of black people all over the world. But it takes away what was a late-sixties into the seventies notion of the African diaspora and, perhaps, how Africa's history and African Americans in the present would inform it. For me, though, in curatorial terms, it allows us to exist within the world in a way that is somewhat normalized around just artists' practices. It makes sense that now I'm showing Martin Puryear and Isaac Julien at the same time; there's nothing strange about that. We still are a culturally specific institution. That's really how it's playing out.

How it gets further defined, particularly around the notion of Africa, is going to be, perhaps, one of the greatest challenges of the time we're at the museum. Sort of understanding Africa in the global, international, contemporary art context.

**M-C.R.:** I can speak to that at great length, if you wish. We just finished putting together a book about this issue of globalization and Latin American art. We invited a group of curators and critics and museum directors and artists and everyone to comment about some of these changes. In the case of the field that is known, for better or worse, as Latin American art, the whole impact of globalization has been very, very strong, and actually offers some very, very beautiful case studies of all these transformations. The results are both positive and negative. On the one hand, yes, we've seen, over the last ten or fifteen years, incredible attention bestowed upon Latin American art and Latin American artists. There is a greater circulation among the different countries and the centers, and, there, the circuits have somehow been activated in one way or another; however, when you actually talk to people in the different countries, whether it's Mexico, Argentina, Brazil, Venezuela, etc., or even people here within the Latino communities of the United States, for them the whole issue is extremely abstract. It's something that has not touched many of their lives. In some cases, it's very negative. What we've seen is that, in the context of countries and regions that have suffered from chronic political and social situations that you may associate with underdevelopment, or something like that, where art institutions have never really been very solid, they're, at most, very fragile, very vulnerable. This whole issue of globalization and integration into the circuits has imposed a series of pressures on those structures. You have museums that need to be responding to their communities, trying to catch up to this global ideal, and trying to structure their programs around MoMA, for instance, or other institutions, instead of really responding to their constituencies. In the case of artists, we ran a questionnaire to a very large number. We asked them very specific questions. The most surprising aspect was to find artists who have been very much in the limelight and who feel that, yes, they have been participating in all of these exhibitions and biennials and their work has gotten a lot of recognition, but it has not translated into any kind of economic gain. They have not sold works; their condition has, basically, not improved very well. What does that say about globalization? We have to be very careful about not falling into the idea that, yes, because all these things are closer, and there is more of an exchange, that the situation has changed or that we really are engaged in some kind of global dialogue. We are very, very far away from that, and we need to be very well aware of what the pitfalls are.

**R.S.:** Do you think there is the beginning of a sufficient dialogue among the big

institutions that have now begun to deal with world art as a world phenomenon, or do you think we're still pretty far from having that dialogue? And, basically, if the Modern does a Latin American program or if we show African-American artists, is this part of the solution or part of the problem, or, at least, a new phase of the old problem?

**M-C.R.:** No, there definitely is more dialogue. That's unquestionable. We are at a point where institutions cannot go back to the previous position. Certain advances are in place, but it is important to bear in mind that the dialogue has to be a true dialogue. It cannot be just a dialogue of "I'm going to look at you and really take what I can identify with in you, what is familiar to me or what looks like something that I have already in my museum." It has to be a dialogue of truly understanding what that difference is, accepting it on those terms, and not trying to impose any other kind of standards.

Rob had a phrase in his speech this morning about how we think we understand these things, but we don't. There is an issue of context, as Thelma has addressed, that is very important. On the other hand, I don't want to give the impression that I'm putting myself in the position where you really have to be Latin American to understand Latin American art, or Brazilian or Argentine art. Art speaks in very broad terms, and we have to have that very much in mind. I don't, at any point, want to appear like I'm talking about keeping the art of these peoples in their own little realm—not at all. It needs to be integrated on a very, very broad level; even using the category of Latin American art should be discarded with altogether. But it's important to understand that these things are coming from a completely different context—that there are particular reasons why the artistic production of artists who are very widely recognized in some of these countries looks so different or so out of step and so out of place with the things that we're accustomed to seeing here as modern and contemporary art.

**R.S.:** Hans-Ulrich, you've worked in a lot of different places, particularly in Asia, or, at least, brought components of an Asian reality into these exhibitions. I've heard often from European curators that many of these problems of cultural identity and multiculturalism are a specifically American problem. I wondered if that is, in fact, the broad perception? Is it your perception? Do you see these things in some other manner?

**H-U.O.:** In relation to globalization, one can observe, in the museum world, new mergers. So, there might be bigger conglomerates similar to what is happening in the economy. What is very relevant—leading it back to the laboratory discussion—is that these fragile laboratories are not lost in the process.

I recently visited Johannes Cladders, in Krefeld. He was the first person to organize museum exhibitions of Beuys, of Buren, of Lawrence Wiener, etc., and his museum was like a laboratory. Well, at that time, it wasn't really a museum, it was a small house—a temporary solution—right in the middle of Mönchengladbach. I thought, after this visit with Cladders, we can't stop the fact that museums are getting bigger and bigger, but how far—it was more a question than an answer I was raising—would it be possible to inject Mr. Cladders's house as a metaphor into a very big structure? How could we integrate Mr. Cladders's house into a museum? That's something that is incredibly important in terms of globalization and museums.

**R.S.:** One way not to do it is like at the Ransom Center, in Texas, where they have Erle Stanley Gardner's writing shed right in the middle of the library.

**P.S.:** At MOCA, we have succeeded in certain areas, failed in others. Being in Los Angeles, we have a very large Latin American community; that was the reason Richard Koshalek made a decision to have a single curator who specialized in Latin American art. We brought in curators from all over the world to discuss this with us, and we have done some half-dozen monographic exhibitions of Latin American artists, but I don't think it had a very significant impact on changing the profile of the museum in relation to Latin American art. One of the main reasons is that we treated Gabriel Orozco or Kcho, to a large degree, the same way we treat any other artist, and have not, in a sense, emphasized that aspect of it. In our larger thematic exhibitions, however, and the ones that are of the broadest nature, whether it was Richard's "End of the Century" architecture exhibition or my "Out of Actions" exhibition, we have succeeded very well. The history insisted upon us bringing in artists from all over the world, in that a kind of structure within the theme of the exhibition created a context in which to see these artists from a very level playing field. They were not being distinguished because of a certain background or geography, they were being seen as artists. Out of that, the context, the broader context, of where they grew up, where they came to maturation in the broader world in which their work has been seen, seemed much more appropriate.

**M-C.R.:** I completely agree with Paul. That's really the way to go in these cases. Exhibitions like "Out of Actions" or "Global Conceptualism," which was at the Queens Museum last year, and has been traveling, I think, are the ones that do more favor to the field in the long run. They show how these people were on par with other artists working in other places. That is what is really interesting. The agenda for this field is to show those connections, to show and to translate.

When I talked about the curator as broker, the other side of it is the curator as translator, which is where I see myself more than anywhere else—that constant labor of translating what the values of one context are to the values of another context. For that, you need to know the history of the twentieth century, or whatever art you're dealing with, and how these other traditions fit in. The issue of collections is the same thing. I've been called by museum directors who want to do some work in this area, who want to discuss whether they should have a separate gallery for Latin American art. I say, no, that's ridiculous, put them where they belong, next to whomever they belong—whether it's Warhol or whomever. That's really the way we should be going.

**H-U.O.:** There's one thing I have to say, because it didn't come to mind when you asked me the question about European concepts. A current project we are developing at Musée d'Art de la Ville de Paris is with Suzanne Pagé, who's organizing an exhibition on the École de Paris. The idea was to invite Hou Hanru, a Chinese curator who has lived in Paris since the early nineties, to curate an exhibition on the diaspora in the Paris arts scene, and bring these shows together. Also, in a certain way, to create the link to show basically the kind of very diasporic notion of the avant-garde and the current situation.

**R.S.:** I remember at Bard, when I was teaching class, and was talking about a show we had wanted to do on the European avant-garde practice from Fontana onward. A Czech student got very angry. He said, "What do you mean Europe stops there? It's all the way over here." Indeed, when I went to Croatia and found there a whole conceptual body of work of which I was ignorant, it really was clear.

**H-U.O.:** Earlier this year, Zdenka Badovinac, director of the Museum of Modern Art in Ljubljana, curated this incredibly interesting show. It's actually a collection—she put together a collection about conceptual Eastern European art. It was a real revelation.

**R.S.:** Let me ask Paul—but not only Paul—a particular question. It has to do with somewhat of an American situation—but it's beyond that, too. If our world is really global, in a sense, it's also polycentric in a way that it always was, but was not recognized as being. Certainly, the balances of the different centers have shifted dramatically. There was an exhibition at the Modern some years ago, about which I drew very severe criticism from a colleague whom I respect. He said it was a terrible show, and for a number of reasons. I said, after all, this is a show of local New York artists. The assumption is that every time you show New York artists, you are showing people who, as of the moment they appear

on the scene, particularly if they appear in that room, are suddenly to be treated as if they are the next contenders for the front edge of the avant-garde. But there are local art scenes even in New York. There are local art scenes in Chicago. There are local art scenes in Los Angeles. There are local art scenes everywhere. I wonder how people think about balancing the responsibility to artists around them, as well as the artists that they bring in from elsewhere? Your show of California art, "Helter Skelter", was, in a sense, both a local art show and a rewriting of national art, but it was the first, too. I wonder if you could say a little bit about that.

**P.S.:** To connect what you're saying about our discussion on the global, people somehow think global implies something other than provincial, but, in fact, that's not necessarily the case. You can be global and be provincial, and we've all had a chance to see that in various museum programs. It's the same group of global artists that are flopping down in different cities all the time. I had hoped with "Helter Skelter" that I could do a regional show that wouldn't be provincial, and would have an international impact. It did, to a degree that even surprised me and the artists, but that had a lot to do with changes in the air that one wasn't even aware of—the entire flattening of the contemporary art world circa 1990 and 1991. It seemed like all the air had come out of all that we had been supporting and developing throughout the eighties. Then, out of nowhere, or so it seemed, came this new generation of artists that clearly was addressing issues of international importance, but was doing it very much in a regional sense.

We should focus more, as curators, on the notion of regionalism. I know it's a funny word in American art history. If you go back to the thirties, regionalism was sort of a dead end of American art. But there is a lot to be said, when you look at it today, about the particular strengths that come out of any community—whether that is regionalism as seen in the art of Tokyo today or what's going on in Berlin. Sometimes, the more you get into the specific, the more you can understand the general.

**R.S.:** There is a very nice quotation in the catalog of Marina Abramovic's show from the Venice Biennale. A Serbian philosopher, I forget his name, said that the universal is the local without walls

**T.G.:** This notion about the local, or local group of artists representing it, has to do with the rhetoric of museums around the issue of community. The reality, having been in a big institution, is that community can be defined very generally. If one is a big institution with an international reach, you can speak of your local community within that context in some way. An institution like the one I work in now,

the Studio Museum, comes out of a rhetoric that was formed through a notion of community—Harlem, very specifically—but also with this idea of reaching out into the world. This issue of what you do then, how you deal with that group of artists, is finding a way to make that local, whether it's the artist or the audience, exist within this context that we defined as global. The Harlem artist's community exists within the larger notion of what it is we are doing. But it is still very fraught and very complicated, because of the different ways in which an institution has to be in order to engage various communities.

**H-U.O.:** When Hou Hanru and I curated "Cities on the Move," we conducted research, basically, in lots of Asian cities, and felt that the situation in many of these cities was extraordinary. What has happened—actually something that is not necessarily a problem, but, at the same time, might be something to think about—is that many, many of the artists we've met in these different cities have moved to Paris, to London, to New York, because they feel they have to move there in order to make it. It's a problem in the sense of talking about a multiplicity of centers; it creates a situation in which the energy of these artists is missing incredibly. A similar thing has happened in the Nordic context. In Stockholm, in Copenhagen, there was a fabulous energy at the beginning of the nineties, and through the decade, but many of the artists have left. Obviously, it's one thing if the artists decide to move to another city—this is important for many artists—but there is this idea that many artists still feel that they are obligated to move to the center, to the capital. At the moment this is changing in some contexts. I think about the amazing energy of Fernando Romero and others who work in Mexico City.

**R.S.:** What happened to the Russian art scene has to do with many, many factors, but that's also one of them. I want to shift to the ugly question of money. That will be my last round, and I hope that others will step forward. Not the money that we're paid. I have no complaints, but I know lots of my colleagues are not paid nearly enough. Something we should advocate for are real professional wages for professional work. Again, this is not a personal complaint at all. We've been through the eighties and the nineties, two amazing run-ups in the market for objects. I thought the first round was surrealistic, but the second round has really been something else again. Could you talk a little bit about both the cost of doing exhibitions and the cost of collecting works? If you're in a collecting situation, or simply trying to do whatever kind of work you're doing, everybody is looking at cost primarily—and looking at, as Peter Schjeldahl called it, the sex life of money. That's a predominant thing on people's minds. How does this affect your work, the way you feel your work is interpreted, and the way in which you relate to artists?

**T.G.:** I'll start, because I don't have any money.

How does it affect my work? It hasn't yet. How will it affect my work? I'm now working in a situation completely unlike, say, the other kind of situation, which exists, within money, as a total abstraction, like in the lands of the capital campaigns of $600 million. Six or six hundred—it's the same thing in that environment. Where I work, we just don't have any. How it's affecting work, though, is very interesting. There is a mentality that can exist in the world of institutions like mine, where sometimes not having any for so long creates the way in which you work. I am seeing the work I'm doing now as a big conceptual-art project. So, is it possible to work in an environment where finance truly is a day-to-day, minute-by-minute concern, and not the concern it is in a big institution, like, are you going to make the capital campaign?, but, literally, payroll, and all of that kind of stuff. At the same time, you work on an edge that's interesting and exciting. I think, right now, I can. These forces of the market are an abstraction that's outside of that. Somehow, in a way, it's also oddly liberating. A year from now, I might be in deep debt. Still, there is something about this economy of scale where going from nothing to a little more than nothing is a very small step. To me, it's a very, very exciting way to be. Alright, Paul, you have money—you can talk about it.

**P.S.:** It's like that line from a Janis Joplin song, "Freedom's just another word for nothing left to lose." I work at a much bigger institution, an institution that is both very youthful and, in fact, kind of solid. We have two buildings, a rather remarkable collection for such a young institution, and an endowment of $50 million. To a large degree, MOCA has operated until now like a large mom-and-pop store, running around the block trying to gather the money you need to do projects, project by project. But we have made some significant increases in our budget, not in the area of exhibitions but in the overall services of the institution. Quite frankly, we don't have the money at this point. I have every reason to believe that the trustees will buy into that for a year or two, but if there are any kind of concrete results—more membership, greater attendance, larger retail sales—there will come a day when people say, well, it's the program. That's something we really have to be concerned about at museums, about how far we want to take us to that edge, and whether we can back off it, because I do believe— and this may sound very conservative—that we need, as museum people, to protect the assets of the institution. The assets of the institution are the independence of its program. We quickly observe in the museum profession those museums that have gone over to the side being controlled by a handful of collectors who have enormous capital interests; our job is to enhance those capital interests through the promotion of their collections. Extremely significant relations with a handful of galleries that not only, in a sense, promote what we're doing, but, in fact,

define a program to a degree that is, frankly, unacceptable to the artist. They know when we've turned over our program to a commercial entity. I don't know where that point of balance is, and I certainly don't imagine that a museum can stay still and hope that it will all remain the same. But we have to be very wise about how we expand and in what manner we give up certain prerogatives having to do with the scholarship and the independence of the institution.

**H-U.O.:** It has to do with a permanent process of negotiation, and where they think the independence has to be maintained. I want to mention something that was said much earlier. I think it was in your speech [Robert Storr's keynote address], when you mentioned the curator as generalist. The funding of an exhibition the curator curates is very much part of the exhibition. The independence of the exhibition can only be maintained if the whole funding structure is very much in strong ties with the exhibition. When an exhibition has a particular topic or an exhibition deals with a specific aspect, it's extremely important that the whole funding situation is brought in conjunction, so that it is not just a funding department trying to find the money for the show and, at the same time, the curator curating the show; it has to do with bridging the gaps. This notion of bridging the gaps is incredibly important within museums. In big institutions, there is this danger that the different departments don't talk to each other enough. I definitely think that it's extremely important to try to bridge these gaps. Gaps between departments, between disciplines, between geographies. Bridge the gap!

**M-C.R.:** I have been in a situation for the last twelve years, similar to Thelma's, of operating from an institution that is basically linked to a university—a big state university—which is a completely different kind of deal. But I'm feeling that that was an asset more than a liability. I've always believed that money is not, ultimately, the issue. You know what you want to do, and the money is going to come from anywhere. I really feel that, ultimately, it's to the advantage of the curator to master the area of fund-raising. It's a source of empowerment. What I'm saying may sound incredible, but that's my experience throughout the years—that no institution, no matter how big, is going to turn down a project you're doing if you come with the money. That is a fact. The reality is, how do you get that money? If you come up and say, I want to do such and such an exhibition, it doesn't matter how crazy it is. I have the backing, I have somebody who's going to pay for it. I've gotten in planes and gone all the way to Brasilia to discuss, with ministers of culture, how to fund an exhibition. And the money has appeared. You just have to be incredibly creative about it. Ultimately, it is a source of empowerment to what you're doing.

## AUDIENCE QUESTION AND ANSWER

**Roberta Smith:** I write for the *New York Times*. I have a couple of questions, or just things that I feel like you're talking around and have come close to saying. First of all, I was struck by Mari-Carmen Ramirez's remarks about artists who were showing in the international circuit who had no benefit to their careers. Basically, we haven't quite spoken of the incredible expansion, diversification, and fragmentation that's happening in just the contemporary art world right now. Now, you have at least three layers, three strata, that sometimes operate very independently of each other. You have these expanded strata of the international shows. You have museums, on the local level, functioning nationally, internationally, or locally, depending on their mission. Then, you have galleries. I'm specifically talking about New York. But we have a situation now where there isn't that kind of trickle-down, where, if you want to talk about consensus being formed and people having careers, it's like we're all voting on different issues, or for different candidates. I just wanted to say how huge and complicated it has become. The same thing refers to curators. I'd like you to address the fact that, in many ways, your activity, and what I seriously consider the curator's art, is under threat. It has directly to do with funding—and with sponsorship. Again, to just talk about New York right now, I love hearing you talk about your own work, but the fact is that there are a lot of different people who are now doing your work—and they don't have the same passion or commitment or training. You have, for instance, the hip-hop show in Brooklyn, which is organized and commissioned by an historian of hip-hop. You have the Armani exhibition at the Guggenheim, connected to a $15 million gift to the Guggenheim by Armani. Coming up in February, we have "Jackie Kennedy: The White House Years" at the Met, only it's not going to be in the Costume Institute, it's going to be upstairs. At this moment, we have a show sponsored by Shiseido at the Gray Art Gallery, which is, basically, an exhibition that looks like a makeup counter in a store.

I agree that there are many, many different ways of being curators right now, and that you represent them. But there are also a lot of different forces and a lot of different people who are making decisions about who's going to do your activity. They have lots of different motivations. I wonder if that could be addressed? Boston is about to have a show about guitars. I'm interested in it. I'm as interested as anyone in the expansion of the definition of art, or the expansion of the definition of curatorial practice, but is there a point at which it sort of

dissipates or becomes completely diffused?

**Paul Schimmel:** I agree. I'll elaborate a little bit on that.

You've given some very interesting and very problematic examples, and I'm not sure if I can think of one curator associated with any of those exhibitions. I know who the museums are, I know who the funding is, but I can't quite place where the curator is in the picture. Usually, when I hear about shows, I hear about a curator saying, this is what I'm doing, and then you hear about the funding, and then you hear about the tour. In that respect, the cart has gotten before the horse. Quite frankly, I'm very concerned for MOCA. We have made a decision to go into the area of design. We've obviously had a very active program in architecture, and, I assure you, there wasn't an architect in Los Angeles, or beyond that, who didn't see the opportunity to show at MOCA as some kind of enhancement to their ability to get jobs and to have a broader international profile. As complicated as it is in the area of architecture, it's even more so in the area of "design." On a bad day, I'll, quite frankly, say, gee, the reason why they call it design and art is because, like, design, they got everything else. They got all the showrooms, they got the storefronts, they got the advertising, they got everything else. Leave the damn art museum alone. That's why they call it an art museum. On a good day, I think, well, you know, we're deeply committed to an artist like Jorge Pardo. Does it make sense to try to understand the relationship of what Jorge is doing as an artist and the sources that he's drawing from; is that part of the history that we need to bring into the museum? But I can assure you of one thing. If it begins with a funder, it's probably not going to be an exhibition. If it begins with a curator, it, at least, has the possibility.

**Robert Storr:** If I could just respond. What Roberta asked is a very pressing issue. And it is a question, really, for directors and boards. It's a situation where curators can make things happen that are interesting, but it is a question of who has the actual power to decide that this will or will not happen. The Modern has had an architecture and design program for fifty years now. Yes, there are situations where we've shown works of art that are available at Knoll downtown right away. Chairs and stuff like that. But, of course, if we show paintings in galleries, they're often available across town in galleries. I don't think that the lesser economic tie-ins—although there are occasions when it's unseemly—are as significant as when the exhibition itself becomes a form of advertising.

There's another thing to think about. One of the ways in which the nose of the camel got into the tent here was when the discourse about visual culture became so broad, and when people who are serious about how clothes and objects and so on and so forth began to dissolve some distinctions that are now

much harder to put back in place. Only a scholar in those fields, only a genuine curator, can do it.

**Kathy Halbreich:** I think we will discuss this later this afternoon. It seems to me that Roberta's question is absolutely on target. But it isn't only related to museums; in fact, it is related to her own field. The intersection of marketing and editorial has become questionable, not necessarily in her newspaper but certainly in California, for instance. I've actually been waiting for the *New York Times* to tackle this as a bigger issue in terms of the museums in New York and across the country, the examples of which you gave. It deserves a serious policy discussion coming from the newspaper many of us most respect. Frankly, it would even help some of us, as directors, to talk about this with our boards.

**Thelma Golden:** I also think, Roberta, you posed this as to how it affects us as curators, that other people are doing this. It profoundly affects many of us in choosing where we work and how we work. A lot of the movement, whether spoken or unspoken, that happens now often has to do with the pressures that Rob refers to as coming from boards and directors about institutional priorities, and how those priorities will be played out. If they can't be played out with curators, they will be played out with someone who wants to come in and do one of these kinds of exhibitions for a funder or for the funding itself.

**P.S.:** Or, in fact, the curator is supplied by the funder.

It was fascinating. There was a huge article—and it was surprising that it was on the front page of the *Los Angeles Times*—about the Eames exhibition at the Los Angeles County Museum. It went on and on about potential conflicts of interest; the funder and the objects are sort of one and the same. What shocked me, and I pointed it out to the critic, was that, in fact, part of the "curatorial team" came from the very institution, the company, that manufactures those objects. I thought, how can you write this whole article? That's the crux of it. How could you miss that?

**Peter Plagens:** I write for *Newsweek.* I want to start this question with an anecdote. It's related to the question that Roberta asked, only it's without the funding, ethical part. It has to do with the art, and maybe returns it to curating a little bit.

I'll start with an anecdote. A few weeks ago, one of these annoyingly bright twentysomethings, editing a section at the magazine called "Periscope"—these little short items up front—said that he had just seen a movie called *The Cell,* with Jennifer Lopez, and it was very derivative. He

thought there were a couple of art things in there. Would I be interested in going and seeing it? We do a little short item on how many art refs are in a film. I went to see it. Not a great movie, but I was really struck by (a), the number, there were a lot, and (b), it had Matthew Barney all over it. I'm an early, or medium early, great admirer of the work of Matthew Barney. With that—plus a remark that Mr. Obrist made about public art and the LED light boards, etc., etc., maybe being a new form of public art—my question is this: What is the essence of curating in the museum, and what do the curators in the museums offer, if, for purposes of discussion, the real world, or the entertainment industry, does it as well or better? Other than some information and some didactics that the example that's in the museum instead of out there in Times Square, or in *The Cell,* is actually a Trojan Horse, transgressive, etc., etc.

**T.G.:** I guess, Peter, you're assuming some of us don't see ourselves as part of that world. I'm not against it necessarily. For some of us, the line between them is not necessary; it's also not pure. What we do different is that we do it differently—whether it's done well there, or even well on our side of the museum, are things that can be sort of questioned. But, in some ways, just the approach some of us—and I speak for myself—might take to the way in which we work is as informed by that world as any. It allows our work to exist in a dialogue with it in some ways. I thought *The Cell* was a really bad Matthew Barney rip-off. There are lots of good Matthew Barney rip-offs out there, though, in popular culture. That was not one of them. But, seemingly, I don't necessarily think it's a question of how as a curator do you live in the world—do you work in the world? Is the museum a fortress? Is it not in some way infected by all these other things, and is that infection interesting and/or good? Again, it's a question of position and context, and not so much what do we do different, or better, than that world might do.

**Hans-Ulrich Obrist:** Concerning video clips on large-scale, electronic billboards, I should say how my interest in this started. It started out of a discussion with Alexander Kluge, the German experimental filmmaker, who infiltrated all kinds of media. In the last two decades, he has occupied an hour every week on two channels in Germany, and somehow developed a temporary autonomous zone that seems to last forever within television. He said that in the seventies, among experimental filmmakers, the idea was that if maybe they could produce television only out of clips, it would be like a kind of meteor shower—he would have all these one-minute clips—that could eventually go on for a few hours and trigger a program. That, in combination with the fact that more and more artists are working with clips, trying to carry them into different sorts of supports and actually experimenting with this medium, gives this idea legitimacy. If I said that

maybe this could be the public art of the future, I didn't mean that it would replace the museum, because, obviously, the museum *is* a public space.

**R.S.:** I don't want to use the Modern as a paradigm for everything, but there is a specific history there. There is a film department at the Modern that's been going on for fifty years. The idea that such a popular medium produces works of art is not debatable. The question is, which works of art in that context are debatable? The irony of the situation is, there's no film curator at the Modern who's interested in Matthew Barney. On the contrary, most of them are quite skeptical of Matthew Barney, whereas it's always the painting and sculpture curators who think Matthew Barney is really interesting. I haven't seen *The Cell* yet, but, judging from what you said, I doubt if they're going to bring *The Cell* in as an example. It is entirely possible, though, that you might have a film festival of Jean Cocteau and Matthew Barney. Try and work out how this might work. It doesn't come at you as film, but it is in the film medium, relates to film traditions. In that case, a museum is exactly the place where these issues should be debated, particularly because they are differences of opinion.

**M-C.R.:** I agree with Thelma that we are operating in a field that is extremely contaminated. But what we do that's different from what a film like that would do is that we are trying to convey something through our work. Any exhibition or any kind of undertaking carries a proposition. It is something that is out there—it is an idea, it could be an idea, it could be a way of looking, it could be stimulating peoples' perceptions to do something—but there is an idea that is conveyed. The curatorial proposal, inevitably, is like an essay. It's like a piece of writing; it conveys something. If you take something away from it, it's like taking away pages from a book, or taking away parts of the film. So, there is a basic difference. It doesn't mean that we don't operate in the same contaminated space, but there is a difference in the intention that drives our particular practice.

**Dave Hickey:** I had a question. Would I be incorrect in my impression that you all are reconceiving curatorial practice as a form of higher patronage, to intervene between actual patronage and the audience?

**M-C.R.:** I'm not sure that we are reinventing it. I think it's been reinvented already.

**D.H.:** You're patrons, then. I get the impression you're thinking of curatorial practice as a form of patronage?

**M-C.R.:** No, not really.

**D.H.:** Oh, really.

**R.S.:** Brokerage.

**D.H.:** Exactly.

**Naomi Nelson:** I'm education director at the African American Museum, in Philadelphia. There are a couple of remarks that struck me. One was the curator as broker, as you just mentioned. One of my questions had to do with that, as well as the notion of pedestrian bridges. I thought that was very provocative.

I'm thinking of a question that Thelma Golden responded to regarding the ability to act as a curator, given financial restraints. There are far too few persons of color in the role of curator—as I look around this room, I'm in a situation that I find myself in all the time—and that makes me wonder, if the curator is indeed broker, broker via institutions, collections, galleries, and funders or patrons, then where in the global picture do we find the broker for African-American art, or for contemporary African art? Do we find ourselves in a position where if the curator is indeed broker, and broker in the larger sense, even broker in terms of community—if our notion of community varies from the notion of community of the curators who are in the majority—then where do the voices of artists of color enter the picture, and who decides how they enter?

**T.G.:** Naomi, you know the answer to that question. You're posing it just to enter it into the room. Clearly, the issues around inclusion and exclusion are still very much with us—it's just that they're spoken about differently now in the age of globalism. During the multicultural moment, the idea of a dialogue around these issues was sanctioned and allowed and we all spoke too much about it—and some of us even got sick of it. But did the arena change? Not exactly, from that moment to now. So, somewhat like Mari-Carmen has spoken about the plight of many Latin American artists, even though this greater visibility has brought them renown, it has not brought them a real sort of root benefit. Similarly, we are still in that place in institutions. Where are the voices coming from? Although, perhaps, we are still not seeing as many African-American curators, even African curators, in institutions, we are seeing more African Americans as trustees of institutions. I would like to believe, in some way, that, at least at the fundamental structure powering institutions, there is a voice. And there are brokers. Again, not enough, but they are there. The rise of the independent curator is the thing that, perhaps, makes at least a little sense that things are changing, because, while there aren't people like me who are institutionally bound, there are many people existing between and around and in front of and behind many institutions who speak

for African-American, Asian-American, all sorts of American artists. Their voices are heard often in the context of dialogues that, as curators, we might have with each other in this global, globetrotting, show-to-show world we exist in. Is it solved? No. Can it be solved through simple actions? Probably not. But the dialogue is somewhat open, and what we have to continue to do is keep the dialogue there, even if it has to be reformed in a newer language than it was in its beginning, to make real change happen.

**R.S.:** I would like to speak to that, too. The heaviest weight here falls on the question of having African Americans, Hispanic Americans, Asian Americans, and others—I'm not trying to make a list, I'm trying to make a basic point—on the committees that buy art and on boards. There are, in fact, a lot of curators who came of age with the Civil Rights movement and after, who have acted the best they can in these circumstances, absent African-American or other curators there. There should be many more of them in the profession, for all kinds of other reasons. But what you need are people who make the decisions, who vote the monies, who comment on programs. One doesn't want to have a program dictated by trustees, but you want to hear from trustees on whether they think that there is the kind of balance needed, to have that happen from that level, because it's an argument among peers. There's a limit that curators can say at that level. It needs, frankly, a very wealthy African-American person to look at a very wealthy white person and say, I think it's time we did something about this.

**M-C.R.:** I have a comment about that. This is something I've obviously been involved with for a number of years, and I have a very different take on that. That kind of question presupposes that African Americans and Latinos, or whoever, are somehow vying or knocking at the door to enter into this big institution. That is very important, that needs to happen, and, certainly, it's happening, but there is a lot more to be done. I also want to stress that these communities need to develop their own voices in their own spaces, in their own locales, and develop their own models. They need to think through what some of these issues in culture are all about and come up with an answer of their own. That's the real sense of a democratic society. It's not about where we locate them in this big pie over here that's been going on for a number of years. That can happen, but it's never going to change the picture completely. There needs to be another kind of reinvention taking place at the level of our communities.

**Susan Cahan:** I'm the director of arts programs for the Peter Norton Family Foundation, in Santa Monica, which, as some of you may know, has supported a lot of work by African-American

artists and work in museums and elsewhere that has dealt with culturally complex issues in many different ways.

I want to make a comment and then ask Rob a question. Your observation, Rob, that there are people working in museums now that came of age during and after the Civil Rights movement, people of many different cultural, racial, and ethnic backgrounds who are committed to a diverse practice and a practice that serves multiple, interesting constituencies, is absolutely true. In terms of funding, we're at a moment of enormous opportunity in our society right now, with the amount of wealth that has been generated in recent years. In the last five to ten years, we have more billionaires in this country than ever before, we have more millionaires in this country than ever before, and they are younger than ever before. They have come of age during a time when Civil Rights issues are in a different place than they were for some of our older board members, trustees, and supporters.

I just wanted to make that comment. I also wanted to ask you a question, Rob, because I was interested in your making an analogy between the museum and the library. You said that, for you, the library is a model for museums, and that you would hope that people would access museums in the way they access libraries. My question has to do with what you would propose in terms of structural institutional changes that would enable museums to function more like libraries. One big distinction between the library and the museum is that the library is absolutely inclusive, whereas one of the museum's purposes is to make distinctions and to take things into their collections that are considered of certain standards of quality. I was wondering if you were proposing that aesthetic criteria should be changed, or what other structural changes do you have in mind?

**R.S.:** This will get us into the quality debate, and maybe that's where we should end up at some point. As far as that goes, I don't think, first of all, that libraries, except for maybe the Library of Congress, have everything that's been published. Libraries choose what goes on the shelves. Curatorial choice is essential at museums. Economically, it's essential, and for other kinds of reasons it's essential. But the curatorial choice cannot be determined by a single view on what's out there. It can't be because there are debates about what art is of what quality, that are aesthetic in principle. There are different bases of information. I know certain things and don't know other things. You have to have a process of acquisition for the library, as you will have for the museum, that cross-references all those different things, and tends to favor the iffy propositions rather than to push them under the water in order to exalt the things on which everybody pretty much does agree. The other thing about the public library analogy, which is not precise, is that access to this material is limited. It is increasingly the case, for economic

reasons and others, that people are rotating their collections, and that rotation does not begin to create the library effect, but, at least, makes sure that things come back into view. The art of the twenties and thirties that is unpopular doesn't disappear from everything and forever. From time to time, and within reasonable periods of time, you see a lot of things that are out of fashion. How much work that was bought in 1980 is on gallery walls right this minute, in the museums? Bring back some of it. It may not be the greatest art you've ever seen, but it may look fresh in a way that you wouldn't have imagined. If you're constantly tilling this field, basically, making sure there's no single category that disappears altogether, that things have some real variety, then people can come and select.

 **Chrissie Iles:** I wanted to talk about space in relation to what you just said, and also what Roberta said. I'm a curator at the Whitney Museum. I've worked for most of my career in England. There are some things I want to say, one in relation to Paul's comment, one in relation to Rob's, and one in relation to Roberta's.

I worked in an alternative space in the early eighties in London, called Matt's Gallery, where we worked with the artist Richard Wilson, producing a piece called *2050*. It's a very complicated piece. It took three months to build. Then, we just showed it for a few weeks, reversing the usual pattern that took place in museums. I was very interested in that, in working with an artist. Basically, we turned the gallery into a studio, or created a time span that is impossible in museums. When I went to the Museum of Modern Art in Oxford, I invited this artist to do something, and wanted to try and translate that. The Museum of Modern Art, Oxford, isn't the most rigid of institutions, but, even so, it was very hard to ask institutionally for the artist to be there for six weeks to create something instead of the normal week's installation. A lot of what gets shown in museums is determined by a museum's inflexibility in terms of space, because there is a turnaround. One must get the customers in, one must get tickets sold; it's all about audience and all the rest of it.

That relates, Rob, to your comment about film, because I now find myself film and video curator at the Whitney Museum, even though I'm actually a sculpture curator. I'm very interested in that, because we have what might be called a rather inadequate film and video gallery, which I love; it's a black box with uncomfortable chairs that turns into a gallery space. MoMA has a wonderful film department and two great auditoriums, but never, ever will you see an avant-garde film screened in a gallery, which is what I've been doing with a couple of benches, so that it almost looks like a Shirin Neshat. What's been very interesting to see is that if you screen an avant-garde film with two benches in, basically, what looks like an installation space, you completely reframe the way in

which an experimental film can be shown. Likewise, if you have a black-box, white-cube situation, you can ask questions about that.

All these things have much to do with the pragmatics of space. As I've learned living in New York, gallery spaces are talked of in terms of real estate—as everyone's trying to buy a loft, it's extraordinary—and how one spends that real estate in curatorial terms. Museums tend to be extremely rigid in the installation time they give to a project. There was a very important space—alternative space, again—in London, in the seventies, called Acme, where Stuart Brisley knocked the ceiling down to make two spaces. The new Tate Modern, in London, asks artists to go and actually look at spaces in Europe that they want their museum to look like. What were the most wonderful spaces in Europe? Of course, Schaffhausen comes out as a wonderful example of that. When they showed the Beuys piece, they just knocked the ceiling down, because that's a private space and they could do what they wanted to; they weren't constrained by all the institutional factors that exist. The key issues, to me, are those kinds of issues, the issues that Donald Judd brought up; he disliked museums for the way they mangled art. It's a huge problem, because the amount of power that designers seem to be allowed to have, or architects, goes absolutely against art.

R.S.: I agree with about seventy-five percent of that. One cannot imagine, or I cannot imagine—realistically speaking, ideally perhaps—that one institution can serve all of these functions properly. There has been a lot of discussion about a black-box space in the new Modern. I don't know the upshot of it, frankly, but it's keenly felt in a lot of different corridors. There are limits, and that's part of the fact that this whole system is very diverse. If there was one institution that could do it all, that institution would swallow all. It's better that there be a variety of opportunities, and that, somehow, more effort was made to move the audiences to places where these things were done best, rather than creating a kind of Bloomingdale's of art in which there's a department for everything.

P.S.: MOCA's been very fortunate in that we have not designated either curators or spaces. The fact that we are not departmentalized, to the degree that some other institutions are, has allowed curators and, therefore, the spaces to reflect a variety of media, and not, in a sense, be dependent on the relative power of one department over another. As you create project galleries or black boxes, one has a tendency to always say, well, we have to put that artist into that space; that can be very limiting, both for the artist and for the curatorial practice. On the other hand, if you don't designate spaces and you don't designate curators, you have to work doubly hard to make sure that your program is, in fact, inclusive of all of those areas of art that are not necessarily in the pecking order, as the trustees see it.

**R.S.:** Let's have a few more questions. Then, maybe, we should give ourselves all a break.

**Terry Myers:** I'm a critic and independent curator. I may be stirring up a little trouble, but in response to Roberta and Peter, this isn't necessarily supposed to be the critic's corner here.

I'm about to say something that's going to sound very American, but I mean it symbolically and as a comment. I walked in here knowing that in a month I'm going to vote for Ralph Nader. Now, I know even more. I'm curious—I've been hearing what I would call sort of Bush-Gore answers to the questions being asked here—and I'm wondering, do you think we need a Ralph Nader in the curatorial community? I can elaborate. In terms of this idea of waiting for more billionaires, and more of this idea of appealing in terms of coming out of the Civil Rights movement, there was another part of me looking at this—once again, in relation to what Thelma was talking about—as a classic what I call heterosexualized moment. This thing that's never said in the room, this assumption of a certain way of working, a certain way of being in the world. I'm confused here; maybe a little nauseous about this. And I'm just curious, is there any sort of agency? Maybe Hans-Ulrich is someone who has specifically gone out in the so-called global setting, who tried to cause some trouble. I admire him for that. But, maybe, we all need to be doing that a little more than assuming that, especially in terms of what Peter was saying. How do we want to react to this fact that's happening all around us, in industries that have, relatively speaking, unlimited resources and unlimited access to audience?

**R.S.:** Except for the fact that you make an awful lot of assumptions about us, I'm still not clear what the precise complaint is.

**T.M.:** I sense a sort of waiting for things, and I'm just wondering about making things happen. I'm too young for the Civil Rights movement directly, but my understanding was, that was a moment where people went out and caused things to happen. Speaking as someone who's tried to function as an independent critic among, let's say, an art magazine conglomerate that is set up against me, there are editors I refuse to work with because I see conflict of interest, and I see colleagues who don't do that. I'm curious—where's the space for that, in terms of what I think is the goal that we're all looking for here? I want some more specifics, and I'm not getting them.

**R.S.:** You have to accept some of the terms that we have accepted by agreeing to work for institutions. Then, if you accept those terms, look at what is actually

possible. You will find that there've been real changes as the result of the activities of a lot of the people who are present here. In my days of being twenty-five, thirty, and wanting to do it from the outside, certain things seemed very possible that turned out not to be. Until you get your hands on certain levers, you can't do very much except write out an idea about how it ought to be, how it ought to turn out, and what's wrong. I see every reason in the world that people should write protest criticism, that they should push very hard; it actually helps, in many circumstances, to do the work from the inside. But we are now working from the inside—we can't pretend not to be. And we won't. But that doesn't mean we're Gore and Bush—and certainly not Bush. There's Al Checci, who ran for governor of California and said it's easier to teach a Democrat about economics than a Republican about compassion. Some of that's in there, too.

**T.G.:** In response to Terry's question, as someone who's made a lot of trouble, and had both the cause and the effect on every level, it's not a question of waiting necessarily—or the waiting that you're referring to is not, at least, how I've seen my own work. It's more waiting for the rest of it to catch up. So, yes, there are some things I am waiting for. Maybe they'll come, maybe they won't. But the way in which I work, in whatever moment of whatever context I'm in, usually is with some informed sense of not necessarily trouble for the sake of trouble but the sense that what it is I represent, by default, is, in particular environments, particularly the ones I've worked in, going to cause some trouble. The sense of change, perhaps—in what Rob referred to before about what the legacy of certain political actions might be—is that there's more room for that trouble to happen. And there's more room for it to happen, perhaps, on the inside, both for factors that people want to acknowledge and those they don't want to acknowledge at all. Maybe the question is not a Bush-Gore thing necessarily as much as that we are in a very interesting place right now. It comes down to the choices people make about how they want to work. And that can or cannot work out in some ways to exhibit something that's visible as trouble, or perhaps more invisible—that can't really be felt until it's really understood a little bit better.

**R.S.:** I want to add one thing. One has to be very careful about assumptions about the rich. There's a funny thing in Billy Wilder's *Sabrina*. The daughter of the chauffeur is about to marry the head of the family, and she says, this is a very funny democratic culture where it's not all right for somebody poor to marry somebody rich; democracy only works in the reverse direction. But the fact is, there are certainly a considerable number of patrons. Peter Norton is mentioned as one. Aggie Gund, who, when she introduced me for the first time to the Committee of Painting and Sculpture, said, "This is Robert Storr, who I met at a

Visual AIDS program, and we were discussing a whole lot of the politics around that." It is simply counterproductive and it is also, I think, arrogant to assume that people who have a lot of dough are automatically in this category or that. As a practical matter, if you find allies, it's snobbism not to deal with them as peers, and deal with them directly on problems you have in common.

**DeDe Young:** I'm the program director and curator at a site that just opened three weeks ago in Wilmington, Delaware, called the Delaware Center for the Contemporary Arts. I left the museum field and an academic institution in Florida to get away from the frustrations that I felt as a curator—not being able to work quite so directly with artists—and to get involved with this new model of an alternative site. The risk for me was going to a place completely unknown, to Wilmington, Delaware, where nobody really thinks of art as being the center of the scene.

The site that we opened has taken the risk of creating a new model. Along with six galleries, we have an artist-in-residence program, where artists are invited to come and live in a studio apartment, for eight weeks, and then exhibit their work. At the same time, they go out into the community and work with a so-called underserved audience at a wellness center or a boys and girls club or a homeless shelter, or something of that nature. But we also, side by side, invite artists to come and participate very actively in creating their exhibitions. Like some of the panelists, I'm involved in a place that has very little money, but gives artists an opportunity to get outside of their studio to some place where we hope, a new audience will form. On this site, we also have twenty-six artist studios, a cyber cafe, an auditorium for 125 seats that will eventually have a time-arts program. What we've tried to do is look around at the models that you are all speaking about, and add alternative sites and create something new that can include not only curatorial practice, in a very traditional and ongoing sort of innovative format, but also invite artists as the best resource. They seem to be very eager to interact in a program that would not necessarily get a lot of press, but to have the opportunity to work in a space where they can see their work looking really great, because the architecture is very factorylike and large and allows big installations, and so on. Inviting artists in to see what they can do is something that alternative sites are able to do, and to avoid any kind of Bloomingdale's hybrid of what a museum and alternative site and a gallery can be together.

I agree—it's important to look around at the many models that there are, and how everything fills a gap that something else can't do. Curating in that way can continue to be very innovative. I can invite such artists as Willie Birch, who was willing to come and donate his time to resurrect a piece, which had lost its

place in the world, called *Spirit House*. It was a collaboration with one hundred other artists. Willie does not need to show in Wilmington, Delaware, but he was so engaged with the idea that *Spirit House* could be resurrected—and we could do an education outreach program around it—that he was willing to come and donate his time and be there for a few days, in exchange for us giving him some dinner and some paint and paste to put this beautiful papier-mâché and wood house back together. He felt it could create a place for the community to come and understand how the art site can be part of the community, how that division between inside and outside could begin to dissolve—that what's going on inside institutions and outside of them can come together in the same way that many curators are dealing with.

I wanted to say that alternative sites are doing some of the things that museums can't. At the same time, I wanted to ask the panelists, how much are you really dealing on a day-to-day basis directly with artists? Do you find that that is part of the heartbeat of your program as well as your collections, which obviously you have to be paying very much attention to? How long do your relationships with artists go on before you are able to give them space in the museum?

**T.G.:** There are some value judgments implied in the way your question is framed. What you describe you're doing is great, fabulous. I resist this idea of the alternative as this construct that embraces that, and the museum as one that doesn't. Many of us here, and in the audience, work in different kinds of institutions and relate to something that might be defined in these ways as the traditional alternative more than, say, the ways of the museum. The question is not so much how much we engage with artists day to day, because I think we all do, but how long is that engagement before it becomes a project? It depends on the project; it depends on the nature of how we work. But it's more about what I think you're getting at as being part of the alternative, which is artists at the center. As contemporary art curators, that is the case for all of us. It's not necessarily different just because we're working in a place that might have a collection or have other administrative details that define it.

**R.Sm.:** I have three reactions. First of all, in the discussion of Matthew Barney, what got left out was just saying, Matthew Barney's work was first visible in museums. So, they start a process of dissemination, of presenting of information, that is now getting extended and expanded and accelerated by a lot of other forms of culture. But curators, at least, should be given credit for that. Hollywood did not go out and find Matthew Barney and decide to be influenced by him. Second, to respond to Kathy about what you said about the *New York Times*: I'm not here out of idle interest. Leave it at that. Third, I had some of what Terry was

reacting to, but I'm not going to put words in his mouth. But, I felt, Rob, that when you first responded to my question and said it was in the hands of trustees and directors, that, to a certain extent, is true. But, to another extent, that's sort of passing the buck, because I really feel that your jobs are threatened. Thelma knows exactly how a change in director can threaten her job. I just wanted to get the feeling like you're opposing something or fighting for something, which I know you are, but I just wanted it . . .

**R.S.:** The nature of those discussions has to take place within the institution. What my guess about the arts are, at any point, goes up and down. If you're going to work in a direct way with other people in a situation like this, you cannot take your business out into the street. It is the responsibility of advocates outside the institution to make these points, and make them very, very forcefully. It is not a measure of how passionately or how persistently those of us inside institutions argue these cases and whether or not you hear them in quotes or in panel discussions; some of this stuff has to be a one-to-one conversation. And on many of these issues, it is very direct and very pointed. But that's it; that's all I can tell you.

**R.Sm.:** It seems like one of the reasons for what's going on at the Guggenheim is that there aren't a lot of curators there. There's a kind of absence of them.

**R.S.:** I would assume that some of my colleagues there have also spoken up, as much as can be done.

**M-C.R.:** I want to add something to that. Yes, I agree that, in a certain way, our curatorial practices are threatened at the present moment. There is a perception that I'm sure is present here in the United States in the art world, but I'm seeing it in Latin America, which is a very good case study. We've seen, first of all, the emergence of the curator where there was none before, so it's easier to track these changes. There is a very strong reaction right now on the part of institutions and collectors in certain sectors that we view the curator as having a lot of power—as being too empowered.

What happened to Ivo Mesquita in the São Paulo Biennial is one example of that—and the debate that came out even before, in the biennial that Paulo Herkenhoff did; if you read all the criticism, it all goes in that direction. In that sense, our practice is threatened. But that's what gives it more relevance, and reveals how important it is in our present structure to have these kinds of practices that, as I said before, mediate between all of these levels and, therefore, have a potential to impact upon all of these levels of the social structure. In that sense, I'm not quite there with Rob, because I feel that he's continually bringing the

issue back to the institution. The institution is what needs to be completely reinvented. Our curators, as such, in the way that we are operating right now, have to go beyond the institution. We can make a choice to work inside the institution, but our perspective on our purview cannot be circumscribed to the institution. It needs to move outside of that and kind of contaminate other spaces, and become involved with that.

**T.G.:** In response to Roberta—and I only say this because in some ways it's purely semantics—because this panel is about curatorial practice, I'd like to make the distinction that, yes, the change in director at the Whitney threatened my job, but it didn't threaten my curatorial practice.

**R.S.:** I'm not defending the permanent state of my institution. My institution, in fact, has changed enormously in recent years—not as much as it needs to—but the particular part of the problem that I've tackled is over in that corner; it's not to the exclusion of the other problems at all. It's very much aided by the activities of other people in other areas, who have essentially demonstrated and said, look, this is not only possible, it may be a whole lot more interesting, so move this way. But, if I'm being cautious, it is because I don't think palace revolutions are possible. You can have a wholesale revolution, or you can have reform. At the moment, I'm in the reformist's job.

# INVENTING NEW MODELS FOR THE MUSEUM AND ITS AUDIENCES

**Kathy Halbreich** > *Director, The Walker Art Center, Minneapolis*

 When I was told my talk would be about, and this is a quote, "The challenges of integrating the demands of fund-raising, audience development, education and interpretation, public relations, etc., with the imperatives of creative, scholarly, and innovative curating," and that I should speak for an hour, I panicked. I wasn't certain I had entertained enough long thoughts in the last few years to justify standing here for that long.

Confession number one: This director's life is no longer centered on reflection. I profoundly miss the slowness of time, but seem to spend my days moving rapidly from topic to topic in a topical manner; running for meetings downtown and to dinners around town; shooting from the hip and sometimes leaving others to mop up, because I'm not even certain what the target is; intuitively responding and speaking in sound bytes; and, oddly enough, for someone who grew up in a field inhabited by things that are the physical embodiment of ideas and values, living vicariously.

Confession number two: Some days, it seems that my pleasure is sublimated in the pleasure of others. A not entirely undesirable state of being, but one I'm not certain I want to adjust to. The vision thing gets done in the darkness of night, when I wake myself talking to myself. It gets hashed out, remade, and refined with the staff I truly love and am comfortable arguing with, and a board I know respects us, loves the institution, and wants its city to be competitive. Every day, I wander into the curators' offices that surround mine—I resist being on the floor with administration—and I go there just to schmooze. I confess I am jealous of the curators whose work I so much admire, because it grows out of time, usually a long time, spent understanding how another human being ticks. (See how even my metaphors relate to the clock?) Regrettably, speed is *time* for me these days. I confess I'm wistful about time—its passing, the real luxury that having some more of it would be, the twin necessities of reflection and dreaming, both of which demand desire and leisure. And I'm not going to even mention family. Suffice it to say, the best museum director probably is an unwed celibate with a gift for marketing.

Confession number three: There aren't even enough hours in a day to do what I'm supposed to do, as well as to learn how to do what I don't already know, which is lots. For instance, this month someone mentioned they were waiting for a liquidity event. Now, I can tell you this phrase has nothing to do

with either the *Raft of Medusa* or adult diapers; however, it does have to do with the possibility of completing a capital campaign.

Once the panic subsided a bit, I realized that you all had actually provided me with something crucial—a way to make the fleeting thoughts that occur to me in the dark of night comprehensible to myself.

Confession number four, and it is the final one: It is clear to me that the creative pleasures I once gleaned from my curatorial work have been replaced by my desire to reinvent the social role the Walker plays in the life of our community, in tandem with my desire to create a reasonably nonhierarchical workplace that is equitable, respectful, and mission-driven. We were, for instance, one of the first local companies—and I use that word judiciously—to offer benefits to domestic partners, when the board agreed it was the right thing to do, nearly nine years ago. It was actually one of the first things I asked them to do. I've tried in my comments to weave together the social and artistic strands that shape the Walker's mission and my job.

We've just crossed into a new century, in which the rate and dimension of change promises to test all our powers of invention. Invention will be everyone's new business, and cultural institutions should capitalize on their currency in this domain. Change itself can be measured by the speed of the Internet, a conduit for an increasingly global network of competing values that exist in a virtual space without hierarchy or agreed-upon standards of civic discourse. While that's neither good nor bad news, it does offer cultural institutions a new set of challenges and opportunities. We must adapt to become a filter, through which some of these competing worldviews can be debated and new communities established.

I understand that change can be threatening to us all: for trustees, some of whom cringe at noise in the galleries, while others wonder why we just don't give our guests what they want; for directors, some of whom think a business model built on Impressionism of any sort and season is a populist strategy, while others wonder how to compete with collectors in an inflated market and, sometimes, our own board members, for new acquisitions; for curators, some of whom are confused about how to gain global insights when their travel budgets are minuscule, while others watch their dot com classmates travel first class; for visitors, some of whom find the naked body in a photograph a startlingly different creature from the nude painted on the Greek urn, while others wonder why we've left popular culture outside our gated community; for funders, some of whom think they should lead the field, while others believe it's healthier to follow; and even for artists, some of whom are devitalized when a museum structure proves pliable enough to make subverting it less interesting, while others consider building community a way of making sculpture.

Even though I know change demands that we set new priorities, that we stress recently acquired and consequently unseasoned values over old ones, and divide precious resources differently, I like to think of change as a process of multiplying possibility rather than subtracting things that matter. While I admit that sometimes it's not so easy for our traditional audiences to understand initially what's been added so much as what's been taken away, we must not let our faith in what's aesthetically, intellectually, and socially necessary falter. It is crucial for all of us to remember that we entered this field because at least some part of our psyche was mesmerized by invention, by the ways in which artists often simultaneously make visible the values we prize, while insisting that we question our own perceptions. We, too, must use Januslike vision, with one eye that of the skeptic and the other the convert, to reevaluate those traditions and histories that have shaped our institutions as we re-create them for the twenty-first century. We need to make a case to ourselves, our publics, and our politicians for change, not the status quo or stasis—two words that seem perilously close to the status some of us have enjoyed.

In considering the ways in which museums are changing, and how the role of director as well as the expectations of the visitor are shifting, I'll use the Walker as a model. I want to stress, however, that every institution's mission must be carefully calibrated to reflect the aspirations, ambitions, and needs of its own community. Our mission statement states, "The Walker is a catalyst for the creative expression of artists and the active engagement of audiences." Now, I'll just digress here for a minute. I was very surprised this morning at how few times the words "audience" or "visitor" came up in the conversation. Back to the mission. "Focusing on the visual, performing, and media arts of our time, the Walker takes a global, multidisciplinary, and diverse approach to the creation, presentation, interpretation, collection, and preservation of art. Walker programs examine the questions that shape and inspire us as individuals, cultures, and communities." That mission really is our mantra. I believe if you were to go through the institution, people could quote it to you.

We are the only major cultural institution in the United States persistently engaged in establishing the relationship among artistic activities that occur in the light and dark spaces of galleries and theaters, between static and moving pictures, between real, virtual, and fictive time, and in our own community as well as countries as diverse as China, Brazil, South Africa, and Germany. As a multidisciplinary institution with an increasingly global focus and curatorial departments in the visual arts, performing arts, film and video, and new media, I believe we are uniquely positioned to participate in the congruence of these disciplines in an increasingly digital twenty-first century; to expose our audiences to a wide spectrum of related ideas across the disciplines—from down the street as well as

around the globe; and to provide artists with the necessary resources to make new work without regard to the traditional disciplinary or departmental hierarchies within most museum structures.

We offer our increasingly diverse audiences multiple points of entry, with an active exhibitions program that champions the new or gives alternative context to the old. Like a great university, we should be involved in creating pockets, if not laboratories, for research into our social, economic, cultural, and intellectual lives. Those laboratories can be exhibitions, such as some of those we have traveled to fifty-eight other museums in the last five years. I love Joseph Beuys's statement, "I want to make museums into universities with departments for objects," except that I'm not certain we should divide the objects into separate departments.

Clearly, one way to expand and diversify our audiences is through the support of different disciplines. With the largest museum-based performing-arts program in the country, the Walker's activities often include commissioning new work in new music, theater, and dance. Some of these are failures, others transitions, and a few are truly markers of our age. If you support artists, you support the range of possibilities, and it becomes important to permit our audiences in on a little secret: Not everything they're exposed to is of equal significance. The pleasure can be in the unfolding of a process over time and in a long-term relationship.

Our film-video department brings the best practitioners of both studio and independent productions to town for dialogues and screenings, including, for instance, Chen Kaige, the great Chinese director, before he won the Golden Palm at Cannes (and I stress that *before*). Our new media department, singled out as the national leader in the field by the *New York Times*, developed ArtsConnectEd, a collaboration with the Minneapolis Institute of Arts, which was voted the Best Educational Museum Website at the International Museums and the Web Conference in 1999. During the past six months, 884,000 visitors spent 109,000 hours viewing more than 5.6 million pages on the Walker's website. Despite a huge investment in the educational components on our site, many virtual visitors gravitate toward Gallery 9, the museum's online gallery for digital art. I've begun to wonder how we will distinguish between our online and on-site visitors in the future. But since more than eighty-five percent of our online visitors are from out of state, with twenty percent coming from out of the country, I'm not worried that we're cannibalizing our own visitor base.

As we move forward, I believe the classical distinctions between media and disciplines will continue to blur. Our tasks will be to recontextualize and treasure the artistic accomplishments of this century as we support the possibilities inherent in the next one, and discover new criteria by which to make our judgments.

I remember looking at an early prototype of a section of our website and finding that the quality of its design was banal. When I mentioned this to the head of our new media department, he agreed it was stylistically challenged, but suggested I hadn't either acknowledged or explored another, perhaps more important criteria—the speed, density, and quality of its interactivity. This is something I think about in terms of all of our other programs. Our success depends upon our nimbleness or capacity to embrace change, coupled with a worldview that is both informed and open-minded. Curators no longer work in isolation from educators or audiences. Curatorial decisions often involve conversation with many partners: social service agencies, arts organizations, and schools. We organized an exhibition drawn from the Walker's permanent collection of the nearly complete set of more than four hundred multiples by Joseph Beuys, an artist whom I think we might all confess is a bit inscrutable. At the same time, we also organized a project on the Cass Lake Reservation, home to many Native Americans in northern Minnesota and a place where environmental concerns—a love of the earth—are highly developed. This collaboration involved thirty community organizations in planting more than one thousand trees as a way of extending a similar project Beuys had himself begun in an attempt to spread his ideas of how art can effect social and environmental change. A front-page article in the *Cass Lake Times*—I know we all do look to other journals for our success, but somehow this had real meaning to me—explained the artist's work, and asked community residents to mark their doors with a green ribbon if they wished to plant a tree in their yard. Curators and educators led the planting and the conversations that grew out of those efforts, which were really the point. The article ended with a quote from Beuys: "We shall never stop planting." That's a marvelous metaphor for the role of cultural institutions.

Similarly, we support more than twenty artists and residency projects each year, enabling artists to make new work in close proximity to their audiences. These residencies in visual, performing, and media arts are enormously time-consuming, ranging from multiple weeklong visits over a year to an intensive several days, to many visits over three years. They require that the curatorial staff, along with educators, be out of their offices a lot, talking with partners about what their organizations or neighborhoods need, what artists might best address those needs, and what resources can be channeled to the collaboration. The conversations are with politicians, community activists, immigrants, housing specialists, historians, you name it. For instance, choreographer and director Bill T. Jones and his company return to Minneapolis in April to continue working with local residents in the development of a new theater work. This second weeklong visit this year is part of the company's four-year initiative to develop audiences for modern dance, which involves an ongoing home-away-from-home commitment to the

Walker Art Center and the Twin Cities. Past visits have included lecture-demonstrations at a neighboring vocational school, and I can tell you that the guys—and they were primarily guys—were incredibly skeptical about hearing a "ballet dancer" talk. As only Bill can do, he left converts behind. It was a remarkable discussion, as were the talks with teens during a back-to-school open house that we run every year; seminars with religious leaders, which are something new for us, but, I think, particularly fascinating, given that we have spent some time being castigated as heathens because of some of the artists we have supported in the past; and a radio program broadcast from Lucille's Kitchen, an African-American café, when Bill, in fact, raised the issue of the black church's relationship to people with AIDS.

Gathering material for a new dance-theater work entitled *Loud Boy*, a contemporary interpretation of Euripides's *The Bacchae*, the company will work with broad cross sections of the community to explore cultural and personal images of God, the thematic issue at the heart of the Greek tragedy. A series of discussions raising the question "What does your God look like?" will provide Bill with rich resource material from many different cultural perspectives, including Hmong and Somali, two of the most recent immigrant groups in Minneapolis. Additional workshops, master classes, a lecture-demonstration, and public showings of the work-in-process will take place at venues throughout the Twin Cities. The Walker has presented Bill T.'s company more than nine times over the years. He's one of several artists across the disciplines to whom we've made a long-term commitment and with whom we will grow. His work was seen in the exhibition "Art Performs Life: Merce Cunningham, Meredith Monk, and Bill T. Jones," which we organized, in 1998, to begin to understand how things that occur in real time can be translated to galleries.

Two awards, one local and one national, suggest how I hope our work in the community is meaningful, both in the neighborhoods around us and to the field. In 1998, we received a Quality of Life Award from the Minneapolis Chamber of Commerce for a partnership with the Powderhorn Neighborhood Association, which results each year in an arts festival along Lake Street that celebrates the achievements of artists from near and far. The truth is, Lake Street is a most diverse network, bisecting the city from the Mississippi River to the urban ring of lakes. It is home to those who first settled Minneapolis and those who have arrived most recently. The festival has encouraged the redevelopment of one section of the street, giving vendors as well as residents much needed visibility and security. In some small way, this festival has resulted in the neighborhood's economic turnaround. Two weeks ago, we received word that the Lila Wallace-Reader's Digest Fund had selected us as one of fifteen organizations nationally to receive a grant of $1.25 million to continue building new audiences.

We also have established a Global Advisory Board of colleagues: Walter Chakela, artistic director of the Windybrow Center for the Arts in Johannesburg; Vishakha Desai, vice president for programs for the Asia Society; Hou Hanru, a Chinese-born curator now living in Paris; Paulo Herkenhoff, director of the last São Paulo Biennale and adjunct curator at MoMA; Vasif Kortun, an independent curator from Istanbul; Hidenaga Otari, a performing-arts critic from Tokyo; and Baraka Sele, producer for the World Festival at the New Jersey Performing Arts Center. The committee meets at the Walker twice a year, for five days, with curators, educators, and designers, to critique our programs, to help expand the global and disciplinary range of our collection, and to plan a collaboration and a multidisciplinary project for year three. But what we really do collectively is stop, leave our offices, and grapple—sometimes with painful delicacy, other times with robust giddiness—with such questions of expertise and practice as, how do we interpret the global for the local? What changes are necessary in interpretative strategies to help our audiences understand work from different cultures? What is the role of art in your culture? What are the leading forms of artistic practice and entertainment? What is the relationship between artists and audiences? And, why is it so common that the language of exchange for global projects is English?

A recent agenda focused on the Walker's collection, recognizing that the works we acquire should become the permanent demonstration of the viability of our discussions. While we must put our money where our mouths are, this is not simply a matter of reallocating acquisition funds. As the focus of the collection, certainly through the eighties, was on North America and Europe, how do we begin to understand, then, even where to begin collecting? Is it possible that a collection that is more about hyperlinks or simultaneity than linearity is the collection of the future? How do we provide a larger context for understanding the significance of work that is shaped by cultural values remote to many of our traditional visitors? Parenthetically, I wrote that last question before going to hear the superintendent of the Minneapolis school system, who mentioned that there are more than eighty languages spoken in the public schools in Minneapolis today. As we begin to really look at who we are serving, we will find that no matter where we live, it is a more diverse community than we probably imagined.

The curators at the Walker have begun to recognize that there is no homogeneous definition of what constitutes a work of art, or what the useful, evaluative criteria might be across cultures. While Western cultures have traditionally placed a high value on such avant-garde classifications as innovation and individuality, other cultures, particularly those under siege or particularly fragile, have underscored the preservation of traditions and the engagement of community. We've begun to make progress in incorporating some more traditional work, albeit work that tends to be self-consciously balancing the old and new in our

performing arts programs, but we're still struggling to understand its place within the exhibition program and collection.

As an international institution with increasingly broad and deep connections to neighborhoods that surround us, the Walker seeks to make visible the sometimes competing and often complementary values of the diverse cultures that compose our community and the world we share. I like to think we are a safe place for ideas, some of which may challenge our individual assumptions about what's good and what's bad, what's meaningful and what's not. I agree with somebody this morning who talked about the word "nice." I often say that nice is great for above your couch, thank you, but it's not a great institutional mission.

It's important to remember that the nineteenth-century definitions of quality, which surfaced in Europe, presumed a cohesive and homogeneous worldview. Consequently, most Western museums have assumed an aesthetic hierarchy in which painting and sculpture are elevated above other media, and in which popular culture is rejected. Modernism also is often equated with a dependence on stylistic and formalistic analysis, an approach most rigidly expressed in the phrase "art for art's sake," which first appeared in 1818. Considerations relating to the autobiography of the maker, the function of the artwork, the social context in which the artwork was made, or the economic conditions that prevailed were often denied. But as we enter the twenty-first century, we all recognize that we live in an increasingly hyperlinked time, and in a world that is far from homogeneous. Henry Kaufman—he's a funny person for me to quote—but the economist Henry Kaufman wrote something that indeed has shaped our thinking: "Understanding cultural diversity is perhaps one of the greatest challenges of our global interdependence. As economic borders disintegrate and political borders shift, what remains are cultures."

But these cultures are wrapped in difficult histories, which museums often either segregate or sweep under the rug. From February 20 through March 13, 1999, master artists from China, Japan, Korea, and the United States were in residence at the Walker, offering a wide range of community activities while concluding the final development of *Forgiveness*, a major, new work commissioned with the Asia Society, in New York, which premiered at the Walker. This music-dance-theater piece examines a pain-filled twentieth century of inter-Asian conflict marked by war and peace, unspeakable atrocities, the past dream of a united Asia, and slow movement toward reconciliation. The diversity of artistic collaborators—among them a Chinese director, Japanese Noh master, Korean dancer, American composer, Korean singer, Japanese-American percussionist, and Chinese Peking-Opera performer—reflected the larger challenge of communication (with three different translators speaking four languages running back and forth between artists) but also the complexity of various stylistic conventions and

historical relationships among these countries and peoples. The differences and variations of a given word in each language—forgiveness, or shame, or guilt—became points of departure in developing the piece.

The accompanying residency programs brought a level of interaction with the community that was an important component of the project, and probably forestalled political demonstrations protesting the sensitive histories covered in the piece. And I confess that I barely knew what these historical sensitivities were when we began this project. Each activity was created in collaboration with new as well as established community partners, who sometimes have no tradition of working together. Because of the historical problems between, say, the Japanese and Korean peoples, they had little desire to do so. Often, Walker programmers, when planning events, had to move carefully between these painful histories. In the case of one young Walker staff member, they became personal when a Korean partner, turning to her to walk to dinner, said he had never imagined eating with a Japanese person.

The artists participated in numerous residency activities, including master classes in which they compared their respective theater traditions, meet-the-artist interviews on the making of *Forgiveness*, and humanities panels on the concept of forgiveness within the historical context of Asia and World War II. In addition, the cast and crew were given dinners by local community members, including the director of the Korean-American Today and Tomorrow Center, a member of the Walker's Community Advisory Neighborhood Group, a member of the Chinese-American Society of Minnesota, and artists from Theater Mu, a theater company that supports Asian performing arts. Ultimately, it wasn't only the Walker that cemented new relationships—each of the communities involved also had conversations with each other that, perhaps, might not have happened except through art.

Since the Walker is singular in its support of commissioning new work by artists across the disciplines, I'd like to suggest our future by quoting Marcel Duchamp, who reminds us that "the creative act is not performed by the artist alone: The spectator brings the work in contact with the external world, deciphering and interpreting its inner qualifications, and thus adds his contribution to the creative act." This quote maps a direction described in our long-range plan: The Walker is to be "a pioneering, twenty-first-century, multidisciplinary center with audience engagement and experiential learning at its core," whereby it "will become a pleasurable destination—real and virtual—that is not event-dependent."

A recent article in the *Harvard Business School Review* highlighted the emergence of a new entertainment economy by which sneakers are sold through stores that provide more experiences than figuring out your shoe size. We have something to learn from this, but corporations should not be the only institutions

telling our stories, providing our experiences, and animating our communities.

I hope our model subverts that of the Mall of America, in Minnesota, one of the main destinations of both teenagers and tourists, but I also know I can't ignore it, or the interactive model that science museums present. Consequently, in the future, the Walker will provide our audiences with multiple opportunities for inquiry and discovery personalized by each participant. Many stories, artistic disciplines, histories, interpretative strategies, and databases can be connected to create richer, more contextual, and interactive links between art and life. We are using new models for thinking about how information can be presented and personalized, some of which have arisen along with new technologies. We hope to provide daily access to the artist's creative process across the disciplines, with new spaces devoted to each art form. Imagine watching a new dance or musical composition evolve, seeing the choices an artist makes along a creative trajectory. This is what could happen in a technologically sophisticated performing-arts studio. We hope to provide greater access to institutional resources, such as our now-private library, and I would wager that most of our libraries in museums are private, which startles me. Imagine, at least, a public reading room that is organized around changing curatorial programs. And, finally, we really hope to create the most inviting public space in the Twin Cities—a sensory environment animated by community conversations of an artistic, civic, and critical nature.

The Walker Art Center's emerging plan for an expanded facility and expanding engagement strategies will make visible the fact that we are more than a museum, recognizing that the word "center" suggests a focal point of activity and conversation. We want to change the metaphor for a museum from temple to town square. We aim to magnify the ways in which visitors to the Walker can become more active participants in a series of memorable experiences based on discovering the links between art and life, as well as among multiple artistic disciplines. We know from our research that visitors seek more active engagement with living artists, in a universe of content and information more easily tailored to each individual's knowledge, desire, and style of learning. Some people, for instance, learn more through oral or written communication, others through tactile or kinetic experience. All learning styles are, at present, incorporated into our educational efforts, but need to be brought into the design of the expansion itself. Just as there are many forms of intelligence, there are many approaches to engagement, ranging from the individual's meditative experience to the interactive conversation, to the "a-ha" of collective discovery.

Here, it might be useful to note that we have spent enormous intellectual and financial resources, including a very generous commitment from The Pew Charitable Trusts, in Philadelphia. Some of the rewards of this work can be seen in the fact that attendance since 1993 has risen twenty-eight percent, to nearly

one million people in 1999. If anyone still thinks cultural institutions are elite and remote, let me say that thirty-six percent of our annual visitors have household incomes below $25,000; fifteen percent are people of color, a population that was not even measured when I first came to the Walker ten years ago; and ten percent are teenagers, also a population not measured when I moved to the Walker. The teenagers are not coming with school groups. They are self-selecting the Walker as their place for conversation.

Although the search for certainty remains with us as we end a century in which many geographic, psychological, scientific, and even spiritual absolutes were tested, the open-ended miracle of the arts is that they allow each of us to form our own answers and find our own meaning. I'm sure that doesn't seem a provocative statement to anyone here today. In principle, it shouldn't be, but in practice it can be. All of you know that last year, in New York City, a creative center admired for its open-minded spirit, the mayor withheld public funding from the Brooklyn Museum because he found a painting by Chris Ofili "sick" and "offensive" to Christian values. (And I think the Christian values also were in quotes.) If the mayor had, perhaps, taken the time to recognize the cultural conditions that shaped the intricate painting of a black Madonna made by a Catholic artist of African descent, he might have come to recognize that the dung affixed to and supporting the painting is not simply excrement, as he called it. He might have considered that the cutout images of female genitalia from men's magazines were there not so much to titillate as to critique. Given the fact that dung is a precious material and a sign of fertility in some cultures, the mayor could have seen this painting as a celebration of the sacred against a backdrop of the West's rather persistent degradation of female sexuality to sell everything from cars to cigarettes. The question, then, is certainly about the democratic principle of freedom of expression, but it also seems to be about cultural differences, authority (both curatorial and political), society's tolerance for both ambiguity and provocation, and the role of cultural institutions within the civic life of their communities.

That being said, I also worry when either the controversial or the already well-worn creates the popular, and when the popular is the most significant sign of our success. I'm happy when our numbers are good, but I'm happier when the engagement is repeated and deep. That's one measure of success in our new plan. I worry when we lose our focus, treating audiences with less respect than they deserve.

Doubtless, we will spend more time communicating, learning, and creating online, yet I believe the desire for a sense of community, as well as a safe place to discuss and debate those values that separate and bind, will become stronger. Are we strong enough as institutions to embrace those controversies, to establish a framework for such debates? Our collective efforts to support the creative

expression of artists in the active engagement of audiences depends upon just such courage.

The true miracle we share, I believe, is best stated by a group of fifteen teens from six local high schools who studied at the Walker three days a week for four months to make a film called *The Listening Project*, which served as an introduction to our permanent collection. These students found that there were five approaches to looking at and understanding contemporary art: questioning, listening, responding, challenging, and dreaming—a wonderfully cogent way of describing the methods for confronting the unfamiliar. One student told me she learned "not to accept spoon-fed solutions," while another said her experience "forced me to change the ways I see history, culture, and the news." That idea, indeed, should be our collective mission as we move forward into the twenty-first century. By the way, I just saw one of these students, who's now a graduate student, at an opening the other night. She's returned home from RISD, and she was amazed that I remembered her after all this time. I was struck that so much time had elapsed since I last saw her presentation on Jana Sterbak's *Flesh Dress for an Anorexic Albino*, when she was a high school sophomore. One of the things that's remarkable about these kids is that every time I talk about them, somebody inevitably raises a hand and says to me, "But these are really special kids." What I want to tell you is that these are everybody's kids.

In closing, I want to read the words of Maggie Perez, one of the twelve members of this year's Teen Arts Council at the Walker, and a junior in high school, who is episodically homeless. The council worked closely with Glenn Ligon, an artist who incorporates text, primarily by African-American authors, into his paintings. Glenn asked the students to use the techniques of sampling often found in today's rap music, but which I associate with, perhaps inaccurately, Picasso's collages, to study the permanent collection in order to produce their own work and a label for it. Some of the students' work was on view in the Andersen Window Gallery, in the permanent collection galleries. It's a gallery that provides a context for the collection, and it's a hybrid meeting place and media-reading room as well. Maggie's piece, which she titled *Below Suspicion*, is a multimedia work that includes "photocollage and sand mounted on plastic bag, with audiocassette transferred to audiodisk." She incorporated ideas she found in Jud Nelson and Lee Bontecou's sculptures, as well as a sound piece by English artist Christine Borland of a child reading the passage in Shelley's *Frankenstein* in which the monster becomes aware that he is different from human beings. Maggie describes her work of art: "I was first inspired by Jud Nelson's *Hefty Two-Ply*, the ironic, marble sculpture of a trash bag. Quickly, I came up with a story about different forms of enclosure within people's lives. It began as the story of a man trapped in a plastic bag and expanded from here. Christine

Borland really struck me with her work *The Monster's Monologue*, which is simply a voice coming from the wall, and this led to my vocal recording. During the making of my piece, a lot of outside influences became part of it. I watched a video about fractals, the geometric formulas for constructing anything from a cloud to a tree, to DNA. This prompted me to ask, when the answer to the ultimate question is found, is that God? I think the answers have always been right in front of us, even within us. This concept blends well with Lee Bontecou's *Untitled No. 38*, because it uses the mystery of holes, inner space, and darkness. I feel it enveloped its surroundings, paralleling my stories of enclosure. Finally, the sand I used is a symbol of the repetition of life. I collected it here in Minnesota, where, hundreds of millions of years ago, there once had been an ocean, its waters and sands teeming with living organisms." I think we should send Maggie to congress to advocate for us all.

Thank you for inviting me here today to stop, to linger, to collect my thoughts. What I wish for us all is the time to dig deeply, to ask good questions, and to share those things that make us more widely human.

# PANEL STATEMENTS AND DISCUSSION

 **Ned Rifkin** > *Director, The Menil Collection and Foundation, Houston*

I want to compliment Kathy. That was an extraordinary presentation and an inspiration. *I* want to work for you.

I want to go back to Thelma's analogy. For over thirty years, I've been a lacto-ovo vegetarian, and, however, I have worked in museums that run the range from university museums, kunsthalle, the New Museum, a private museum in Washington, D.C., a Smithsonian Museum in Washington, D.C., which is sort of the inverse of that, and then a private museum that was, essentially, the museum for a city and a state. Now, at long last, I'm working for a private museum with a private foundation, and I guess what I would be is a "situational eater" in this circumstance. Or was I covering that the whole time?

The thing about the Menil Collection and Foundation, which I should say right off the top, is that, first of all, the foundation has existed since the fifties and was established not simply for art; in fact, it's very important that it's not simply for art. Originally, it was for human rights as well as religious and other activities. One of the major projects from the late sixties, as you probably all know, is the Rothko Chapel. For the record, it is not a part of our purview any longer, it was given to the foundation that now runs the Rothko Chapel. But that stands, in so many ways, as a paradigm for what the de Menil family was trying to do and to offer and imbue in Houston, Texas, at a very interesting time.

If you think back to the late sixties, they were not only putting African-American people up for public office; Mickey Leland was a board member of the Menil Foundation many years ago. Many of you know who I'm talking about, but, in case you don't, he was a very farsighted congressman from Houston, from, I believe, the third ward—it might be the fifth ward (I'm still learning my wards in Houston)—but he was killed tragically in an airplane crash, I believe, going to Africa on a mission. (I want to say five to ten years ago.) My main point is that the spirit of the foundation is very much attuned to what the Walker is trying to take up and, clearly, planning, which is to see art in a context, a much larger social and cultural context, and, even in the case of the Menil, a religious context as well, that enables people to find inspiration, to find a place for meditation, reflection with art so that art becomes an apparatus to leverage perception, seeing, knowing, and exploration.

I feel extremely fortunate to be put in charge of that, but also quite daunted by the legacy that we are now responsible for stewarding. What I want to say mostly is that while I've worked in all these different museums in the past, it's fascinating that all of these museums are situation-specific—that is, you have a vision, you have a belief system. Sometimes, it's provocative, sometimes it's contrary. But whatever you do, it's within the context of what that situation is, and you try, as all of us here do, to expand that, to make it more available, to widen it and deepen it, to use your word, Kathy.

One of the things about the Menil Collection, which is different from the Menil Foundation—but I won't take our time today for that; I may in a footnote later—is that its holdings run from 15,000 B.C. to approximately the present (not quite the present). But that's not unimportant either. Most of us know that the Menil Collection has extraordinary Barnett Newmans and Magrittes, and that the Menils were patrons who commissioned artists and were engaged in supporting artists in the old sense of patronizing—that is, giving stipends to surrealist artists Max Ernst and René Magritte and others. They were supporters of contemporary art, again, in depth and with a mind to really break out of the mold—Mark Rothko being another good example, and, more recently, Cy Twombly, one of our great living artists.

Admission to the collection is free, and what I've come to realize about that is the following: The Menil Collection is, perhaps, not for everyone, in the way it's presented and the way it's offered forward, but it is for anyone, and that is a very significant part of what I perceive to be the legacy of John and Dominique de Menil. What we are experiencing right now—and I say, "we," because I've been there eight months, so I really do feel very much that I am a part of that experience—is the shift from a powerful, individual patron, someone who had vision, but who also, as someone said earlier today, was not afraid to make mistakes—and, in terms of the collection, they made plenty of "mistakes." People don't see them; they're usually upstairs or even downstairs, where we keep the less likely works to be put on view. But even storage as a concept was elevated and meant to be instructive; it was put there as what she called a "treasure house." The idea is that creativity of artists, ambition and boldness—not so much innovation, but boldness—of the patron could work to converge in a way that would be singular in some manner of speaking. It would represent an individual, or, in this case, a couple's vision of what art could be in the late twentieth century, the second half of the twentieth century. The idea of commissioning artists—Mrs. de Menil's last commission was Dan Flavin. A lot of people don't realize that we have a space dedicated to Dan Flavin as well. The point is that, throughout Dominique de Menil's lifetime, she was continuing to learn, continuing to grow and probe.

This is an inspiration for us, the stewards of that institution, and this is the

point as we're shifting from an individually driven private institution into a collectively stewarded institution, as it turns into a public resource. It isn't there yet, but we have the luxury in Houston of having a Museum of Fine Arts, the Contemporary Arts Museum, as well as Diverse Works, which is an alternative artist-run space, and the Blaffer Gallery, which is at the University of Houston. We have all of these different organizations doing different things, which frees us enormously to do what we believe is different and not to replicate. An example of this is that we don't have an education program as such. In fact, I wouldn't even call us a museum, quite honestly. The reason I left the High Museum of Art and other museums was to go to a place that decided it was not a museum but a collection and a series of projects and a foundation. It's such a different model as a museum-type of place. The key to our future, which we're just now planning, is to preserve those aspects that make us unique and different and to be sure to enhance that specialness: the rarity of going into a relatively unmediated experience without a lot of labels, without a lot of voiceover narratives, to see art in depth. We can turn it into a more conventional museum in easy order, but we haven't, since that would be such a pity. The challenge is trying to figure out what really differentiates us in so many ways. Our membership program costs us $15,000 a year, just to give you an idea. Our bookstore costs us tens of thousands of dollars a year. It is a foundation that underwrites its own uniqueness. I'm not saying that that is right from the business standpoint, but it is right from a different standpoint. So, the problems that we face are trying to understand the relationship between commissioning not only art but new research by scholars and new research by artists, for that matter.

Mrs. de Menil, in her bequest to the foundation, left us her residence, which many of you know is a very early Philip Johnson building and a very important symbol, within our community, of modernism implanted into 1950 Houston, which is, to me, unimaginable right now. But that building, that home, and, frankly, what we have in the Menil Collection is not a museum but a home for art, a place where you can experience the intimate power of art as an encounter. This is a bit of an endangered species within the world of art museums.

I want to enter into this conversation in a meaningful way, having worked at other museums, but, in so many ways, the Menil Collection offers us a clear alternative to what museums were like and can still be like. The other little element I would add is that scale, not size, is what that place is about in the end, and that scale, perhaps, is something we need to replicate but not expand upon, if you understand the difference.

**Nicholas Serota >** *Director, Tate, London*

As is the way on these occasions, the panel met last night over din-
ner. We met in that rather extraordinary building whose collection
you all know, the College of Physicians. As we left, Paula kindly gave
each of us a small souvenir of the occasion, a replica of one of the
accessory body parts that one might find in the museum. I couldn't help notice
that the two Europeans, Hans-Ulrich Obrist and myself, were both given a
growing brain. When I took it back to the hotel and read the instructions, it said
to put the brain in water and it will take forty-eight hours to expand. So, I did,
though some of you are in for a slight disappointment, because it's going to be
another twenty-four hours before I can tell you what happens. Although, evi-
dently, Hans-Ulrich Obrist put his in hot water.

This is not entirely an aside. I make no apology for continuing to believe that
the curator represents and is, indeed, the brain within the museum, and the muse-
um should continue to be a place of discourse, debate, reverie, enlightenment, and
inspiration through an encounter with an object, which is a primary experience
of a work of art. The museum is not a book and it is not many other things, some
of which we discussed this morning and that we'll go on to talk about this after-
noon. But it is, undoubtedly, a place of social interaction and it is a public space,
which, in my view, should make it a fundamentally different experience from the
experience of art within a commercial gallery. For the purposes of this discussion
alone, I'm taking museum/kunsthalle as being, generically, one type of space
contrasting with a commercial space. What should be the role of the curator in
this public space? It has to be, as I say, the brain, to give structure to the
experience, and to take responsibility—that is, to take responsibility for creating
the frame through which the public will see and experience the work of art.

Very often, one goes to exhibitions—especially in Germany, at present—
where you encounter a single room given over to a group of a single artist's
work, and, adjacent to that, another room given over to another artist's work,
and, adjacent to that, yet another ordered in the same way. These presentations
undoubtedly reflect the aspirations of artists, but they also reflect the pattern and
the structure of the gallery world. Such displays are not, in my view, museums;
they do not place an intellectual construct over a range of objects. The responsi-
bility of the curator is to make readings, to rethink history, and to show his or
her hand. In the past, there was a sense of an institutional voice that controlled
the way in which display was structured. Naturally, institutional attitudes inform
many of the activities of the Tate, in London, or the Museum of Modern Art, in
New York, but I believe that each of us, as curators, should be prepared to take a
more personal responsibility and disclose our involvement in that when we

present our displays.

At the Tate, that means we now have wall texts that are signed by an individual curator, which helps to indicate that a personal view, a personal reading, is being made. No one objects to a directorial viewpoint in the theater. When they go to the National Theatre in London, they expect to hear and see Richard Eyre's or Trevor Nunn's view of *Hamlet*. They don't go to see the National Theatre view of *Hamlet*. The same should be true in museums. As Rob said this morning, to do this effectively, curators now need a huge range of skills or, at least, access to those skills: theory, history, marketing, publicity, interpretation, and, dare I say it, writing skills. Not all curators have all these skills. What is needed, above all, is an ability, as someone else said this morning, to listen, to pay attention to what others are doing and saying, but, nevertheless, to form a judgment and, in my opinion, to form a view. As Rob said, and rightly, it's not a question of the curator being top dog, but it is a question of the curator having his or her own view about the way in which these other traits, these other skills, are used in the service of art. Of course, the person to whom the curator should be listening most of all has to be the artist, and that applies not just to the curator of contemporary art but to the curator of classic modern art equally.

I remember meeting—Hans-Ulrich Obrist mentioned him briefly this morning—Willem Sandberg, early in my career, and being aware that this man who had directed the Stedelijk Museum, in Amsterdam, with such brilliance had always maintained very, very close links with artists. His successor, Edy de Wilde, was also close to artists. He was a director at the Stedelijk Van Abbemuseum, in Eindhoven, from, I think, 1946 until 1963, and then, for twenty-two years, director of the Stedelijk Museum, in Amsterdam, two of the great institutions in the Netherlands. In thirty years, he never built an extension or a museum building. The consequence was that when he came to make his final exhibition in 1985, it was an exhibition about art, made with artists, and not an exhibition about his achievements as the builder of a great architectural monument.

The role of the curator, in my view, is to create this frame. The purpose has to be to create a frame that will give confidence to the audience, confidence to follow their own judgments, confidence to respond to what they see, and, as someone said this morning, not simply to believe, necessarily, that all art is good for you or, necessarily, that all art is art that you or I will like. One of the most frequent questions I'm asked as director of the Tate is, "Do you like everything in this building?" Of course, the honest answer is no. Art is not simply a matter of like or dislike, it's a matter of responding to a whole set of experiences put together by another individual or group of individuals and responding to that. The curator has to try and mediate this work in a manner that reveals knowledge but does not intimidate. It's a matter, therefore, of using language in a way that

does not obscure, that is transparent, that tries to evoke associations in the mind of the viewer, of that member of the audience who will then use their own experience to come to terms with what it is on view. Of course, people respond in many different ways, and I'm not saying that everyone has to respond in precisely the way as the lady who wrote to me last week with a long list of every orifice and protuberance on the female and male form that appeared in works on view at Tate Modern.

Beyond the issue of the role of curator in mediating the display or exhibition, there are other questions about how we should build audiences. I'm not going to talk about marketing. Institutions build audiences by, as Kathy was suggesting, transparency in their program, making it evident what they are doing, and doing it consistently. We should not try to do everything. We should make it apparent that we are an institution that will show a particular kind of exhibition and we will do it repeatedly, so that we build an expertise in doing it well. The audience can come to count on us for doing that. We build an audience by the nature of our publications and our other forms of interpretation. We don't build an audience when we produce a catalog with twenty-five Ph.D. essays that precede 450 color plates. We need to make publications that reach a much broader section of our audience than is traditionally the case. We will achieve it by scoping and shaping the large catalogs, but also by producing other publications that are, as Rob said this morning, rooted in knowledge and scholarship. It is not a matter of simplifying or talking down. It has to be done by the person who knows most about the subject. We will, I believe, build audiences, especially for new work, by sometimes placing it in parts of the museum where people come across it, not having to search it out. Occasionally, we will do it by taking it outside the museum, as Tate Modern did, before it opened, in placing Shirin Neshat's *Turbulence* in a local church. That action raises further questions about the way in which the institution and the museum will operate in the future.

As Paul reminded us this morning, the museum is not simply an architectural space, it is a construct, it is an intellectual framework. Tate will operate not just within the buildings but in collaboration with the Open University, in collaboration with the BBC, working with a range of local schools, working with Afro-Caribbean groups in Brixton, or whatever. These are ways in which the museum will extend its reach into the community.

Any institution dealing with the twentieth century has to have a commitment to the present; history begins with the present. You cannot hold back from making judgments, from beginning to create the frame. You cannot wait for five years; otherwise, you allow others, including the commercial world, to establish history. You have to be in there, you have to be purchasing, and, above all, you have to be working with practicing artists.

Within the institution and the wider art world, the role of the director is very straightforward. It is, essentially, to resist—to resist the pressures from trustees, from commerce, from funding organizations, from curators who only wish to worry about their next job and write some obscure text that means a great deal to their prospective next employer but not to their readers. It means, essentially, holding on to the intellectual and ethical frame and structure of the institution. For an institution such as the Tate, which is there, essentially, to serve a public purpose, this means working to help people open and broaden their own lives and not, simply, our own.

**Anne d'Harnoncourt >** *The George D. Widener Director, Philadelphia Museum of Art*

It's hard to follow three very eloquent presentations, one of an admirable length, considerateness, and cogency throughout that length. Kathy was extraordinary. Thank God Rob Storr gave us, this morning, the right, maybe the obligation, to be corny, because, as I often am, it was a great relief to me.

I better say, right from the beginning, that if everybody is going to turn themselves from a temple into a town square, I'm stuck; there's nothing that's going to make the Philadelphia Museum of Art shed its stones. We just have to get the town square inside; in some wonderful, metaphorical ways, it already is inside us. It's also very nice to have that temple be the place that Marcel Duchamp chose to make his own traveling *Box in a Valise* a permanent fixture, contradicting everything one would have thought he would have wanted. When the chips were down, he went for the temple. When it comes to that, between the temple and a power plant, the power plant actually has the word "power" in the name. Clearly, my colleagues are asking themselves how they survive as directors with all the stuff going on, when they've got curatorial souls yearning to be free. One thing that does keep me sane is remembering a very early, very clean quote from Gilbert & George, to the effect that "to be with art is all we ask." I've always imagined it at the top of the steps leading up to the new entrance to the Sainsbury Wing of the National Gallery in London, inscribed right on the marble where, in times past, we would have inscribed the names Rembrandt and so forth.

One thing I do agree with, and I think it was Hans-Ulrich, this morning, who reminded us, is that we have to keep hold of our humility, because we do all tend to talk as if we were facing certain issues or certain problems for the first time, and we also tend to talk as if certain things had never happened before. It's great that Richard Flood, as a former art critic and gallerist, is at the Walker Art

Center. It was a fantastic appointment, but we need to remember that there was Tom Hess at the Met, and there was, before him, Bryson Burroughs, God help us, at the same place. In fact, one real thing that's emerged from this conversation in a wonderful way is that the issue of fluidity among curator, dealer, collector, and critic is very important. I hear Nick say that museum space is not a commercial space; at the same time, I think of spaces I know that one would call commercial spaces, because things were for sale even if nobody bought them, which were just as major spaces to see new art: the Bykert Gallery, for instance.

The world is full of patrons, collectors, and even trustees who ended up with some kind of curatorial voice in a museum, which was not altogether amiss, and, looking back, one could think of a good example, surely not a bad example, in Philadelphia that's useful to revisit. Henry McIlhenny organized seven of the biggest and best exhibitions the museum ever did, before becoming a trustee and then chairman of the board, and then leaving us his entire collection and a large purchase fund. If any one person does all that, the interlinking between collector and curator is great to think about.

We have to make barriers of one kind between various functions and, at the same time, we have to make sure those barriers are somewhat porous, because the worst thing is a hard-and-fast rule that you cannot break when it's to the advantage of the artist or the institution. I should put artists in that mix of fluidity, because, of course, artists are wonderful critics, and artists can be great curators—or they can't, as the case may be. But don't leave them out in this discussion of roles. It's also fun, and Ned has spoken about that eloquently from the point of view of the Menil Collection, which, in my view, represents the ideal. Whether it's the ideal museum, the ideal entity, the ideal whatever, it's an extraordinary and magical place; it's one in which the magic is very real and it's one to which we all aspire. Not the same kind of magic, but some similar kind of effect. Obviously, we're not here to talk today about my great preoccupation, which is the presence of contemporary art in the midst of an encyclopedic art museum—a big, old-fashioned, city encyclopedic art museum that is, on the one hand, very unwieldy and, on the other hand, very rich in the associations and ideas and encounters between the works of art that are there, let alone between the visitors and the works of art, which is what it's all about.

I drive the curators completely crazy—and there are several from Philadelphia in the room, so just close your ears, here she goes again—but one of the great opportunities is to have, for instance, in the same building, a floor apart, two extraordinary paintings about fire. One is Turner's *Burning of the Houses of Parliament* and the other is Cy Twombly's *The Fire That Consumes All Before It,* part of his *Fifty Days at Ilium.* The art history books are horrified, but there is something very stimulating about this juxtaposition. It's why we're continually

bringing artists into encyclopedic museums, to look at them in a very different way than curators do, than educators do, than conservators do, because there are connections we need to make and also that our public might make on its own, and often does, that we don't even see. The presence of contemporary art in a big, old-fashioned, public museum, as I think of ourselves, or the Art Institute of Chicago, or the Met, or Cleveland, it's invaluable, it's invigorating, it's subverting. It also makes every artistic encounter, in a way, more valuable and more pointed, because the living artist's presence, in whatever medium they work, in a big, old-fashioned, art museum, makes the old-fashionedness a bit less and also makes some of the old-fashionedness, perhaps, in a way, more valuable.

One of the issues of temple vs. town square—I'm coming back to that for a moment because it struck me very much—is the question about places that are quiet, places that are noisy, places where there's lots of conversation, and places where there's little—that the temple metaphor shouldn't be all negative. Maybe, we have an immediate aversion to—I don't know if it's a Greek temple or whether it's Chartres, or whatever, but do we have the same feeling about Ryoan-ji and that current exhibition in Philadelphia (which I hope all of you will have a chance to see tomorrow) devoted to a seventeenth-century Japanese artist that feels, in many ways, very contemporary, and has been admired a lot by very contemporary artists. One of the challenges of being a curator in the twenty-first century—Nick talked about it very eloquently—is that we, in a sense, need to go back to the slightly greater fluidity of the past. I was much more boringly educated to end up as a museum director than my father. He never had a lick of art history and I had maybe not enough, but that was my course. His career of twenty-five years at the Museum of Modern Art—with having one of the great art historians standing, I should say, out in front of him, in the person of Alfred Barr—was certainly as flexible and interesting as we would all like our careers to be. The route to directorship is more complicated now. It's not only art historians. People can come in from architecture. In England, they often come from the world of painting, or a world of painting and teaching, that's very different from a museum world. We think we all get to places by more or less the same route, only it's either harder or easier, and that's not true. We get to where we are by a lot of different routes and, as far as I'm concerned, the more routes the better, which is not to say that training in art history is not hugely important. One of the great issues today—maybe less than ten years ago, but it's still a real challenge—is the shying away from object-based education in university art-history departments, wherever they may be—that long influence, whether it's French, whether it's English, or whether it's American, of the "new art history." Wherever it's coming from now, it's still there, and that's one reason why you're casting your nets for new young people to come into

curatorial life in the museum, or into conservation life in the museum, or to education life in the museum. It's sometimes harder to find people because they've just spent five, seven, eight years of their lives doing art history without any reference to works of art at all.

Everyone in the room who is a curator or a director has a huge obligation to try to expand the exposure of people, who might end up working in museums, to objects and to what museums are all about. That comes back to the whole issue of audience and not wanting to second-guess any visitor who walks through the door, whatever age he or she may be, as to what will most interest them and what will not interest them at all. This is one of the great challenges, because it's the unexpected thing that strikes you—which is not a question of the temptation *into* the museum; maybe, in part, that will be the expected thing. You go because you want to see something that particularly connects to your own experience or that you think you're going to hate, so you really want to see it. But, on the way to see that particular work of art, you see something else that actually changes your life, and nobody is going to predict what that may be. So, I thought it very interesting, the whole issue of what you put where as the visitor makes his or her way, particularly in big places like ours where it takes a long time to get from one end of the museum to the other.

I'm also fascinated by the subject of the floating curator, like the floating world in Japan. Curators float a lot, even if they're connected. Theoretically, we've got them rooted in the institution, but floating and moving around the world is terribly important. If they're not attached to an institution at all, that also can be great, because they come zipping into the institution and see it in a way that you've never seen it before. On the other hand, they get out quickly before they're in trouble. The other thing I worry about is this issue, which I've again found in the quote from Pontus Hulten, about permanent collections as energy sources. They certainly should be energy sources for people coming in, coming in from outer space, as they often do, but the real issue for anybody who is a curator in a museum that has a collection is the question of their interest or lack of interest in the place. And by place, I don't mean only the museum but the bigger context—the city, the culture.

There's a bunch of other things I'd love to talk about, but, finally, one of the things that is fascinating—and, again, it's not new—is that museums have always been involved in the history of their cities. That is very interesting to me. If you look at the general population of Minneapolis, you can bet that the Walker's consistent contemporary programming over fifty years has affected what some of those people are like and what they like and what they don't like. You're looking skeptical, but I bet it's true. We'll devise a survey—God help us! Take the museum, or cities where museums are free, as opposed to where you have a big fee to

enter. The degree to which people feel free to wander in and out of a museum for a repeat visit—I can't believe that that doesn't make a difference. Because this is a big challenge for curators. I think it was true—but everytime I say something like that, I rush to deny it myself—that thirty years ago or forty years ago, the curator was much less involved, *needed* to be less involved and *was* less involved, in a lot of things that interact with the larger community, whether it was fund-raising, whether it was talking to city planners and people who were thinking about the city in which they live in a very different way, even perhaps talking with the media. The media have changed enormously since that time. Whether the curators then were having real conversations, as we are now, with donors, or with schools and universities, or with critics, it's a very different kind of conversation than went on thirty or forty years ago. I'm going that far back because we have to get it back before most of the people in this room can remember. Certainly, directors have to do that public interaction all the time. One of the pleasures and one of the agonies of being a director is that there's just not enough time to go around; it takes a huge amount of time connecting with all kinds of wonderful aspects of your community, both in the large sense and, often, in very specific smaller senses, in which your museum exists. I'm sure it's true of New York, even though everybody thinks New York doesn't have communities. It has a lot of communities. As does London or much, much smaller cities.

One of the questions for curators is, how can they be somewhat involved in some of those conversations and still have time to do what they do? Having loved so much being a curator and having loved so much spending a lot of time with art and with artists, the idea of asking somebody who is doing that now to spend less time than I did with art and artists, because they have to spend more time with other aspects of museum life, is tough, but it has to happen. Directors have to make it easier for curators to do this, make it less time-consuming, and, at the same time, we have to protect the curator's time to do what they must do— otherwise, the whole museum falls apart—which is to focus on art. That's the crucial thing, and each of us has said it in a different way. It's "to be with art is what we ask." Well, it's not necessarily all we ask, but it's what we want for everybody who comes through the museum door. If art isn't the central issue for all of us, we're dead.

*[handwritten note: INVOLVED IN COMMUNITY BUT STAY FOCUSSED ON ART]*

**Robert Storr:** I'd love to see that engraved on the cornice of the building.

# PANEL DISCUSSION

**Robert Storr:** I want to ask a few questions to open up conversation here, but I will turn it over to the floor quickly. It won't be as long an exchange as it was for the first round.

One thing I wanted to ask, or sort of throw out, is that the role of the curator, in many cases, is to be what Gertrude Stein called the village explainer—to be the person who tries to make sense of what they do to a variety of constituencies within the museum and outside the domain of museum directors. They have to explain to a different group of people. They have to explain to city governments, if, in fact, as in Philadelphia or London or wherever, there are state interests or city interests, or what have you, involved. They have to explain to trustees, which is the most tender issue, but also the most important, in many ways, not only what it is that they're doing, in general, but what it is that is being done in a particular moment when changes and challenges and reinventions are taking place. I wondered if anyone wants to jump into that heavily mined territory and talk a little bit about how you interpret the overall function and the particular work being done by the curators that you, in a sense, curate.

**Kathy Halbreich:** What worries me a little about conversations such as this is that we set up whole hosts of false dichotomies. We set up a dichotomy that says our central focus is art, and I think our central focus is bifocal. But let's be clear about that. We set up dichotomies between trustees and directors and curators, when, in fact, the healthiest organizations are organic. If directors only spoke to trustees, institutions would be boring places—not because the trustees are boring, but because the conversations need to be multiple. I spend quite a bit of time, it's true, with trustees whom I really like, and I guess it's okay to say that, but I also spend time with high-school principals, I spend time with artists, I spend time with educators, I spend time with designers, I spend time with community activists, I spend time with bunches of people, because I need to take the temperature of where I live as well as the temperature of my institution. It's also because the only thing I have is my curiosity and integrity. Other than that, my days are spent with many people. If I let my curiosity go, it doesn't just take me to trustees.

What I worry about here is casting any one group as evil or as pure. I wonder whether disinterest is the only state or the best state. So, the question that came out to me this morning was this question of the ideal seems to be a disinterested stance in terms of the marketplace, and, yet, I wonder if that's really possible or if it's useful. On the other hand, I'm quite old-fashioned, Anne, in the sense that I don't yet allow corporate logos on the walls of the museum; when people come to the museum, or the art center, and see corporate logos, they're

confused about what's in the gallery and why. It muddies the good part of the disinterest to have those logos up there. Actually, we're trading in visual symbols all the time.

**Ned Rifkin:** How does it muddy it? I don't quite understand what you mean by that?

**K.H.:** Exhibitions aren't advertisements.

**N.R.:** No.

**K.H.:** Once you put a corporate logo on the wall, it's saying, this is endorsed, sanctioned—this is an advertisement for that company.

**N.R.:** So, the name and graphics would be better than . . .

**K.H.:** Yes, it seems to be once removed.

**N.R.:** We've had this conversation.

**K.H.:** I know this is subtle—maybe it doesn't make any sense—and I certainly would enjoy hearing about it.

**N.R.:** What if it's a good logo, well designed?

**K.H.:** I don't know. Like what I was trying to say earlier to Roberta, and I don't think I said it very well, is that—and we might as well get into it, because this is what caused the greatest heat this morning—the role that money plays in our institutions is very complicated. There is a necessity to be very clear with our audiences about how we're supported and who supports us and, perhaps, even why. I'm not really confused by the Armani problem. It is wrong for an institution to do an exhibition on an artist, however broad that definition is, and then accept multiples of millions of dollars from that artist from another hand. It's just too confusing and it's wrong. But that's easy. That's the easiest way to suggest to our publics that commerce has entered the temple. I don't think it's all bad, but I don't yet know exactly where the lines are, and I think it's healthy to talk about it publicly.

**Anne d'Harnoncourt:** It's very healthy. One thing that also complicates it is that the line may be somewhere slightly different in different cases. This always makes everybody uncomfortable, because they love to have (and I'm part of the "they")

a single rule that made a lot of sense—there it was. Maybe the only rule—and maybe that's the least possible rule—is transparency, because with transparency, at least, you know where you are. But, if you look back at the history of exhibitions and who has or hasn't sponsored them, there's almost always somebody who's crazy about an artist's work and owns two or three or more of their things. So, if you can't get a corporate sponsor, you say, please, we've got to do a show of X and we know you love X, won't you help us? It's a tricky situation, and that may be an extreme case, but there are all kinds of gradations of that. Does it make it less problematic if the value is not very high? For instance, if somebody is a passionate collector of a certain kind of thing that doesn't have a big monetary value, but they think they're just extraordinary and they know a huge amount about them, and they give you money to do that exhibition? The transparency issue is one aspect of how one might answer that.

I hear your statement about the Armani show and the millions of dollars, but what if it were an artist, and that artist gave you millions of dollars of their works of art after the exhibition? At the moment, they don't get a tax deduction for that, but that's kind of a crime.

**N.R.:** The Menil has a Cy Twombly gallery, and he's the major patron in donating works of art, by comparison to anyone else. He's probably our second largest patron. I say that aloud, but that's not a bad thing, if you see the result. It's perfectly wonderful.

**A.d'H.:** As long as you're saying, I'd love a Twombly gallery and not an X gallery.

**N.R.:** That's right.

**A.d'H.:** Mr. X or Ms. X can't make you take X things because they're giving you X dollars.

**N.R.:** Right.

**Nicholas Serota:** But it comes back to a question of the sequence of these things . . .

**N.R.:** Yes, sure.

**N.S.:** . . . and also, ultimately, the responsibility of both curators and directors for drawing attention to their boards of trustees or their governing bodies to the issues at stake. The Tate is in the rather fortunate position of having a board of trustees that is composed in a rather different way from most American boards, in

that they're all appointed by the Prime Minister. Three of them are, by statute, artists. It might be thought that there was a conflict of interest, but, in my experience, the presence of the artists on the board is a very, very powerful force that ensures that some of these positions of conflict are exposed and discussed.

**R.S.:** Could you say a little more about that? That doesn't exist in America, and it is perceived as possibly a conflict of interest, although I think Chuck Close, now, is on some kind of advisory commission at the Whitney.

**A.d'H.:** He's a trustee, I think.

**R.S.:** Is he actually a trustee now?

**A.d'H.:** I think so.

**R.S.:** But this is a new thing, and I wondered if you could say a little bit about how it does work, and what the nature of the contribution is, and the limits of the tenure.

**N.S.:** In my experience, it seems to work best when the artist concerned is between the age of, roughly, thirty-five and fifty-five, fifty. That is to say, they are artists of some standing but not canonized as yet, or, at least, not in the eyes of other trustees. What that provides is an authentic voice for artists, but also a view of what is happening both from the younger generation and from an older generation, which is not yet so powerful as to intimidate the "lay" trustees from expressing a view. There were times in the past—for instance, when Tony Caro became a trustee rather late—when he expressed a view, everyone followed his lead and said, well, if Tony thinks it's not a great Picasso, then we couldn't possibly have it.

Artist-trustees have played a big part in helping to shape Tate Modern. Artists were closely involved in the selection of architect and, indeed, in the development of the design. Artists also play a role in guiding the educational, and, to some extent, even the moral purpose of the institution. I wouldn't go so far as to say they're the moral conscience, but they, undoubtedly, will remind some of the trustees who come from other worlds, including corporate finance and, that the rules in our world are not necessarily the same in theirs.

**R.S.:** Since the marketing issue is still there a little bit, and since you raised it and it's connected to the other issue of fund-raising and so on, there's a body of criticism that speaks about museums almost offhandedly as part of the culture

industry. There's also the tendency of newspapers to list what we do in the "arts, leisure, and entertainment" sections. There's an overall perception that we are somehow driven by these marketing imperatives to the exclusion of almost everything else, or, if not to the exclusion of everything else, then in such ways that we are implicitly always compromised. I wondered how you view the actual predicament, and has it changed in recent years? And, two, how does one undo some of those perceptions in order to get to a place where, in a sense, transparency really is read as such?

**K.H.:** Some days, I think we have done this to ourselves by quoting statistics— more people go to cultural events than sports. So what?

**N.R.:** It's very misleading anyway.

**K.H.:** What does that mean? Do they have a different experience? Do they have the same experience? Do they have different food? How much time do they spend there? If you start to think—and I think about the language I use to sell my institution all the time—it's very easy to accept the corporate model as the appropriate model for a cultural institution. We should be well run, all those things, but I don't think we're corporations.

Getting back to Peter's earlier question, what's the difference between what we do and an entertainment center? We're asking people to consume something very different. It's still about consumption, on some level, but, I often say, is it possible, for instance, with the teenager—where we focus so much energy on increasing the teen's engagement with the Walker—what am I trying to do? It's the time of life when somebody is actually beginning to consume culture; that's part of what the teenager's life is about. Is it possible to, if not replace the sneaker, add something to the sneaker's appeal? If you think about what our institutions are supposed to be about—again, not the status quo—that's exactly what's going on in a sixteen-year-old's mind. How can I be subversive? What difference do I make? Who wants to listen to me anyway? These questions are not that different from those artists ask, so it's a natural link to make. We need to think of ourselves as civic organizations, not corporate ones. I say that, recognizing I'm in a really luxurious position. I have a huge endowment. I have a very supportive community, and, after nine and a half years, I have a board that really trusts me and a community that actually knows the things that I started out saying I wanted to do basically still exist, almost ten years later. So, it's very easy for me. On the other hand, I don't want to pretend. It's easy to say we shouldn't be corporate, and then it's harder to know whose money to take and not take. I know, for instance, that Bob Gober is going to be in the U.S. pavilion this summer,

representing the United States at the Venice Biennale. He decided not to have either of the sponsoring institutions, the Art Institute of Chicago or the Hirshhorn, seek corporate funding for the pavilion. I think that's terrific. He has made a portfolio, which he will ask individuals to acquire, of his works that will go toward the sponsorship. Now, it is possible that one of the ten people who will buy these portfolios is a corrupt and horrible person.

**N.R.:** Then there's pure corruption, a form of purity.

**K.H.:** I was trying to get away from dichotomy.

**N.R.:** That's why I brought it up. Someone once told me all money is dirty, whether it's corporate or otherwise. I'm a little troubled by that. Do you invest in the stock market? Is that a corrupt thing to do? I'd also like to make sure we don't get away from how we differentiate ourselves from the corporations and entertainment industries—and that is to slow people down, to get people into an opportunity to reflect in depth, in time. We talked about time this morning on the other panel, and that sense of enhanced absorption is what museums are about. If corporations are willing to sponsor that, then I say great. But who sets the agenda is the key, and what they're buying and what you're trading is the question. How many parties does it take to make it . . .

**K.H.:** Does the public know who set the agenda?

**N.R.:** If you tell them.

**K.H.:** You tell them, read this along with the corporate logo.

**N.R.:** The corporate logo, yes.

**K.H.:** We say, by the way, the curator came to the director first, and then we found a corporation.

**N.R.:** My only objection to your logo thing is, a logo is much more succinct than writing it out. It's the same information as far as I'm concerned.

**A.d'H.:** I totally agree that museums are not corporations. They are civic organizations. The reason my emphasis on the art side of things was not to the disadvantage of the audience side is that the audience that we attract is an audience for art. That's what I really meant—not an audience for something else. I'm using

art in a very broad sense to include all the arts that each of us may show. The worry of having a corporate sponsor could easily be extended to each individual that might fund an exhibition or the museum as a whole, to the board of trustees, to some—the Tate has this in part—that are funded directly through the treasury of the country. That happens in England and it still happens in France. Unless you disagree violently with the policy of the country on a particular issue, which you could well do, depending on the country, that money is, at least, coming through so many sources that it's kind of purified, to some degree. It does depend on whether the corporation has such a very clear agenda, in terms of sponsoring something, that you really do worry. One example would be Philip Morris sponsoring an exhibition going to China, where so many people still smoke. That worries people in a very specific way.

**K.H.:** What do you do in that situation, though?

**A.d'H.:** I have no idea what I would have done; that's not a situation I've yet faced in that way. Artists certainly have made the decision, as in the case of Bob Gober, that they don't want to be supported by any corporation.

**K.H.:** Adrian Piper at MOCA faced this issue, didn't she?

**A.d'H.:** You examine it with each individual corporation and you could have a different effect, but the same is true to a considerable degree for individuals. It's the responsibility of each institution to look at the situation very carefully and try to make the best decision it can, rather than to have an absolute rule. It's certainly easier to do if you can afford to do it, rather than if you can't. That, of course, is hard as well; it puts the greatest pressure on the places with the least resources.

**N.R.:** That's a good point.

**N.S.:** It puts, obviously, a huge pressure on institutions to make the blockbuster show, to take the corporate money, to squeeze the contemporary art to the margin, and, essentially, not to deal with the more difficult kinds of exhibitions and the more problematic ones. Tate is in a fortunate position of, as you say, receiving government money—rather less in proportion to our overall expenditure, which was the case ten years ago, and much less than we would wish, but we do get public money—and that money is there and is used very much to support the contemporary parts of the program. But, as that money diminishes, there's a tendency, obviously, for us to find ourselves doing more and more shows of a certain kind. That can knock in with other pressures to do with corporate giving,

large admission numbers, membership, all these other factors. How do we resist?

**K.H.:** How do you buffer your institution from these kinds of pressures?

**N.S.:** We buffer by setting a frame for each year, and saying we will only do one show of that kind, however difficult that may be. We could fill a whole program with those shows every year.

**K.H.:** Which show of which kind?

**N.S.:** The blockbuster.

**K.H.:** Okay.

**R.S.:** Can I ask another question about the art part, but on the collecting side? There have been moments in American museums where almost any city you went to—thanks, in part, to very skillful dealers—who should not be sneered at, because they truly were skillful dealers, had pretty much the same list of artists. The factors around that had to do with the genuine interest in these artists. It had to do with passions of collectors. It had to do, again, with the industry of the people selling this art. But, now, it's increasingly apparent that the range of things that we're confronting is such that we can't do this any longer. Museums, for instance, buying the Beuys acquisition, it's a specialized decision. There are things I would dearly love, but I can't buy them even though they fit perfectly into some history of art that we've already developed to a certain point. How do you, in a directorial position, manage the priorities that curators bring to you, assuming that the curators are the ones who make many, if not most, of the selections and encourage the particular choices?

**N.R.:** It's different in each museum, though.

**R.S.:** I assume so; that's why I was asking.

**N.R.:** The Menil is going to continue to collect according to a certain—what should I call it?—the collection already sets the tone. We're probably not going to collect in prehistoric and tribal arts anymore; in the area of contemporary art, certainly we will, but it's going to be within the sphere of how we begin to define that. Other museums I've worked in have different parameters, but my experience, both as a curator and as a director, is that there's always a collaborative dialogue, and that dialogue is a refining dialogue that, ultimately, defines

those parameters. I don't know how else to say it. It's different in each place.

**K.H.:** We have a mission. Under the mission, we have a section that deals with the collection and where it's long-term focus should be. Then, beyond that, each year, we have an acquisition plan that leaves ample room for serendipity, but has very targeted research goals as well as acquisition goals—and that's one area that I haven't delegated. I am in there with the curators, although it's clear that there is work that I don't see that is very important to them, that should be acquired. In the same sense, there's work I don't like that is very important for us to collect, because nobody dies when you make a certain acquisition. It means that the collection sings with many voices and, ultimately, that's what we are talking about today as well. I don't think there's a science to it, but it's one of the major things we do, because people perceive it to be that way, too. We're saying an exhibition is up for three months, the catalog stays in our basement for nineteen years, yet the collection is supposed to be forever, on some level. It requires a different kind of time than other decisions, longer time.

**N.S.:** We will have to train ourselves and our trustees and our audiences to recognize that museums are going to have to become more particular. Even the supposed encyclopedic museums, such as the Museum of Modern Art, in New York, or even the Tate or Pompidou, can no longer and, indeed, should no longer pretend that they are trying to collect across the whole range. They will need to focus. Then, they will need to collaborate with others in exchanging works that will, otherwise, spend fifty percent, and more often ninety percent of their lives in storage.

**K.H.:** By the way, this year we bought a work of art with another museum. We bought the last Matthew Barney *Cremaster* installation that he made, which we helped commission. It took up 2,500 square feet of gallery space. It dawned on us that it was ridiculous, even if we could have afforded to own it all ourselves, because, again, the public doesn't give a rip whether the Walker owns it or SFMOMA owns it. Now, the piece is owned by SFMOMA and the Walker, and increasingly . . .

**N.S.:** We've done that.

**K.H.:** It wasn't a big issue in our institution, but I could see it being a big issue, like authorship, ownership, or even atomizing notions of ownership—and that's healthy.

**N.R.:** Which brings up the whole subject of collaboration, which we haven't even gotten into yet, and the co-organization, but, now, also moving into collection management. It's going to be much more complicated in the future if this model takes.

**K.H.:** We are like dinosaurs when it comes to partnership. If you look, again, at the Internet as a potential model for a lot of different ways of operating, or you look at corporations—and it blows my mind that the major car companies now have a website where they're buying their materials collectively—this is a major change in the behavior of corporations. We have not gotten to that point progressively. We're still very territorial, usually, even those of us who are friends.

**A.d'H.:** One more note on acquisitions. It's much more appropriate to some museums and cities than others to try to think, where possible, across the city as a whole, with a view to opportunities that arise and a view to gaps. It's not only the issue of lending, perhaps, whole chunks of collections that are in one place that have a great many of certain kinds of work and could make do with a smaller group—and we've certainly begun to do that a fair amount, and so have other institutions. But, also, not to jump squarely into the great strength of another institution in town, such as the Pennsylvania Academy of the Fine Arts, which we're sitting in. It has fabulous long suits in some areas and short suits in others, as does the Philadelphia Museum, and vice versa. The contemporary issue for us is harder, simply because we have eight competing departments of very different natures, of very different strengths. Yet, it's the way the whole comes together. I may be idiotic enough to still think that we can be read, to some degree, as a whole or, at least at the Philadelphia Museum of Art, as having great strengths in various areas. For example, Thomas Eakins over here and Marcel Duchamp over there have a lot to say to each other—and, indeed, there are some artists in Philadelphia who are, clearly, very affected by their encounters with both of those artists. So, there we probably have to pick and choose and jump on serendipity even more than the rest of you, partly because of limited funds and partly because of the great range of opportunities we should be able to take advantage of.

**R.S.:** I have one last question, and I'll open it to the floor. In the eighties phase of the culture war in this country, there was a lot of discussion and a lot of unhappiness about the fact that the large institutions did not go to the defense of the smaller institutions who were, in fact, showing the controversial, difficult art that the large institutions started to buy ten years later. In the most recent incident, which was in Brooklyn, the large institutions—and some small ones, and some

that weren't even art museums but were science museums, and so on—did, in fact, rally around. It took days for people to discuss this, because their vulnerabilities were all very different. Nonetheless, they did rally to the defense of that show, despite the fact that many of the people involved had dissatisfaction with the show, but the principle of free expression was something they understood. Could you say anything about how you see the big institutions in that kind of specifically political defense, where the small institutions don't get rolled under.

**N.R.:** In general, part of the director's role, but also the curator's in that kind of partnership, is—the word hasn't been used—advocacy. It is not just educating people but advocating for certain moral, aesthetic, and even social, and, sometimes, political perspectives. As community leaders, it's embedded in our roles, and it has to happen. If it doesn't happen, then no one shows up, as you've indicated before. I'm a smaller institution—I'm sort of third tier, as it were, in Houston—but the role is just as important. Whether they want to hear it or not, you have a moral obligation.

**N.S.:** I have no doubt at all that the success of Tate Modern has given Tate as a whole a slightly more powerful voice within the body politic. We will need to use this voice to defend, to support, and to sustain smaller institutions, not just in London but around the country.

**R.S.:** Okay-doke, I've said my piece. They have more to say. Please.

**K.H.:** Some big institutions did get in trouble during the cultural wars.

**R.S.:** Oh, yes, I know, I know.

**K.H.:** And are still lonely.

**R.S.:** I know.

# AUDIENCE QUESTION AND ANSWER

 **Nicholas Baume:** I'm from the Wadsworth Atheneum, which is actually a museum so old that they didn't have the word when it was inaugurated. Last year, we changed our name to the Wadsworth Atheneum Museum of Art because nobody, the theory goes, knows what an atheneum is. It was interesting to find, in Kathy's presentation, an idea of the museum as an integrated cultural experience that combines these different art forms in ways that, perhaps, are truer to the way that artists think and realize them, that actually harks back to the model of an atheneum that contains spaces for the exhibition of works of art, for the preservation of history, for libraries, for performance, for readings. Maybe this is another motif that, in looking back at our history, we've rediscovered—models for practice that we now think of, or, perhaps, already cast, as innovative.

Against that, I'm particularly interested in bringing that back to the question of the role of the curator and to think about a couple of the comments that were made. Nick, for instance, was saying that the reading of the curator should be foremost, but, at the same time, that that reading needs to be most closely informed by a dialogue with the artist. I'm not sure. Maybe the details of that comparison are something you could elaborate on further. It reminded me, in another way, of a comment this morning that Rob made that also was critical of the idea of the auteur curator—but, at the same time, insisted on the need of the curator to control everything in terms of the projection of exhibitions. And to do that in a context where, at the same time, we're recognizing that the museum is changing, in a way becoming more specialized, as Nick said, but also becoming more integrated, as Kathy's model showed, and, in doing so, recognizing the importance of other professionals and colleagues who can contribute in ways that we as curators can't. My question is about how this new model, which may also relate to older models, implicates for questions of curatorial practice.

**Kathy Halbreich:** I didn't agree with what Rob said, in the sense that the curator controls it all. For instance, I don't think the curator, necessarily, is trained in graphic design. We have a design studio, and the designers work closely with the curators and the artists. It's kind of hackneyed, but it requires teams of people who are mutually respectful rather than a hierarchy of points of view. It's possible even to do an exhibition that's based on the audience's frame of reference— maybe not everyone—but it's certainly possible to do that, and it should be done.

Rather than the professionally trained curator, you invite people who aren't professionally trained to make some of the decisions, to shape some of the questions, and even to tell us what's good.

**Anne d'Harnoncourt:** I also think the issue of signing labels is a fascinating one. Not to go on at great length, but some of the best labels—and I'm a very biased reader—I've ever read were essentially the result of three perspectives: a conservator, a curator, an educator. They don't sound like three people; they give you a terrific kind of buzz about the object you're looking at.

Museums always struggle with the whole situation of the star problem, the star curator doing this or that or the other. Maybe the curators don't mostly feel like stars, they feel like underpaid drudges, and I certainly understand that side of life; on the other hand, if you sign all the labels in the museum, that means a huge fight as to how many names are going to be on that label. It also could mean that there are a lot of voices that are, oddly enough, suppressed by that process.

**Ned Rifkin:** Wouldn't it be amazing if you had opposing points of view on a label?

**Dave Hickey:** I have a real specific question that I would like an answer to. What is the position of your institutions on anonymous donations? The reason I ask this, if any are anonymous, all could be anonymous, and we would be saved the fantasy that announcing donations is not advertising. I don't know a museum that doesn't accept anonymous donations. What I'm saying is, the alternative to total transparency might be ethical opacity. I'd be interested to know the position of your museums on anonymous donations, and if you take both anonymous and announced donations.

**K.H.:** We take both, but we will not take anonymous donations to exhibitions from somebody whose work is in that exhibition.

**A.d'H.:** We certainly take both, and I don't think we do what Kathy doesn't do, but I'd love to be sure. I'd like to be just as pure as Kathy, but my memory is not as good; but I don't think so.

**K.H.:** It just came up; that's why I know it.

**A.d'H.:** There are also, certainly, issues of gifts of works of art, as well as gifts of funds to purchase works of art, as well as gifts for exhibitions. In each category, the question might be slightly different, and people's reasons for anonymity are different. Whether a corporation would ever give anything anonymously is a question.

**N.R.:** Yea, right.

**A.d'H.:** But some might.

**N.R.:** I don't think it's a question.

**K.H.:** I don't think it is.

**A.d'H.:** Oh, sure.

**N.R.:** Yea?

**A.d'H.:** Sure.

**N.R.:** I don't know the answer, Dave, in the case of the Menil. I don't think it's ever come up other than on a work of art. The one thing I will tell you is that I asked, when the work of art was given anonymously, didn't we need to know who it was? We weren't even being told who it was ourselves, as opposed to the public display of that credit.

**N.S.:** We basically have a rule that it can be anonymous, but it cannot be anonymous from the board.

**Peter Plagens:** It would seem commonsensical that if money were given by corporations, and there were a hundred museums in the city, and there were Joe's museum and Fred's museum and so forth, it wouldn't carry quite the kind of gravity that it does; even if you aren't a monopoly in your given city, you have a kind of imprimatur—the *Philadelphia* Museum of Art, and Walker is, in effect, the *Minneapolis* Museum of Modern Art, etc.

One issue that hasn't been talked about, if you can touch on it lightly, is the business of how the elephant turns around without leaving footprints. In other words, in everything you do, you make art history and you give an imprimatur to things. Every time you have a group show, every time you have that town square, no matter how diverse and temporary you make it, there is a stamping of impor-tance, which is one of the reasons why the corporate funding gets so heavy. Could you talk just a little bit about the business that every time you move, you make art history, rather than just record it and house it and show it?

**A.d'H.:** That's why it's great that there are lots of museums, because there's lots of variety of art history being made, if that's the question.

How does an elephant turn around without leaving any footprints? Either very carefully or it gets a balloon to lift it up; I don't know. Obviously, what institutions do makes a difference, and each of us tries in our own way to make that difference be a productive one. There will be minefields; each decision you make could have difficult repercussions. You try to see as many repercussions as you can, and then do the most positive thing for the mission of your institution, under the circumstances.

That's a mealymouthed answer, but every institution has a particular kind of power, and, no matter how small, if it does what it does really well, that institution is, clearly, going to be something that people watch—for exactly how it does it and what money it accepts and all kinds of things. I don't think it's a question that only pertains to the big ones, but the big ones have to pay a price for their visibility, which is a good price.

**N.S.:** It's a very beautiful object, but there's nothing worse than an elephant that is asleep in its field, and an elephant, Peter, that is asleep doesn't leave footprints. And so, as Anne says, you have to move with care, and you have to be aware of what you're doing. You need to make sure you don't stand on and crush too many other people. We need to move with care. But if you don't move, you are, by definition, asleep or dead.

**K.H.:** This probably is characterological, maybe it's gender-related; I don't know. I don't think about my life like that every day, or the lives of the people I work with every day. I don't think about us making history. I've tried to think of us making meaning. What institutions are, primarily, is a congregation of individuals with very, I hope, diverse passions. My job, in a funny way, is, again, to make sure that all of those passions have a place, but that there's some overall eccentric balance in it. I know I'm getting old and I'm getting fat, but I don't think of myself as an elephant yet. If you think about your footprints, as Nick says, you become slow.

**N.S.:** Peter, the other thing is, there are lots of elephants that move without making history.

**P.P.:** But you know it makes a difference . . . [INAUDIBLE] . . . if the Philadelphia Museum of Art shows an artist rather than X institution, there's something that has to be relative to the perception of that artist contemporaneously in our history, etc., etc., etc., and it can't be helped. I don't think there's any harm in being constructively self-conscious. I was asking what you do about it, not trying to indicate what you should do.

**A.d'H.:** You do what you believe in, with due consideration. You just keep moving, and you hope you've made terrific decisions.

**N.S.:** Peter, let me go back to when I was talking about moving and not standing on other people. For an institution like the Tate, which sits in a city where there are a number of other institutions also concerned with contemporary art, it is a matter of concern for us that we shouldn't take all the opportunities. I can remember a time when I was at the Whitechapel and there were moments I wanted to do a show and was told, "Oh, Tate is going to do a show." Indeed, I even remember an occasion when there was a show that was committed to the Whitechapel, which was then canceled by the artist in the belief that the Tate was about to offer him an exhibition. I never was quite sure whether I was pleased or sorry that the show never took place. We need to be careful and thoughtful about not taking opportunities for ourselves that can be better discharged by others.

**K.H.:** Here's the other thing, too. I've always been surprised that big institutions are so lumbering, because, in a certain sense, we're so much better protected than the smaller institutions that we should use that responsibility to be less safe, to be more searching, to be less blockbuster-oriented. I hope I haven't suggested a kind of purity, because I thought I indicated I was very confused about a lot of this, but I do think that, as a big institution, I can and must be more experimental, more inclusive, do better research, and all those things. On the other hand, I also believe—having been through major controversies in the culture wars when, finally, all I could say was look, nobody's got a gun here—we're talking about values. This is very dangerous to people. But we should be dangerous sometimes.

 **Danielle Rice:** I'm curator of education at the Philadelphia Museum of Art. I want to shift the discussion a little more in this area of public responsibility. To me, as director of an education department, one of the biggest challenges that we face is, who gets to represent the voice of the public within the institution? It's probably one of the main causes of tension within most museums—that any number of different departments feel that they represent the public the best. Inevitably, all of us who work in museums probably take ourselves as the primary audience—curators do that, but educators do that as well—and one of the biggest challenges today is not to do that. I would like to hear some solutions to this problem of inner tensions within the institution: Who gets to be the one who says, this is the public for this particular exhibition, this is the public that we speak to, and here is what they look like?

**N.R.:** The first way to do that is to find out who they are when they're there. The question that's more difficult is, who are the people who are not there, and how do you find out how to represent the potential audience that isn't now coming to an institution? I don't know how to do that, quite honestly, except from demographic studies of who is there, and then making an effort to engage the audiences who aren't there through various strategies.

**K.H.:** But isn't your question about internal politics and conversation, too?

**D.R.:** Yes, it was. Ours is a large institution. One of the things that's happened in recent years, it seems to me, is that curatorial departments have largely stayed the same while other branches of the museum, which supposedly represent the public, have expanded. For instance, the curatorial staff is very much the same in the Philadelphia Museum of Art as it was fifteen years ago when I started working there, but we have entire departments that didn't exist: visitor's services, marketing, and P.R. Development is way larger than it was—education has grown spectacularly in this time, too—and each one of these departments feels that they represent the public.

**K.H.:** Oh, I think they do. The trick is to get all of the "theys" focused on the mission.

This is a simple way of explaining it. When I got to the Walker, there used to be curatorial meetings. Actually, that meant only the visual arts curator, because the head of performing arts was called the director and the head of film-video was called the director. I went to them and said, you guys do the same things that the guys over there do; could we change the title to curator? Yes. Then, we had curators' meetings, where all the curatorial departments were represented. I looked around after a while and realized there were huge numbers of other people with expertise who weren't at the table. Now, we have program meetings, and educators are there and P.R. people are there and, occasionally, development. They don't come that much. But that's okay; you're meeting people to death, too. I always thought it was odd that public relations and audience development—that's the name of that department—didn't talk to education when, in fact, they're involved in the same thing, from different areas of expertise.

So, that's what we do. When we look at an exhibition or when we look at a program in performing arts, we're trying to find crossovers among all the curatorial departments, but we're also trying to find a strategy. We have a program sheet; after the curator presents the exhibition, we try and figure out who the audiences are and how we can reach them. Sometimes, that means reaching them through films, or through marketing, or through lots of different ways. We have

to break the silos down internally. You must be doing something like that, too.

**Robert Storr.:** Roberta wanted to ask something.

**Roberta Smith:** I'm going to take the conversation back again to Peter's comment. What you're saying presupposes a kind of institutional infallibility about how every time a museum moves, it makes history.

**K.H.:** No, I was saying I didn't believe that that's what we were doing.

**R.Sm.:** Okay, fine.

**K.H.:** I asked Peter if he was sure that's what we were doing.

**R.Sm.:** I mean, it's—okay.

**K.H.:** I, personally, don't think that's what we're doing, but that's what I tried to say. I don't know what you were trying to say.

**R.S.:** There's good history and bad history. I wondered if any of the curators who spoke this morning have things they would like to bring to the discussion now. Paul?

**Paul Schimmel:** I'd like to make a comment about corporate support for contemporary art. From my standpoint, there just isn't enough of it. We're running around trying to get corporations on a regular basis to support our exhibitions, and on a regular basis they say no. There are times when corporations come to us with their ideas, and we probably say no more often than they say it to us. But I have a question for all of you. MOCA has a policy where we don't show private collections unless the collector has made a very significant gift to the museum of works from that collection that we're going to show. There's no hard-and-fast rule, but it has to be significant. I'm wondering what your institutional policies are with regard to showing private collections.

**N.R.:** I can tell you from my previous jobs—no, no, no, not the Menil, but in Atlanta—the institution requires a major gift from that collector, from that collection that's being shown, in advance of any kind of commitment on the institution's part. I don't think it's even relevant to the Menil, unfortunately, as a lot of this isn't.

**K.H.:** It might be some day.

**N.R.:** It might be some day, yes, but not for the moment.

**N.S.:** We have a simple policy, which is not to show private collections unless they are already committed to the Tate.

**K.H.:** All of it?

**N.S.:** No, not all of it.

**K.H.:** How much of it?

**R.S.:** The Modern's policy is that it has to be a preponderance of it. It's not just one token great thing and then you show dozens of others. The gift has to be the heart of the private collection.

**A.d'H.:** Our policy has been the same, either to have a commitment of the entire collection or some significant group of things. I'll just say, interestingly, that, to some extent—and very sadly and, maybe, just as well, but maybe also not—the policy, which makes a great deal of sense to me, has therefore meant that the public did not see some absolutely staggering private collections—like Bill Copley's collection, for instance, of which the only record is an auction catalog. The same could be said to be true for a couple of others. The very reason that museums don't show private collections is because they're afraid of being accused of increasing the value of something, which is certainly a risk and can happen.

I don't know how many of you knew Bill Copley or his collection, but it was one of the most extraordinary collections of surrealist art anywhere in the world. He was an artist who collected his works by running a gallery in Los Angeles and showing such surrealists as Magritte. Nobody bought anything, so he ended up with them all. He decided to change his life altogether after a divorce, and he sold it all. I still regret that no museum did a show of it.

**R.S.:** I remember seeing a show at Sotheby's when they put it up. It was amazing.

**N.S.:** Even so, this is not quite as hard-and-fast as we're suggesting, because all these institutions will take loans of single objects from private collections. Our rule is, simply, that we will not showcase a private collection.

**R.S.:** We have a rule that we don't show in collection galleries things on loan. I remember when Leo Castelli offered us a Roy Lichtenstein painting, we said thank you very much, but we cannot do this because we cannot break that line.

**K.H.:** We don't have a policy. We've had a lot of discussion about it. If I look back at the history of the Walker, there have been exhibitions of private collections that I'm sure were sterling exhibitions, and I'm not sure that any gift was left behind. One of the things that's interesting to me about this conversation is, as I've talked to people outside of the art world and said, the museum world thinks that the smartest thing to do is not show a private collector's work unless they give you something, they think that's graft. We think it's absolutely pure, and people outside the art world say, you mean it's okay because they give it to you; they pay you. This is why I say to you that I'm really confused about this. I try to think of myself as an ethical person, but it's confusing. I don't think it's as simple as I wish it were.

**R.S.:** But, in those cases, proportions do matter; it's not a token gift, it is a real donation, and it makes a lot of difference.

**K.H.:** I understand, because we're speaking the same language. But if you go down and ask the man on the street if it makes it any better . . .

**R.S.:** The statement isn't sufficient to the case, is all I'm saying. If you're talking about transparency, then you have to be transparent and say, this is a situation in which we would, this is a situation in which we wouldn't.

**K.H.:** We, by the way, have an exhibition up now that is called "The Cities Collect," drawn from sixty-two private collections in the Twin Cities. We did think about whether this was kosher to do. I thought, finally, it's ridiculous not to do it, not to have the curators out in the community meeting new people, engaging them in the conversation about the culture in which we live, why they bought things, when they bought them, how influential the various institutions were to their collecting habits—to encourage them and others to see this as a legal addiction. They could benefit all of us in the long term. If I'd been absolutely purist about it, I would have had to ask each of those sixty-two people to give me something before I could show the work. I will say, it's an exhibition that has made people quite proud of the place in which they live.

**D.H.:** I just had an observation vis-à-vis Peter's remark about the elephant. What we all have to recognize, especially when you're showing very young and unrecognized artists if you are a major institution, that the real elephant issue is about the elephant in the rose garden. The younger and less well known the artist you're showing is, the more catastrophic the financial effect, the market effect, of the work is. Large institutions, quite rightly, tend to be nervous about showing

very young artists, because you really do drive a train through a delicate garden when you start doing that.

**K.H.:** I'm not convinced that showing a young artist in Minneapolis drives that artist's career. I think it does if you show them at the Museum of Modern Art . . .

**N.S.:** To a degree.

**K.H.:** Yes, but it's not a stampede.

**D.H.:** For a very young artist, it is, though.

**R.S.:** But, nowadays, frankly—although there's undoubtedly an imprimatur that's given by a museum like the Modern—the truth of the fact is, in an awful lot of cases we're talking about, an entire show has been presold by a dealer, who's hyped it to such a point that nothing we could do would rival that in terms of trampling the garden.

**D.H.:** Because you were showing it.

**R.S.:** No, no, I'm saying before. Very often, these things are coming to shows after they've been dispersed to the world. It's the activity of the gallery that makes these people incredibly famous.

**D.H.:** Yea, right.

**R.S.:** No, really. You can't have it both ways. If we're always late, but then, also, too early, I'm not quite getting it.

**D.H.:** Better to be late, I think.

**R.S.:** Yea. Roberta?

**R.Sm.:** I need to ask my question about institutional infallibility again. Everyone makes so many mistakes, and you are ascribing this immense power of the institution to control everyone's faults. In a way, what you're saying is that art doesn't have that much power, and it's all being manipulated by the museum. I am taking the implications to the furthest degree.

**R.S.:** Can I just say you don't need to take it that far? Alfred Barr's rule of thumb

was that seven out of ten things bought by museum curators of his day were likely to not stand the test of time, or, at least, not stand in very high positions after a test of time. He was quite comfortable with that ratio, and he was, in fact, encouraging people to risk real failures in order that they get that thirty percent right. One of the things that's been interesting about these shows we've done recently—there are all kinds of problems within them, not all of them succeed—but one of the interesting things is, when you bring some of that stuff out, remarkably some of it freshens up, and even before we decided what was on the floor. For one particular exhibition, I brought up three times as much work as what we hung on the wall or installed on the floor. I wanted to see whether these things would look good or not, because you can't tell when you see them in the tills, or when you see them in horrible light, or whatever. Bring this thing back up to the floor and see if it can breathe. But it's precisely not about infallibility; it's about a high level of fallibility matched off against the chance to do something really significant by following the sort of iffy cases.

**D.H.:** There are real issues involved here. Museums can, quite literally, lose their imprimatur completely. I can remember being somewhere in New York and having a kid say, well, I just sold a piece to the Whitney, and to have his friend say, yea, well I have a Visa card. In other words, what I'm saying is, these are real issues. The imprimatur of the museum is important and does need to be maintained by some kind of public confirmation.

**R.S.:** Just in terms of the Modern, we have one other policy. We do not sell works by living artists unless it is to buy a superior work by that artist, and we try to avoid that as well. So that, as long as the artist is producing and alive and kicking, what we do in one choice should not then be retracted or revised in a way that's destructive.

**K.H.:** We are fallible. I've tried to say that in many, many ways, and I think it makes us stronger. But we have different degrees of power as institutions, and part of that is history, part of that is place, and part of that is the usual stuff that goes with talent.

**Terry Myers:** This conversation is leading me to the bigger issue—not in terms of museums or galleries but speaking as someone who has been teaching in art schools. One of the things that frustrates me the most about what's going on is this false notion of professionalism, and oh, my God, you cannot make a mistake. To be in a graduate student's studio is to feel this fear—that they have to lock themselves in place because all the other graduate students around them are

looking at what they're doing. Heaven forbid, they make something in their studio that literally or figuratively falls apart, that they make a mistake. If I walk in there and say, you should be screwing up every day, they look at me like I'm an idiot. But this is a bigger issue in terms of the whole system that we put into place.

**K.H.:** Museums play quite a small role in that. Maybe I'm wrong, but where most of the young folks are now looking is toward dealers and collectors.

**T.M.:** Kathy, it's very cool to show at the Walker, for instance, "Let's Entertain." For a young artist, the Walker probably now is better than MoMA. These things rise and fall. I worked at the Museum of Modern Art, I adore the Museum of Modern Art, but the fact is, these things are . . .

**K.H.:** It may be cool, but I still think that the driving force today for young artists—and I'm not sure it's good—is, as I said, the dealer and the collector.

**T.M.:** I agree, but I would put the museum slightly higher.

**N.R.:** Don't leave the teacher out of this. God knows, you're talking about students, and part of the problem is that nobody's really looked at the art school that hard yet. It's a real problem.

**R.S.:** I do a lot of visiting artist's gigs, and I taught painting for ten years. There are certain people who do the circuit and they, basically, teach career strategy. It's a huge problem. That is also subject to institutional critique, but it's a different institution. Our contribution to this problem is real, but it's nothing like the recently famous artist who collects a lot of paychecks going around telling other artists how to get famous, too.

**Catherine Lampert:** Just as dangerous as worrying about fallibility is the force of conformism. Museums, historically, if you look at their collections, are extremely conformist. The more you see other people's collections, the more it brainwashes. It's important that it's not just a question of having an orthodox collection and a little bit of regionalism but being really interested in a variety of things, not everything. I agree with Nick that a museum is unlikely to be good in every subject, but should be a little adventurous in picking some subjects that are not on your doorstep, and, equally, are not conformist. That's not happening often enough.

**N.R.:** That's a very fair comment. I agree with what you're saying. I would add to that the publication of books; catalogs are also one of the things that persuade us.

We look left and right, we do; someone once said they have a better ear than they have an eye. That's a very fair charge against museums, at least in this country.

**K.H.:** I think it is, too. Hans-Ulrich and I were talking about the Bruce Connor exhibition that Peter Boswell, who's here, did with Joan Rothfuss and Bruce Jenkins at the Walker. Traveling it was a bitch, because Connor is not a brand name—leaving aside the artist, who is difficult—but that wasn't really the issue. It was that people didn't know the artist that well. In Europe, it was absolutely impossible. We could not get it across the ocean.

**N.R.:** He's outside of the sphere.

**K.H.:** That's the other side of the issue of conformism that we also have to take into consideration. I hear the Connor show looks very beautiful at MOCA.

**R.S.:** Just a couple more questions; I sense people are wilting a bit. I don't want to hold you for too long, but I don't want to cut it short if there's somebody that urgently needs to say something—like way in the back. Is that Linda?

**Linda Norden:** This question picks up on something Thelma mentioned earlier, and Rob. Could we bring the conversation back to the curator, since we've had directors sort of dominating the conversation? Each of you have spoken of the curator as a uniform entity, as an abstract entity. Whatever attributes you've extended to the curator that you look for, it's not authorial. We talked about that in other guises. One of the things we haven't discussed, and it changes institution to institution, is the relationship between the curatorial responsibility and identity and the institutional identity. How is that relationship balanced, and to what extent is it institutional identity (what attracts contributions—corporate, donor, or otherwise), and to what extent is it the identifiable individual curator? That's complicated by the fact that somebody like you, Rob, has an independent curatorial identity as well as an institutional identity. What are your thoughts about the dynamic and the role that you think individual curatorial conceptions, or ideas for shows, or ideas for acquisitions—especially shows—plays in institutional identity?

**A.d'H.:** Can I take a first crack at that one? Certainly, I didn't—and I bet my colleagues didn't—either mean to give any sense that curators were all alike or that there was one kind of conception of them. You could always say they could be more different, but there are very different kinds of people coming from very different kinds of ways of looking and thinking about art—certainly in our museum, and I suspect in all of ours. I think that's terribly important. Curators,

115

certainly, as well as other people in the institution, but curators, over long ranges of time, give huge character to the collections they're responsible for building or the gifts that they attract. It's a little tough in the Philadelphia Museum, in one sense, because so many of the collections came intact—the Arensberg collection, the Gallatin collection, the Kienbusch collection of armor—so you could say that the curators have less effect. But, in fact, that isn't true, since they basically had a huge role in attracting those very collections, together with trustees or others with whom they made very strong alliances to support the museum. Just an example, not from contemporary art, but thinking of our late curator of Indian art, Stella Kramrisch, who was one of the most amazing people in any field in an American museum, and who really left her entire stamp on our collection, on our intellectual direction in that field. A young curator, Dale Mason, who is now in those small but powerful shoes, is contending not only with the great works of art but with this huge kind of persona, which I think is great. It can be problematic, however, because it's always tough to succeed somebody that's big and complex, but if that can happen, the more that happens, the better. It's very true today, just as it was during the formative years of the museum. The Philadelphia Museum of Art is a good example of the relative smallness of curatorial staff, which Danielle Rice mentioned earlier. We had curator-directors a long time ago. I'm not quite in that category because, I hope, the curators get the feeling they are independent, at least to the degree that I could make that possible. This is what makes museums less like cookie-cutter collections. It's like Sandberg in the Stedelijk; curators had a huge effect, and still have a huge effect on what museums are.

**N.R.:** I see the curatorial-directorial tango as a partnership, in a way, and that, probably more than the director, in most cases, the curators are the people who are most in touch with the art, whether it's historic or contemporary. The director's job is to enable the curator to do the work. All of us here have been curators; Kathy even opened up her presentation with a confession of how she misses being a curator. I would say the same thing. The reason I took the job I now have is to do more curatorial work, because I missed it. But the Menil is a slightly different institution. At larger institutions, the director's job is to enable that curator to do their work. If you've been a curator, you know what that means, and I would hope the best directors are still former curators.

**K.H.:** But it's changed a lot. I came to the Walker because Martin Friedman was a great museum director and it was a healthy organization, but he also was a curator. The board was looking for a director who could maintain her curatorial passions. Yet, it's a more complicated job now.

You were asking about identity, though, and I still don't know what "brand" means. I know we're supposed to have a brand, but I don't know what it is. I've been told by brand specialists that we should market the Walker, but I can't figure out what the organization is without its creative programs. By that, I also mean its connection to people. The curators are one very large part of the brand, but they're not the only creative people in the organization who make the brand. Educators do enormous work. Community program people do enormous work. So, curators are absolutely central, but I don't think they're the only central column.

**R.S.:** Can I say one thing? When I spoke earlier this morning, it was not to say curators were central to everything. I was talking about exhibition practice specifically, and that's a refinement. You may still disagree with me on that, but I'm certainly not talking about curators being seen in this role. On the contrary, I was trying to say they don't belong in such a position. They should be collegial, and they should know that in any given area someone else has much more expertise than they do. Deciding how to use that expertise, I believe, should come back to them ultimately.

**Adam Lerner:** I would ask that same question—but the reverse. And that is, what kind of role do you see for mentoring curators now that the museum is, in a sense, based on a university model, where faculty are fairly independent, in theory? But, in fact, universities are now seeing more importance in mentoring younger faculty. Today, we talked a lot about merging the visions of individuals with institutional visions. As curators, we do not arrive as fully formed elephants. What role do we play in mentoring young curators?

**K.H.:** You're sitting next to four extraordinary curators who were mentored at the Walker, so you should ask them.

**R.S.:** Do any of the curators who spoke this morning want to talk about that?

**Thelma Golden:** I'll give an answer to that, but also an answer to Linda's question, which I don't feel was answered. Maybe, in a certain way, I'm going to hit some generational divide here, but, the reality, in terms of Linda's question about the institutional identity vs. the curatorial identity, in this moment of the branding of the museum, is the reality that young curators do, whether by default or not, have to, in some way, understand themselves outside of the institutional identity. In the era of the five-year director contracts and so on, one's identity as a curator is not necessarily locked into what might have been an older model of curators, who come and stay for twenty years and are the institution. That is not

necessarily a conflict, except when the institution's needs for a brand often move it beyond being program-centered. When the whole branding conversation puts it away from the program, it does become an antagonistic thing. As for mentoring, however, I think it is crucial for the institution to do that, not just because it's the way in which a curator then forms their voice—which is, to me, a better way to put it than brand—I'm a little bit skeptical about the brand thing, too—but in terms of mentoring, it is the only way that a curator can find their voice within an institution or outside of it. Very specifically, my own career was formed completely through mentoring, both by the person I'm now working for as a director, Lowery Sims, whom I met as a high-school student, to the former director of the Whitney, David Ross, and many other people who are in this room. In terms of institutionally making that possible again, because of the structures of museums and the way curatorial hierarchies tend to work, it is not inherent in the day-to-day process, but it does happen by default. That is something we do have to become more conscious about, but it's harder to do it in an environment in which the notion of how even departments are structured changes and is very fluid.

**N.S.:** Increasingly, I see the institution as being very much more like a publishing house. I see it as providing shelter for curators who need to develop projects and need the kind of resources that we can bring to them. I don't see people necessarily making a commitment to the institution that will be a lifelong commitment, and I don't see them handing in their cards when they enter the institution and giving away their independence. The institutions of the future will be able to absorb and use different voices in the way that Kathy clearly does and other institutions represented in this room do. There should not be a house style and house curatorship.

**N.R.:** The other thing I'd like to say in relation to institutional identity—and it depends on the institution—we always say that as a disclaimer—is that the collection as it exists in most institutions, if they're collecting institutions, has more to do with the identity and the kind of curatorial magnetism that may exist for bringing somebody to that collection as well. This is supposed to be about exhibitions. Exhibition programs do a lot more today than they once did in defining institutional identity. For that reason—following up on what Nick and, more or less, what Kathy has said—you want a constellation of people, not necessarily stars but, rather, a grouping, a convergence, a variety of voices to reflect the range of possibilities. The subject of mentoring is very timely; I've heard from a lot of directors that the pool isn't as deep as it once was for upcoming curators. I hope that's not true, but I'm wading into it to find out. If you're out there and you're a

young curator, let me know. I'm interested in finding out about the next generation here.

**K.H.:** One of the things I've discovered recently is that some of the best young curators don't want to work in these big institutions. They want a different life. Actually, they want a life. I get incredibly resentful of this on some level, I confess, and they know it. But I also admire it, and that's part of the change we were talking about earlier today.

**A.d'H.:** Mentoring is not only vertical but horizontal. What should happen more is a shared responsibility among the people who have been in whatever museum, whatever size, for a bit longer, to connect with the people who are coming into it, whether they are curators, whether they are educators, whether they're conservators.

Just a little parenthesis that we have talked hardly at all about is the whole role of museums in conservation and preservation. This issue is one that appears less relevant for discussions of very contemporary programs, but it couldn't be more important in helping artists become more aware of what's going to happen to something that they make and how it's going to be cared for. That's another side of things. But we all run with a huge schedule, and we're all laboring under a certain amount of guilt for not taking more of our time to mentor new staff as they come into the institution. I feel guilty about spreading that burden, but the curators and educators that have been there longer should share the responsibility of connecting with their peers and their new colleagues to kind of ease them into the situation.

**K.H.:** The one thing I like about living on the curatorial floor, as opposed to the administrative floor, is that I live also next to the interns. I thought you were going to say, Anne, that we get mentored.

**A.d'H.:** All the time.

**K.H.:** Which is really true.

**A.d'H.:** All the time.

**K.H.:** People who are coming directly out of graduate programs or from other kinds of institutions to work with us, they're nudging me forward. So, mentoring goes in lots of different ways.

**Peter Fleissig:** We've been talking about the DNA of museums. Can I ask the

panel what the implication would be if you were joined together as one museum?

**R.S.:** It would look like the chorus of "We Are the World." I don't know. I wanted to ask a question to Hans-Ulrich, because, in a sense, the work that you've done by interviewing and talking with Pontus Hulten and others is, in some ways, about that dynamic as well. It's the transmission from one generation to another of curatorial practice. I wondered if you had anything personal, or otherwise, to say.

**Hans-Ulrich Obrist:** Concerning this research in general?

**R.S.:** Yes.

**H-U.O.:** On the one hand, I always see this transmission of curatorial knowledge from other generations. On the other hand, for a curator, somehow artists are also mentors, to a certain extent. I've learned most of the things I know in discussions with artists. In terms of the whole curating discussion, very often a lot of shows are very strongly artist self-curated. There have been a couple of books that have tried to pin down the one hundred most important exhibitions of the twentieth century, or the fifty most important exhibitions, etc., etc.. Within this framework, whatever the most objective choices, they required a big overlapping of shows, and a lot of them, at least fifty percent, had actually been artist self-organized. That's something to keep in mind. In addition, the curator, very often, has a much more modest role in being the catalyst or the trigger or something like this. I like the notion of the catalyst, following Gordon Pask's conception of cybernetics.

I recently reread Alexander Dorner's list of what he thinks curating within a museum should be, and that was, indeed, early twentieth century, so I wanted to ask how you feel about some of these points one hundred years later, as directors of museums at the beginning of the twenty-first century. A few points have already been mentioned. Dorner viewed the museum as a multi-identity type of site, as a locus of the crossings of art and life, as well as a laboratory. Another notion Dorner explored is the museum based on a dynamic concept of art history, in his own words, "amidst the dynamic center of profound transformations." And within this profound transformation, how a museum, in general, faces the notions of uncertainty and relativity. Another notion, the elastic museum, which Dorner beautifully describes. Elasticity, not only in terms of elastic display, but also elastic buildings. Last but not least, two more points, that are the most interesting ones and that I wanted particularly to emphasize. The museum, basically, as a bridge between the arts and other disciplines. In Dorner's own words, "We

cannot understand the forces which are effective in the visual production of today if we do not have a look at other fields of modern life." And the last point, the museum as a risk-taking pioneer. Particularly, how do you feel about this notion of risk and of the museum as pioneer?

**N.R.:** I don't think it's a question. Your listing is very admirable. It's incumbent on museums, curators, directors, entire institutions, to hold up a standard of exploration rather than simply reprocessing the current knowledge. So, it is a laboratory, it is an exploration. I would agree with that.

**A.d'H.:** We all get stiffer as we get older. Elasticity may be the hardest thing to keep going, but that's why this issue of mentoring, from new curators to old directors, is fairly important. We learn hugely from curators and artists how to make our institutions more flexible.

PHILADELPHIA EXHIBITIONS INITIATIV

## RESPONSE

**Dave Hickey >** *Writer and art critic, Professor of Art Criticism and Theory, University of Nevada, Las Vegas*

It's very nice to be here in Philadelphia. I was trying to think of the turn on W. C. Fields's epitaph—that, probably, on the whole, I'd rather be dead. But that's not it, since I really appreciate this opportunity. Although I have to doubt the wisdom of The Pew Charitable Trusts in bringing a person like myself here to address a group of people who represent more capital leverage, more institutional authority, and more political power than the entire continent of Latin America. Here's what Pew has done: They have asked a private citizen, who lives in a small apartment in a small city in the middle of the desert, who teaches at a small university where they don't like him, who writes periodical art journalism, the weakest kind of writing you can do, to respond to your discussions of curating. And so I shall, and you may take everything I say with that very large grain of salt. I realize, as I look around, that I am probably the senior person in this room, so the future is almost certainly yours.

I do, however, have thirty-five years of experience in various ghettos of the art world. I also come to you informed by the absolute certainty that, had the museum world that I first encountered been like the museum world today, I should not be doing what I am doing. In an effort to show my hand, then, I should make clear my predilections in this area at the outset.

So, what is a museum? For me, it's a site upon which those with power to do so share their pleasures and enthusiasms with their fellow citizens. In this regard, I like to quote Christopher Knight's remark that "the best thing about living in a democracy is that anybody can be an elitist." The first time I heard this remark, I asked myself: What are the privileges of a democratic elitist? I think those privileges are to have the state afford you with a site for elite contemplation, with a refuge from commerce, with a refuge from fashion, with a refuge from relevance, and with a refuge from education—that is, from all of the evils of our obsessively historicized culture. The museum, as this sort of site, as this sort of refuge, is a site upon which new meanings can be derived and new value can be adjudicated.

This, I would suggest, is the content and subject matter of ninety percent of the conversations that you hear in museums. Ninety percent of the questions that people ask themselves and one another come down to this: Is it any good or not? In truth, I don't think there's any serious discourse of art that doesn't begin with the discourse of value, with a preferential choice. Since I am taking issue

here with the pervasive jihad that has been waged against the idea of quality and value in art for about twenty years or so—on the Little League principle that every tyke gets to play—let me digress here for a moment and clarify.

In my view, when we talk about quality in art, we are, invariably, displacing some quantity of our own response, so that when we say a work of art is good or that it has quality, what we mean is that some quantitative measure in our own response invests it with value. What we are saying, really, is: Wow, I can look at this for a long time; wow, this makes me really excited; wow, I can write a whole lot of words about this (my favorite); or, wow, this is really expensive; or, wow, I want to take this home and look at it for a long time; or, wow, this work is so memorable that I can go home without having bought it and think about it for a long time. These are all quantitative measures that invest art with its perpetuity. They all measure one thing: the extent to which a work of art presents itself to us as the incarnation of values that we value.

Having said this, we may ask, what is the task of a curator? In my view, curators are appointed conservators, not elected officials. They are facilitators and practitioners of a secondary practice, as critics are. The curator's job, in my view, is to tell the truth, to show her or his hand, and get out of the way. If you can do that, I think you're okay. People come to the museum to figure out for themselves what they think is good—to engage in a general discourse of value—to ascertain or discover in works of art values that they value. Curators help, and, having said this, I should explain to you why I'm a critic and not a curator, absolutely not a curator, although I have just taken a job curating an international exhibition next summer in Santa Fe.

The first thing I realized when I took this job is that I'm not a curator. I can do one show, and I can put the artists I like in it, and then, if I had to, I could do the next show, which would include the artists that I wanted to put in this show and couldn't get in the room. Then, I could do a third show of all the artists I like who are really different from the artists who were in those first two shows. After that, my curating career would be over. Simply put, I don't like enough art to be a curator. I'm being dead serious here. I do not like enough artists to be a curator. I do not like enough of the art world to be a curator. That's not my job. My job is to sit in my little room and type.

The second reason I couldn't be a curator is that, for the purposes of critical argument, I propose fugitive and mildly silly ideas about art that make small points. I just wrote a short catalog introduction for a Robert Rauschenberg show, and, for the purposes of this little essay, I was talking about Rauschenberg as a Southerner. I compared him to William Faulkner and to Thomas Wolfe, to Louis Armstrong and to Duane Allman, by relating the tropical profusion and organic density of their production—likening the generative, tropical attitude that

the work of all five artists seems to embody. That's okay for a catalog. It makes a small, relevant point about Rauschenberg, but it would make a really *hideous* exhibition. "Rauschenberg's Yoknapatawpha County." Not only that, it would make a hideous exhibition that Ned [Rifkin] would have taken were he still in Atlanta, because it fulfills regional, cultural, racial, and interdisciplinary criteria that museums, at present, deify. It would still be a hideous show. So, again, that's why I'm not a curator. I have dumb ideas that are okay for about the time it takes to read the sentence, but not any more than that, although I routinely see exhibitions based on correlations no less whimsical.

In other words, criticism is not curating, although critics and curators do have parallel pathologies: We habitually mistake the practice of artists for our own. Critics, for instance, do critique. We write about things that are absent from what we write, and, occasionally, we seduce ourselves into thinking that artists do critique as well. We succumb to the fantasy that art is "about" something, that it's "critiquing" something. In my experience, art does no such thing; it provides a correlative presence in the world for the adjudication of value. Critics write "about" things; art is the something we write about. Curators, on the other hand, have a democratic, governmental mandate to do what all democratic governmental functionaries do, which is to mitigate the inequities of commercial society. All curators have this responsibility. All public officials have this responsibility. Art, however, does not have this responsibility. It is the job of curators to mitigate the inequities of this culture. It is not the job of artists to mitigate the inequities of this culture. If you ask artists to do that, you're asking them to be government officials. You are asking them to promote the regulations by which you must abide and the ethics by which you must function. Artists are supposed to make art. They don't do government. They don't do critique. The presumption of critics that artists do critique, the presumption of curators that artists do social engineering, results in covert, and often inadvertent, ideological censorship. As curators and as critics, of course, we all tend to privilege those people who do not have the same opportunities that others do. If, however, we choose to privilege the expression of a person of color from a small regional town, is it really fair to ask them to do our job for us? If this person of color from the small regional town wishes to compete with Ross Bleckner in the genre of salon abstraction, it should be fine with all of us. What I'm saying is that our public responsibilities do not pass on to the artists we write about and select for exhibitions.

I'd also like to note a difference that I discovered yesterday between critics and curators. Critics seem to have rules, you know, even if they are only rules of thumb. I have rules. My two primary rules, developed over the years, are, first, to do everything that I do with a whole heart and with a passionate commitment, and, second, to never lose sight of the frivolity and smallness of the endeavor that

I'm involved in. I write about things in the world that people look at, sometimes pay for, and sometimes just walk by. This is not a big deal. It may have large consequences, but it is not a big deal. My secondary rules are these: Make it shorter, make it clearer, make it personally more persuasive, and make it less institutionally coercive. Again, criticism and curating are secondary practices. Our job is to get out of the way.

There are also some ancillary rules that seem to me to apply to both criticism and to curating. First: Never oversell your own product. If you pretend that it's more than it is, you will lose in the long run. Somebody will come up and say, Hey, the emperor doesn't have any clothes on; and you will say, oh, yes he does! And then they will say, hey, not only is the emperor naked, the emperor is *dead*. And you will have no defense. So, you should never claim as true anything that is not self-evident. I mention this because, yesterday, I heard what I would consider to be some absolutely outrageous claims for the efficacy of works of art—claims that I cannot imagine defenses or proofs for. And if an overeducated professional like myself can't imagine them, I want you to imagine what the public thinks.

My second ancillary rule is, never use your sales talk on your peers. We all have a line of public bullshit with regard to the civic virtue of art. Sometimes, it's necessary. It's how we get paid. We tug our forelocks to that hopeful fantasy of public utility, but we don't play that game on our peers. Public discourse and professional discourse are not the same thing. Public discourse necessarily involves positive generalities; professional discourse should concern itself qualifying specifics. What I'm trying to suggest here (and, again, I'm being a critic; that's what you're paying me for) is that I did not hear *any* discussion yesterday on the limitations of curatorial power and practice. Everyone seemed to have a limitless ambition and limitless goals. Nothing about verboten practices—nothing about ethical gray areas in the promotion, presentation, and interpretation of art was mentioned—so I think we should all remember this: Somebody has to do something before we can do anything. Somebody has to do something before we can do anything.

What I heard yesterday was a clearly voiced aspiration for curatorial practice to share the role of the artist and usurp the role of the patron—a mandate for curators to function not as selectors of art but as patrons of *artists*, as integral parts of the art process. What I heard yesterday was a discourse about artists—a totally artist-centered discourse. There was no talk about art. None. Only about artists and working "with" artists and commissioning artists. Obviously, you all like artists better than I do, but I wonder if that's the function of the curator, you know? Are you really accredited in aesthetic midwifery? I don't know. And from whence do you derive your authority to function as patrons to a large, democratic

culture? I don't know. I also discerned another ambient idea, derived from this, that the curator is sort of a moral money launderer—that public institutions have all this dirty money coming in from corrupt corporations, dealers, and patrons that magically passes through the curator, as the river of grace passes through the Virgin, and is thus transubstantiated by his or her ethics and passion and vision. This came as a big surprise to me—the idea that curators function as a screen of virtue through which the wicked money of commercial culture flows and is redeemed. In my view, this is nothing more than an arrogant institutional rationalization for intervening between the artist and the money. Just the sort of thing institutions accuse dealers of doing.

I also heard a couple of remarks yesterday about the task of the museum, and of the curator, to educate the patron classes. Now, I don't know about you kids, but most of the members of the patron classes I know are fairly damn well educated. So, if you're proposing to educate these elaborately and expensively educated citizens, I think what you really mean is that you're proposing to reeducate them—to raise their consciousness. Well, I don't know that they need to be raised, or, if they do, if that's the curator's job. I know that many of you work for the great museums of this nation, but I would remind you that these great museums were not founded by museum directors. They were not founded by curators. They were not even founded by directors of education programs. They were founded and built by purportedly "uneducated" members of the patron classes. They bought the art. They got bored with having it in their house, so they built the buildings and shared it with their fellow citizens. That's not a bad thing.

I grew up in a town—Fort Worth, Texas—that was the beneficiary of a genuinely enlightened, if not altogether housebroken, patron class. They were all thieves, perhaps, but they stole very good things. The Kimbells and the Carters, the Cantys and the Hudsons, all of these people bought great stuff and shared it with me. When the Kimbells began collecting and started to go to Europe, as was their wont, after years and years of looking at cattle and groceries, La Kimbell fell in love with eighteenth-century British painting. She brought home a Romney. She brought home a Gainsborough. She brought home a Reynolds. She brought home a lot of pictures, and she hung them in her house for a while, then decided that that wasn't enough. So, she took down about four of those pictures and hung them in a little room in the upstairs section of the Fort Worth Public Library, where I saw them. Not only that, she would hang around there so she would have people to talk to about them. I talked to her for a whole hour one day. I was a kid. I didn't know who I was talking to. There was this lady who wanted to talk about the paintings. That, I think, is the real character of patronage, and it is not a bad thing. Moreover, I would suggest to you that patrons who share their joys and their enthusiasms with their fellow citizens create a very

different and much healthier communal atmosphere than that created by jumped-up educators dedicated to redeeming the virtue and improving the general habits of the lower orders. Educating the masses is a governmental function, perhaps, but is not the function of patronage. So, I would suggest to you, again, that the whole idea of regarding the people who care about art, however imperfectly, who talk about art, in whatever vernacular terms, as your natural enemies is nothing but prissy, professional prejudice. Your real natural enemies are working down at Pep Boys; they are out in the country forming militias. Trust me on that.

Also, I heard a good deal of talk yesterday about avoiding conflicts of interest, and it would seem, from the tenor of the discussion, that one avoids conflict of interest by usurping the role of patron in the name of "professional" judgment. In other words, as long as a "professional" is commissioning the work or selecting the work to be bought, there is no conflict of interest. If a trustee says, why don't you buy this Gainsborough, and you say, oh no, we have our eye on a little David Salle, that somehow redeems the conflict of interest. If, rather than having one of your trustees commission a work for a public park, you yourself commission a work for a big, empty warehouse that the museum has just taken over in its never-ending territorial ambitions, that redeems conflict of interest. What I would suggest to you is that the discourse of art in this particular culture is *about* conflict of interest (see James Madison in *Federalist #10).* That is its subject—the conflict between monetary interest and social interest, between monetary power and aesthetic power, between civic virtue and civic grandeur. We trade them back and forth all the time. How much monetary power do we trade for this much aesthetic power? What objects do we like better than money, better than power? How does one resolve the conflict of interest between one's role as a civil servant and one's role as a serious devotee of visible culture? This is not a conflict that is going to go away. Nor is the conflict between the power of money and the power of art. These conflicts are what you're hired to negotiate with civilized integrity. There can be no disinterest. We all know there is no disinterested position. What are you supposed to do? Stand back and sort of casually intuit what people will love?—what will make them better? That's not a doable job. We're dealing here with a situation whose content is conflicting interests, so, perhaps, it would help to simply acknowledge that and to stop being unctuous about it. It's a real world out there.

Further, I would suggest to you that a public institution devoted to the visible arts need do no more. It needn't serve everyone nor do everything. The fact that you don't have Lamaze classes, midnight basketball, or macramé seminars at your museum is not per se a bad thing. It's okay if you care about the visual arts. It's okay if you advocate the realm of the visible. You are a public institution, but you're a public institution of visible art.

One of the peculiar subtexts that ran through all of our discussions yesterday, however, was the presumption that it's better to get bigger. This is a reflexive institutional pathology. American institutions are, basically, the product of an agrarian culture. They are about controlling territory, and the more territory you control, physically and culturally, the more power you perceive yourself as having. Economies of scale are not the same as the economies of size, however, and I would suggest to you that small is okay. Small is always okay. In a puritan republic like this one, where there is small interest in the visible arts, it's perfectly rational. It's like, are we going to expand the Frick? You know, Jesus, guys! I would suggest further that the instinct to expand is one of the ways in which the people who run institutions unconsciously mimic the moral habits of their business support-ers. In corporate culture, economies of scale and size are really equivalent, but this does not necessarily translate into institutional culture. A little-bitty good thing is really okay. Intensity trumps volume in the realm of art, and a little-bitty good thing that privileges those citizens who would otherwise have no access to the objects and accoutrements of visible culture is not a bad thing. It is something to be proud of, and it is cherished wherever it exists—in the Frick, in the Menil, and in any number of other institutions. You don't have to get bigger; you are supposed to get better. If art were as popular as you people presume that it should be, there would be no need for public art institutions. The commercial sector would intervene and make money out of that popularity. So, let me ask you this—if most people in America don't like art, and museums keep changing until they discover something that most people like, will that be art? Do you understand what I'm saying?

That's why museum expansions never work quite as well as they should. First, they exploit the baser motives of the local support community, since most of the guys and gals on museum boards build buildings, they don't make art. If they can build a building, they're happy. If they can sell some plumbing fixtures, they're happy. If they can tear down the neighborhood where unpopular artists have studios and build a white block by some Connecticut architect, they're really happy. And if the local viewing audience can come to the museum to see movies and play basketball, they're happy, too. And if they're happy, their elected representatives, who fund your institution, are happy as well. That doesn't necessarily mean that it should be done, and I think it's the responsibility of some people in authority in the arts to say, Stop it! Small is okay!

It also helps to remember that art is fast and cheap, while architecture is slow and expensive—that art is always most at home when it is most out of place. Art always looks best in the architecture of the previous period, and architecture always tries to accommodate to art and dominate it. Jackson Pollock and Mark Rothko's paintings looked great in those tiny West Village apartments where I

first saw them. Then, modern architects built vast halls designed to reduce them to postage stamps. Now, reduced in scale, they have lost their size and presence. Then, artists who show in these spaces react against the preemptive architecture and make even larger works, so, in recent years, we have opened up three or four major museums filled with giant spaces that are going to be very useful if Anselm Kiefer clones himself and continues to produce for the next century.

I was in a museum in Chicago the day after it opened. I looked at those spaces and I thought, how nice; the normative product of an artist under twenty-five right now is a foot-square painting. It's going to look great in here. My point is that there is a necessary time lag between art and architecture and a necessarily aggressive relationship between them, deriving from the iconophobia of modern architecture in this century. As a consequence of art's fluidity and architecture's ideology, then, the task of creating a useful, lasting contemporary art museum is, almost by definition, impossible. Better to worry about the art.

There is another related issue I would like to raise. I heard a good deal of talk yesterday about interdisciplinarity. The term, however, was never used to describe people or practices or objects that manifest skills and learning in two or more disciplines. It was, invariably, used as a code word for *antidisciplinarity*, and antidisciplinarity describes the practice of subsuming all endeavors under some totalizing religious, civic, scientific, sociological, or political discourse. Disciplines, I would remind you, were originally *invented* in the late Middle Ages to evade the antidisciplinarity of Christian thought. In the late twentieth century, antidisciplinarity has returned under the woozy haze of Frankfurt School sociology and Freudian psychology, which subsume all they touch. Interdisciplinarity is a very different thing. It refers to individuals or groups or objects or practices that manifest multiple disciplines. Antidisciplinarity is what we do today—we presume that the personal is political, that the aesthetic is economic, that the sciences are social, and that everything is psychological. The presumption that art does not exist as a distinct category of experience, however, is demonstrably wrong. If it did not exist, we could not distinguish between the noise of a sonata and the noise of a vacuum cleaner, and I, for one, can do that every time. I can even expand my artistic category of response and listen to the vacuum cleaner as if it were music, but I cannot, in good faith, admit to being able to listen to a sonata as extra-artistic cultural noise. Q.E.D.

At this point, I would like to comment on two other trends that were discussed yesterday in general tones of approbation: the promise of technology and the coming hegemony of time-based art. To begin, I think that you have to acknowledge, as participants in a contemporary museum culture, that if art is fast and architecture is slow, institutions are even slower. If you work in an institution, you're dealing with increments of change that are exquisite in their tininess, and,

as a consequence, you can't really keep up with secular culture without impeding the rate of change you aspire to reflect. An instance: I heard some talk yesterday about the embrace of digital technology by museums and universities. From a fund-raising perspective, this is a positive move, because the people on the boards of museums and universities hate employees and love hardware, so if we can expand through hardware (which my brother-in-law, by the way, can get you a very good deal on), this is good, I suppose. If this obsession with hardware leads to an obsession with digital hardware art, it is somewhat less positive. In fact, if contemporary museum culture wishes to create a situation that privileges change, it might do well to consider the real relationship of art and technology in the history of the West.

The problem, as George Bernard Shaw remarked about the vogue of Richard Wagner, is that "when everybody says something is the next big thing, it is not the next big thing. It is the last of the previous big thing." Now, any of you who know the history of music know Shaw was accurate to the point of prophecy about Wagner. In other words, Wagner was the last of that and not the first of something that came after it. The same might be said of James Joyce, T. S. Eliot, Jackson Pollock, and many other dominant figures who were perceived to be the next big thing and were, in fact, the end of the last big thing. So, let me suggest to you, apropos of this, that the relationship of art and technology is simultaneously dialectical and prescient—that art and technology oppose and predict one another.

To begin, there are two dominant modes of art-technology interaction. There's an art-technology interface that deals with issues of incarnation and one that deals with issues of representation. The tradition of incarnation begins with bronze casting, and goes up through oil glazing, suspended pigment, plastics, color film, acrylic paint, etc. Then, there is a tradition that deals specifically with issues of representation, that stretches from the technologies of perspective to the printing press, to engraving, color printing, and, ultimately, to digital representation. The relationship between art and technology, however, has never been one-to-one. Quite the contrary: Art, at any particular moment, is always giving us back what the dominant technology is taking away.

As a consequence, I would suggest to anyone in the art world who is beguiled by digital culture that what you really like is getting eighties' text-photo art really quickly on your home computer. Websites *are* eighties' photo-text art. I saw a website the other day that mimics a Bernar Venet installation that I saw, in Soho, in 1968. This relationship is dialectical and prescient. We spent thirty years getting ready for the web—standing there reading shit, looking at Xerox photos on the wall. Right? Now, we can do this at home. But this ain't cutting edge, guys. This wave is on the beach. Again, keeping in mind my reservations about

art museums trying to be trendy, I think that if you do want to privilege the future, you can do better than embrace the popularized expression of the same crap you've been exhibiting for twenty-five years. I cite the authority of my students on this, the best of whom insist that "computers are corny. I've been doing Adobe since I was in eighth grade."

This, I think, is a reasonable position. My students understand that digital technology has reached the point where it is taking things away from us: the haptic, the tactile, the fractal, and the chromatic. You don't have to go very far to see art beginning to give these qualities back to us. So, let me be clear: There is no particular reason that museums should be au courant and respond to this response, but there is also no particular reason that they should oppose this perfectly rational tendency. The whole history of conceptual art begins by giving us back what the sixties' technologies of incarnation, of plastics and color film and projection, were taking away from us. Consequently, in the late sixties, we got the concept. Now, we have, perhaps, a surfeit of concept and artists giving us back the other thing. This is perfectly normal. So, I think that institutions, even though they are not obligated to be trendy, are obligated not to be professionally and aggressively reactionary in this regard.

This brings me to another important issue: the growing hegemony of time-based arts in American museums. I, personally, regard it as arrogant pandering to vulgar taste—the last dying wheeze of lumpen representation. So, let me make a small, theoretical digression here and remind you that the primary critical question we ask about time-based art is the exact reverse of the first question we ask about object art. When you listen to a sonata, the parts are all available to us one at a time. There is this part, there is that part, there is this part, there is that part, the end. The issue with a sonata, the idea we must construe, is the idea of the whole. What's a sonata? If anybody here knows, tell me later, because I don't know anybody who does know, but that is the critical issue. How do we characterize the whole? In object art, the issue is exactly the opposite. We see the whole and we argue about what constitutes the parts, and the ideological drift of our subsequent critique is absolutely dependent on how we construe these parts. If we look at a Raphael and say, oh, the parts are the Virgin and the Child, which express the iconography of the incarnate word to be used as an aid to devotion, our thought goes in that direction. If, on the other hand, we construe the humanist parts and generalize, saying, oh not the Virgin and the Christ but a mother and child engaged in a warm human relationship, and look how Raphael invests the little baby with individuality, you have another discourse. If, however, you say, please observe the color wheel and the triangulation of the structure as they relate to the edges of the painting and relate back to the history of Greek pictorial organization and look forward to Hans Hoffman, you have something

else. And then, of course, you notice the manifestations of early capitalist culture as they embody themselves in the ring, in the garment, and you also note the signifier of Oriental alterity as that manifests itself in the embroidery. My point: Object art depends on our imagination of the parts. Thus, object art depends absolutely on our repertoire of experience of other object art to determine these parts. The designation of parts is the first determination we make about objects, and it is absolutely dependent upon our prior experience of other objects.

To contrast this with our experience of time-based arts, I could take any number of you, presuming that you're in a condition of perfect innocence, and give you a CD of Beethoven's Ninth Symphony, and, even if you've never even heard Oasis, you could take it home, play it four or five times, and learn to appreciate it, because you could internalize the tonality, you could internalize the pace and sequence. You could understand the second movement in terms of the first movement, the third movement in terms of the first and second. When you got to the end, your experience would be based on that which comes before. What this means is that time-based art privileges the ignorant. It is perfectly perceptible within its own stochastic relationships. Therefore, it brings with it the benison most dearly beloved by commercial culture—instant gratification. I saw the first of the video; therefore, I understand the last of the video. Object art is something very different, because I can give you Beethoven's Ninth Symphony, and yet, even though Beethoven's Ninth Symphony is a lot more complicated than a Jasper John's *Target*, I could not give you Jasper John's *Target* and have you take it home and gradually come to terms with it, if you haven't seen any more paintings. Because the paintings that come before Jasper's *Target*, in your experience, constitute its first movement. The paintings that come after constitute the third movement. The perception of object art is a serial, experiential, and accumulative experience. You gotta see a lot of it. You gotta not understand a lot of it. You gotta worry about a lot of it. You gotta understand the first in terms of the second and the second in terms of the first. This is not a crowd-pleaser without sufficient narrative. So, what I see more and more in museums is the imposition of totally artificial narratives upon objects through the use of text and video— also, the gradual substitution of time-based video for objects that require a repertoire of precedent responses.

Now, I really like video—some. But I also see it being exploited as the museum, in its quest for popularity, becomes more and more a cineplex. I see it as one of the ways the market-driven museum seeks to exploit and privilege the ignorant for dollars at the door. So I think that this is a real consideration, but to take this into consideration, you've got to be willing not to be too popular. You know? If you put up objects, you may not be the most popular girl. You can't go to the city council meeting, and say, well, little Darryl is learning about habitats

of the Hopi when he looks at this Marsden Hartley. There are people who say things like that. I'm not kidding you. Give it some thought. Give some consideration to the real function that the shift from object-based to time-based idioms has in the museum. Also, ask yourselves how much you like watching movies standing up. Speaking for myself, I like it about as much as I like reading standing up, which is another one of my least favorite things. These issues—antidisciplinarity under the guise of interdisciplinarity, the disingenuous embrace of digital technology, and the growing hegemony of time-based art—are concerns that museums need to address. They all derive directly from the effort to make the museum more market-driven than Mary Boone. Actually, I have an idea for Rob [Storr] in this area, for the perfect Museum of Modern Art show: Picasso paintings of the Holy Land from the collection of Jacqueline Onassis. If that don't fetch 'em, I don't know Arkansas.

In any case, I think it might help to be preternaturally self-conscious about the commercial aspirations of museums, because I suspect that most of them are driven more by territorial ambitions and regional competition than by the need for funding. Things have become extremely distorted here, so we should never dismiss the possibility that societies of northern European Protestant extraction don't like visible art and can't afford it. Or, rather, that they can only afford anti-materialistic, puritanical, iconoclastic, therapeutic art that reinforces the values of the governing classes. This might just be the fact. If it is the fact, however, that doesn't mean that the museum of art, as a combination temple and forum for the adjudication of value, for the creation of new meanings, is not viable. It just means that the site can't be quite so grand and full of virtue.

Also, in this regard, I think we should free ourselves from the delusion that we are creating the art world. I do not think, based on my long experience, that this is the case. I think art creates the art world. I think certain kinds of art predict and necessitate a certain kind of art world. Pop art could not create the art world we know. We live in an art world now that is created by the academic proclivities and governmental ambitions of postminimalist practice, which, as my wife would say, is *so over!* The issue today is, how do we keep the art world, created and permanently institutionalized by yesterday's art, from retarding changes that cannot be suppressed? How do we facilitate our own obsolescence, in other words? A certain amount of foot-dragging is inevitable, of course. That's one of the functions of all institutional culture. It is irrevocably conservative. All institutions are conservative, dealers are conservative, curators and critics are conservative. We all want artists to want what we want them to do to facilitate our practice. This can be fairly confusing when the conservative instinct of the art establishment is to keep art revolutionary, but it's still a conservative instinct. "I just want to go back to the barricades in '68." They ain't there anymore, kids. We

live in quite a different world.

Now, by way of conclusion, I would like to raise a couple of issues with the imposition of civic mandates on aesthetic diction. I find it extremely nervous-making, for instance, when terms like "research" and "laboratory" are used in the vicinity of art. They imply scientific, educational, and liberal-arts ambitions to which the culture aspires, to which works of art do not aspire and cannot fulfill. As Rob [Storr] said the other day, art is a propositional discourse. It has no truth-value; it cannot be proven. Therefore, one cannot be educated by art, because art bears with it no knowledge. It entails a relational, experiential adaptation to a disorienting experience. Art that confirms our knowledge is invisible. Art that subverts our knowledge ain't knowledge. I can teach you some things. I can impart to you knowledge about art history. I can impart to you knowledge about art practice. Art doesn't teach us anything. It doesn't teach us anything about art. It doesn't teach us anything about life. If it did, we would all be redeemed human beings. Our long experience with art would have so bettered us that we would barely touch the floor. Now, rock and roll *does* make you better, but art, sadly, is a propositional discourse. It exists in what Karl Popper would call an environment of confirmation or refutation. It is either accepted, rejected, or revised. It is an externalized discourse of value. It is demonstrably an axiological practice and not a pedagogical one.

Now, I understand perfectly that you can't raise a dime for art without saying it's education. But don't believe it. We're talking about an experiential discourse here. Even those conceptual-art discourses that aspire to pure concept are, in fact, local to their context. And this is not a philosophical objection on my part, it is a practical observation that the act of explaining art is based on the presumption that art has, somewhere in it, some determinate meaning. In fact, works of art have no determinate meanings. No work of art has a determinate meaning. If works of art *had* determinate meanings, sometime in the last five hundred years we should almost certainly have figured out what at least one work of art *means*. When we try to impose meanings on works of art with wall texts, catalogs, docents, and acousti-guides (I don't know which one annoys me more), what we are really doing is suppressing the possibility of new meaning— and art that is unreceptive to new meaning does not survive. Art that survives must survive its original attributions of meaning. That's just the fact. You can't stop spring from arriving. You can only kill the flower when it does.

How would you like to spend your days talking to students, trying to explain to them that Jackson Pollock's paintings are theaters of Jungian redemption? Jackson was vaguely under that impression. What do you do today? You say, Well, now, Jackson Pollock may be regarded as the father of performance art. And that may be so. But that means we've cranked up Jackson's paintings and run a

whole new ideology under them so we can keep Jackson's paintings, not because they're good but because we like them. These new meanings are the consequence of having people come into the environment with the work of art and freaking winging it. That's what it's about, in my view, because one of those people might present a proposition that saves Matisse for us. I don't think John Elderfield is going to do it. But somebody is going to. This perpetual ritual of reallegorization that takes place on the site of the museum is a sublimated version of the larger discourse of value that motivates nearly all commercial cultures, which conduct their valuing in terms of externalized correlatives.

What I'm proposing here, without wishing to fetter the winged stud of your curatorial muse, is a little attention to detail, a little attention to the hard copy of the visible object, an aspiration to put up a room full of disparate works of art that make your thesis self-evident, with no text and no acousti-guide. Having done this, we can all hope that some kid will come in and say, oh, yeah, I know what this is about, and tell you something you've never freaking heard of. That, it seems to me, is the joy of the whole project. Art first, meaning second, new meaning tomorrow. As curators, you have the possibility of doing that. You can create the condition for new meaning and new pleasure and new value, and that, it seems to me, overrides any issues of scale and virtue, because it is out of that particular discourse that the world lives, today and tomorrow.

# AUDIENCE QUESTION AND ANSWER

**Peter Plagens:** A small, perhaps not small, practical question: What would you do, or advise, if you were a curator and in the position that you describe yourself as being in, not liking enough art, not liking enough artists, to go on after the third show? Say you have a job—you're going to come up with shows for the next five years. What do you do other than say, We're going to turn off the lights?

**Dave Hickey:** This is a real problem. I started off as an art dealer, and I thought that was like being a curator, but I suddenly realized that, during one year, I could show the ten artists I loved—then, the next year, I could show them again. If you're a curator, you show the ten artists you love, and, after that, you find yourself in a meeting in which someone says, We haven't shown an Iraqi minimalist in five years. And, all of a sudden, you're not doing what you know and love. You're doing stuff for other people's good, and all of your accumulated experience, all of your embodied judgment, disappears. You're suddenly dealing in a realm in which you have no physical repertoire of responses, only the presumption of your cultural clairvoyance. I think you quit. I've quit a few jobs. You do the thing that the girls in Jane Austen couldn't do. You move to L.A. You get a job at a Starbucks. You hang out in rock clubs. I don't know what you do. But the years of sustained employment in the same job are over, I think. And I'm not making light of this. I don't think it's a small thing.

I'll give you a curatorial project that I think needs to be done. Back in the eighties, when David Salle was the thing, there was no one over the age of twelve that did not recognize the powerful influence of Picabia on this work. The institutions that owned all the Picabias did not deign to exhibit those Picabias, although such an exhibition would have, in fact, provided a rich environment in which David and a number of his colleagues could have shown. It would have given them some historical confirmation and made them a little less boring. No curator did that. Mary Boone did the damn Picabia show. I think this is a perfect emblem of the historical irresponsibility of contemporary museums.

I have been arguing for years, for instance, for a Bradley Walker Tomlin show. He's a modern artist, and if you look at postwar American practice and want to find the pivotal figure in the development of synthetic abstract painting, out of which David Reed, Jonathan Lasker, or even your own paintings, Peter, might be said to evolve, you look to Tomlin. The existence of this new painting rewrites art history, making Tomlin a more interesting figure than he was before. Curators

have an historical mandate to document the perpetual reconstruction of art history as it is revised by contemporary practice. That's a reasonable project, and I think that it's irresponsible not to do.

**Charles Moleski:** I'm from the Fairmount Park Art Association.

**D.H.:** Where's that?

**C.M.:** Here, in Philadelphia.

**D.H.:** Okay.

**C.M.:** I'd like to first confess that I'm not a curator.

**D.H.:** Okay.

**C.M.:** I wanted to ask about your comments on technology. I was recently at the Experience Music Project, in Seattle, which is a beautiful building.

**D.H.:** Yes, it is.

**C.M.:** But the technological gizmos render the experience a disaster. How do you resist technology without seeming like a Luddite?

**D.H.:** First of all, don't be a dummy. You presume that most citizens of this country, unlike most technonerds, are not control freaks. Most museum display-technology these days aspires to interactivity, which is the last thing you want in art. You want to be out of control. Do you understand? You want, in an isolated situation, to give up control and respond freely. You don't take the brown acid and then punch the rollback button. Do you understand? That's sissy. What I'm saying is, the museum is, specifically, a safe atmosphere in which one may divest oneself of one's obsessive Protestant self-consciousness and self-control, where one may, for just a moment, not impose your bloody whims on everything. You can just let it go. Just let Mr. Rothko do what he can do. It wasn't much, but it was better than nothing. Do you understand? I'm saying I think that the presumption that we're supposed to empower people by investing them with controls and panic buttons, so they can change the story if it seems not to be going well, is uncivilized. Don't like the fifth act of *Hamlet*? Here's one where everything turns out all right! The whole idea is to participate in a stochastic sequence of events and not know what's going to happen. Now, technology can do that; it doesn't because

people that do technology are very insecure and not very cool. Their job is to control things. We have to be aware that we ain't in the interactive business or the education business. The contemporary art museum doesn't really need a dinosaur where you push a button and it tells you about the late Triassic. That is not what art does. It is, however, what people who run museums want, because, as I said, they hate people, they love hardware. Hardware doesn't ask for benefits. Or strike, Rob.

Let me also modify my remarks about my students and technology. I think, to a certain extent, a digital culture has, in fact, made my teaching of art a lot easier; kids that have been on Photoshop since they were in eighth grade are more visually sophisticated than the previous generations. But they are so sophisticated, they know how dopey Iris prints are. In other words, they have, mostly, by the time they are in college, evolved beyond the fact that you can go on your computer and make a picture of Hillary Clinton making love to an alien. They have moved on. So, there is an enormous benison in digital cultures. They have made kids smarter in the realm of the visible, but the kids are smart enough to know that what you want is haptic-tactile-fractal.

**Paul Schimmel:** Given your long involvement with the music world and your stated interest in some video art, what place do you see for time-based art within the museum structure, if at all?

**D.H.:** I've genuinely had a lot of interest over the years in performance and video. It is my suspicion, however, that all of the good video art was done before there was such a thing as video art—when it was just stuff that Bruce [Nauman] and Bill [Wegman] were doing in their studios, because they sold a painting and got a fancy camera. That was a lot more fun. The institutionalization of "other media"—I don't know what you call it—has not been of any help at all. It just imposes old modernist media categories. I do think that most works of performance and video art are on their way to a genre. You know, Laurie [Anderson] was always on the way to rock and roll; Spalding Gray was always on the way to stand-up comedy. Most video is always on the way to Benny Hill, you know? Those are the standards by which we judge. But here, again, I think that the development of video art has not been allowed to blossom under the hegemony of late-seventies postminimalist aesthetics. It is beginning to change. Again, I have no natural reservation about it, beyond those I have expressed here, and, as a critic, I never attack art tendencies I hate, because that only makes kids like it more. Also, no tendency is so degraded it cannot be redeemed by talent and courage, so *vive la performance!* There remains, however, the problem that video dematerializes. There is also the problem that video has about one-tenth the information of a comparable object, and the residual hunger for physical information, with

which electronic culture invariably leaves us, makes video so unsatisfying. It also wastes my time: It takes me about forty seconds to see ten paintings that I want to look at for the rest of my life; it takes me forty minutes to see a video I never want to see again. Maybe it's an old-guy thing. You know? I mean, I used to sit around and listen to Flock of Seagulls albums. I do think that the darker side of time-based art is that it is available to anybody who just stands there, and that's not elitist enough for me, not refined enough. It's got to be better than TV.

Yes. This is Judith.

**Judith Tannenbaum:** It's me. I'm at the RISD Museum now; formerly of the ICA here. I was interested in what you were saying about architecture being behind art.

**D.H.:** Right.

**J.T.:** Do you have any advice about how to plan for building for the future? If that's the case. Which is really an interesting problem.

**D.H.:** To be honest, I think contemporary architecture is totally unredeemable. I dabbled in the world of architecture schools for about five years, and I finally just threw up my hands. We've established such a profound seminary attitude that you don't even meet weird people in the architecture school anymore. I mistake them for seminarians. They want to do good, and do-gooders don't do good art or architecture, so I don't know. I have no idea. But all I know is that I did a little survey of most of my friends and asked them where would they rather look at art. Ten or fifteen, two-thirds of them, said they would rather look at art at the Prado, which is a big, dumb, square building full of great art. That's not a bad idea. The first time I went into the Prado a dog came in with me. A pooch. He just wandered around with me. Whoah, Velázquez, woof!

This might be a good moment to sever art from the current pathologies of contemporary architecture. They will wither soon enough; they will suddenly fall away, and, soon, it will be possible to have a congenial space to look at art—and, in truth, I have been in some congenial spaces. I think Piano's space at the Menil is a lovely space, if you don't mind the image of ghostly nuns swishing down those halls. It's kind of like the world's fanciest convent. I'm not saying you can't do successful museums, just that you always have to keep in mind that art really does change and not only does it change, it usually changes to subvert the dictates of architecture, so museum buildings are almost, by definition, out of date. I think, assuming this sort of dynamic relationship between art and architecture, you need a civilized architect. If you meet one, have him call me.

That was unfair; you get the idea.

**Michael Komanecky:** I'm chief curator at the Phoenix Art Museum. I have to show my hand: I'm not a curator of contemporary art, I'm here because of my interest in discussions about what curators do in museums today. Yesterday, I walked away from much of the session with an uncomfortable feeling about what I would call the "yes, but" syndrome. Curators are encouraged to be creative, to show the art that they are passionate about—*but* we have to consider marketing, *but* we have to consider education, *but* we have to consider audience. And I fail to see, yet, any earnest discussion about resolving what, to me, is an essential conflict there. If you really want people to do the things that they are committed about, how does that happen in the museum today?

**D.H.:** Well, I honestly think that that isn't what people really want curators to do. You know? I'm a magazine writer. My job is to keep the ads apart. I know that. There's got to be a little column of text there so that the Dewars' ad doesn't segue into the brassiere ad—I mean, that's what I do. There is a level at which curators are supposed to keep the walls filled. Not only that, the walls must be filled forever. It's not like the staff at the Whitney is going to get up one morning and say, Jesus, there's nothing around that's any good; let's just close this sucker for a month—no more than *Artforum*'s Jack Bankowsky is going to look around and say, Gee, all this stuff sucks; let's don't publish in April.

If we were dealing with real businesses, this would happen. The great thing about bad art dealers is that they go out of business. The darker part of great institutions is that they just go on and on. The checks are coming in. The system is rolling. The education department is mobilizing its new projects. So, I don't think cynicism is a bad position. You do the best you can. And it's not any different anywhere. I just did what was going to be a six-page piece about Dan Flavin in *Vanity Fair*. It was cut down to four hundred words because they got some new Gwyneth Paltrow pictures. Great photos of Gwynie, though.

Most of the rhetoric we hear about freedom and creativity is part of what we call the discourse of accommodation. All large bureaucratic cultures have an entrenched discourse of complaining about bureaucracy, and that is part of the accommodation to living with assholes, as we all do. I teach at a university. We call it a university; it's a handicapped parking zone. It won't change, so we complain. We should, then, take this discourse of complaint as an icon of our aspirations and presume that it, like art, has no truth value whatsoever.

I think it's possible to do little-bitty things. In college, we used to say that one person can make a difference—and it's usually a bad person. But one good person can make a difference, although that difference cannot be sustained in the absence of that person. In other words, institutions, for all their pretensions, are organizations of people, and one person can make a difference at enormous cost

to themselves. That doesn't mean it's not worth doing. I mean give up show biz?

**Dean Daderko:** I had a couple questions and, first, some observations. It seems that the institutional model is the one that we're talking about here.

**D.H.:** Yes.

**D.D.:** In terms of curatorial work. So, I address it specifically to that and, kind of, to all of us here. My observations are that it seems that in yesterday's session the voice of dissent was represented really by members of the press. Their questions and comments and criticisms touched some obviously really tender spots and got the most inflammatory reactions. The criticism also felt, to me at least, like it came from an outside position, one outside of the curatorial system. I felt there was this need to defend some place. So, the questions that I have are, how can we make curatorial practice somehow more porous, less about a kind of outside and an inside? Can the dialogue of criticism become somehow integral and internal? And is it the function of one type of criticism, in practice, to be reactionary, like a litmus test is?

**D.H.:** Right.

**D.D.:** Or can these situations that we're critiquing exist outside of that? Also, how we, as curators, can create dissent from within our practice and problematize the practice, kind of like a micro coup d'état or something.

I'm going on a little bit. Who is this audience we're talking with or talking to, more importantly? Can audiences at the same institutions differ in number of members or in focus—meaning, can an audience at an institution be four people or does it need to be three hundred or a thousand people? What are the implications of that in terms of fragmenting the institution? Then, the last part is, I imagine, when I'm doing curatorial work, I have a kind of audience in mind, and that audience is usually quite a small one, in terms of who I'm thinking about and addressing.

**D.H.:** Right.

**D.D.:** So, I wonder what everyone thinks are the ethical issues of presenting an exhibition that's made for an imagined audience, say of four or five people, to an actual audience of hundreds or thousands of people. Do we need to radicalize and be able to actually say that the institution can do an exhibition for four or five people and, in those terms, can we extend that to say that because an exhibition, because of its necessities for length, the time it takes to arrange, etc., we're

still kind of organizing it on a one-month or three-month basis. Do we need to be able to say that some of the exhibitions need to take six months in the institution? Others go for a month. Things like that. Those are just some questions.

**D.H.:** Well, Dean, about the microrevolution from within, get real! No, I don't think that that will happen. I have always held that museums are like yachts: If you have to ask how much they cost, you can't afford them. So, let's grow up. People don't like art. Let's get smaller places with better art. When I first lived in New York as a kid, I used to go to the Met every day. I'd go three or four days in a row and see four people. That was so great, because it isolated me from my community—my favorite thing. But an empty museum is anathema now. In a sense, the museum is there for unfashionable things, because we trust commerce to take care of those fashionable things. If the museum wants to piggyback on the whims of *Spin* magazine, that's their business. But, in a sense, the museum is there to be unfashionable, and by being unfashionable it's going to lose attendance. I think, of course, you do it for four people.

The issue of guest curators, however, is a more complex issue than you think: There are a whole lot of resident curators who are eager to establish the respectability of the profession and the role of the curator as an established position within the museum hierarchy. Even though the idea of having guest curators could reinvigorate the discourse, that doesn't mean resident curators are going to be in favor of it. You understand? Because there are very good institutional reasons for them not to be in favor of it. I've been a guest curator and a guest professor, and it's one of those "glad to see you come, glad to see you go" deals. But that's okay. It would be great if every show was guest-curated, but, then, who would do the research and who would count and stack and tell you how many centimeters it is? I think that's important. We are in the "thing" business and I don't see any alternative to it, beyond a fairly rigorous sense of ethics and hard work and not expecting a hug for it. A lot of the problem today derives from this enormous yearning for notoriety, which is the bane of our civilization. I don't understand it, and I think we just might grow up.

 **Amy Schlegel:** I'm the curator of the Philadelphia Art Alliance, which is a contemporary art center in an historic home built in 1906, the place that I want to invite you to afterwards, on Rittenhouse Square. You might like it. It's 2,500 square feet spread out over three floors.

**D.H.:** I like anything that's older than me.

**A.S.:** It's small. We have the problem that people come—great location—for the restaurant, a four-star restaurant, on our first floor. How do I get them to venture throughout the building without resorting to a massive marketing effort?

**D.H.:** I wouldn't bother. You all go to the Approach, in London? It's one of my favorite galleries. It's above a pub—soccer downstairs and art upstairs. I think, if you're patient, you'll develop a constituency. Certainly, the Approach has, and it ain't the lads downstairs high-fiving one another, but if you want to go downstairs, you can. I would just make it clear, make it visible. I don't know if marketing is ever the solution for art. I see them as radically distinct activities. It's okay if it's not a big deal. I really think it's okay. I think the underground is okay. It's okay if nobody knows who we are. I mean, how does that hurt us? I mean, we're doing this thing.

I grew up in the jazz world. If I knew where Miles Davis was playing, I didn't want anybody else to know. Come on! It's okay. It's cosa nostra; it's our thing. No reason you need a bunch of farmers tracking up your museum. I'm being dead serious. Art, at present, has about as many devotees as bebop did. Bebop was never very famous; it was never very popular. It had profound and continuing cultural ramifications. You don't need marketing and a development director to do things that have profound cultural consequences—you should keep your eye on the sparrow. The idea is to win in a long-term cultural sense, although I really do sympathize with you.

As an aside, let me suggest one thing to all of you who are involved in kunsthalle curating: It is one of the most economically determined practices in the history of art. I remember back in the late sixties with the birth of what we call installation art or nonobject art, this whole category of Postminimalism, which starts with Bruce Nauman, Bob Smithson, Eve Hesse, and Richard Serra, all of these people. Until 1972, this was all perfectly viable commercial art. It was bought and sold. Even Joe Kosuth. And it's still commercial art. Even if it's not an object. Even if it's a Doug Heubler you put in a drawer. It was commercial art. In 1972, with the proliferation of kunsthalles across this nation, it suddenly became official noncommercial art for specific economic reasons.

You're running an NEA-funded kunsthalle in Madison, Wisconsin. You and your friends are sitting around sorting seeds and stems in a storefront on some snowy street. You got a few bucks from the state, much the way Stalin used to send money to Siberia. You're out there, it's snowy outside, you're stoned, you want to have a show. One of your idiot friends says, well, man, let's get some of those cool Roy Lichtenstein paintings. This discussion follows. Well, we can't have paintings because (1) we can't afford to ship them, (2) our storefront has no climate control and they would warp and dissolve, (3) we have no security to

protect them, (4) we have no place to store the crates, and (5) we have no money for insurance. All we're getting from the state is rent on this freaking storefront, so why don't we raise some money and fly Inga over here from Berlin, let her go to a thrift store, pile up a bunch of garden hoses, and we can have a great party? We can raise money, and we get all the money—the artist will get nothing but the ticket—and we can continue our practice.

Now, kunsthalle culture in this country has run for twenty-five years, driven by these economic necessities. A lot of wonderful and genuinely delightful things were done. I don't mean to critique it. I mean I don't mean to dismiss it. What I do mean to do is emphasize that this aesthetic was the absolute consequence of the economic necessity set up by the NEA kunsthalle program. Also, I would point out that a great many of the people who were slightly younger than myself, who would have, normally, in the everyday flow of things, become art dealers as I did, became alternative space curators, because that option was available. This resulted in a whole absent generation of art dealers and diminution of the authority of the market, while the kunsthalle culture was surviving, to no real end, on seeds and stems. Now that all funding has disappeared, kunsthalle culture is becoming a little more improvisational and self-consciously underground, more mood-enhanced, and this is genuinely a positive consequence. I didn't answer all your questions, Dean. Did I miss a really good one?

**Danielle Rice:** I hear from you the message that since people don't like art, we should do better stuff on a smaller scale. Is that your message?

**D.H.:** You can't please people who don't like art. There is no tradition of liking art in this country.

**D.R.:** Okay. I'd love to hear what the possibilities are for turning people who don't like art into people who like art, through whatever magic of authentic curatorial practice. Do you think that there's a possibility of that?

**D.H.:** I can assure you that there are absolutely no educational requirements for looking at art. Heidegger is really not required for Mike Kelley, and I'm being dead serious. We could, perhaps, make the world in which art is practiced seem to be a welcoming and civilized place. Everybody could stop wearing black clothing and just wear something nice. But, nah! Actually, I think it might be possible to civilize the society of art a little bit, but the difference between fine and popular art has always been nothing more or less than its exclusivity, so I don't think that's going to happen. Everywhere, people keep asking about educating people about art. What in the hell are you going to teach them? Dirt's

okay? Reacclimate yourself to the discourse of the grotesque—the abject? Whenever somebody says this to me, I try to imagine Dizzy Gillespie and Miles Davis sitting around saying, we got to educate people to bebop. They wouldn't have ever said that. They were doing what they do. Artists do what they do and people that love art do what they do. It is a volunteer discourse, you know. You can't coerce people in this culture, unless you're an HMO. This is not a totalitarian regime. We're not going to have a new renaissance. Although we can have something really wonderful, if we don't spend all our money on brushed aluminum doorstops. I'm not being flip. I'm being perfectly serious.

**Terry Myers:** My question is, how do you resist what tends to happen in these situations, where you try to do the kind of things you're doing, where we turn to the sort of status quo and a re-presentation of the usual suspects? How in this activity you're calling for do we get to things that may bring us somewhere else rather than the same place over and over again? My criticism of this is that you often work back to things that we've seen over and over again, in terms of the names that we use when we talk about these things.

**D.H.:** I guess you show a Bruce Nauman clone. It may be that the art world is a lot bigger than the number of good artists there are to fill it. You have to remember that we live in an extremely literate and expanded ebullient commercial culture, while the percentage of smart, enthusiastic, committed people probably hasn't changed in the population since the Middle Ages. Who is brave? About the same percentage. It may be that the art world is this enormous ocean liner sailing along with three or four guests of honor. Ed Ruscha always says something to me that I take very seriously: "Dave, you have to always remember that whatever is really hot right now, may be really shit. That we may be going through a really bad sandy place. That it's not just you." I think that we all take this into consideration. I certainly test my experience against that possibility. I grew up in a burgeoning art world in Texas that was very much the way Florida is right now, and if there is anything that I can tell you for sure, it's this: It can all go away. All of these things can disappear. If we expect too much of it, it can go away.

There is a beautiful Philip Johnson museum sitting on the Corpus Christi Bay. I went to the opening. Rauschenberg, Stella, Warhol, Serra—great show, great opening. Were you there, Paul? Fun, deep fun at the Bay. The thing is empty now or filled with cowboy paintings, because they just lost interest, closed it down, and moved in the cow paintings. Poof! It can all go away. Some of my critic friends have a pool as to which contemporary art museum will have plywood on the windows first. Paul, you're way up there. But I've got Chicago; I figure I got a winner. But it's an ill wind that blows nobody good.

My point is, when we're selling what we're selling, we have to really be serious about selling *exactly* what we're selling. If we make outsize claims, we're going to look like fools, and less foolish people are going to take our store away from us. I'm really serious. I'm not standing outside here. I'm a part of this. And I think we ought to say, this is what we do; we do it well. It ain't magic. It ain't redeeming. But this is what we do and it's freaking serious and we know more about it than you do, so there! Well, maybe not the "so there" part. I do think it's true that we see the same artists over and over.

For the last thirty years, people have been saying that there's this false canon, that there's no such thing as quality or talented artists. There is a critical agenda expressed by artworkers involved in the progressive collective activity of postminimalist art, but, hey, let's have another Bruce Nauman show, anyway. So why aren't we showing all of the other members of the postminimalist collective? Maybe Bruce is better. Maybe he gives us more. That is a possibility. And it's a possibility that arises when you have an extended monastic bureaucracy of museums with empty spaces that have to be filled. There are many large rooms in this country that must be filled with found objects arranged in a grid every month. Shelves must be mounted. Things in jars must be placed upon them. Everything but pear preserves, which is what should be in those jars. I'm being light here, but I'm not being that light. We might be in a little slough. We might be in a sandy place, you know? It's our job to help that change, but we can't make the art.

# BIOGRAPHIES OF THE PANELISTS

**Anne d'Harnoncourt** has been the George D. Widener Director of the Philadelphia Museum of Art since 1982; in 1997, she assumed the additional role of chief executive officer. Prior to that, as curator of twentieth-century art, also at the Philadelphia Museum of Art, she coorganized "Marcel Duchamp" (1973–74), which originated in Philadelphia and traveled to the Museum of Modern Art, New York, and the Art Institute of Chicago. A major publication accompanied this exhibition. Other exhibitions she organized during her tenure in that department include "Futurism and the International Avant-Garde"; "Eight Artists"; "John Cage: Scores and Prints"; and "Violet Oakley." Under Anne d'Harnoncourt's directorship, the Philadelphia Museum of Art has undertaken a sequence of major exhibitions, including "Sir Edwin Landseer"; "The Pennsylvania Germans: A Celebration of Their Arts"; "Masters of 17th-Century Dutch Genre Painting"; "Federal Philadelphia"; "Anselm Kiefer"; "Workers: The Photographs of Sebastiano Salgado"; "Japanese Design"; "Brancusi"; and "Cézanne." She has also encouraged the production of a series of scholarly publications devoted to the permanent collections. Between 1992 and 1995, in a major building project undertaken to reinstall all of the museum's European collections, more than ninety galleries were renovated and relit, while thousands of works of art were examined, conserved, and placed in fresh contexts. Most recently, in tandem with the chief operating officer, she initiated a new, long-range plan with a view to celebrating the museum's 125th anniversary, in 2001. She also holds board positions at a number of institutions: the Smithsonian Institution, Washington, D.C.; J. Paul Getty Museum, Los Angeles; Institute for Advanced Study, Princeton; Henry Luce Foundation, Inc., New York; Fairmount Park Art Association, Philadelphia; and the Graduate School of Fine Arts, University of Pennsylvania, Philadelphia.

**Thelma Golden** is the deputy director for exhibitions and programs at the Studio Museum in Harlem, New York. Before her appointment, she was the special projects curator for Peter and Eileen Norton, contemporary art collectors based in Los Angeles. Prior to working with the Nortons, she was a curator at the Whitney Museum of American Art, New York, where she organized many exhibitions, including "Hindsight: Recent Work from the Permanent Collection"; "Bob Thompson, A Retrospective"; and "Black Male: Representations of Masculinity in Contemporary Art." She was cocurator of the 1993 Whitney Biennial Exhibition. At the Whitney Philip Morris branch, she curated solo exhibitions of Jacob Lawrence, Lorna Simpson, Matthew McCaslin, Suzanne McClelland, and Sam Gilliam, among others. At the Studio Museum, she is currently working on a number of exhibitions, including "Martin Puryear: The Cane Project"; "Isaac Julien: Vagabondia"; and "Glenn Ligon: Stranger." In addition to her curatorial work, Thelma Golden teaches, lectures, and writes about contemporary art, cultural issues, and curatorial practice. Her publications include essays for *Artforum*, *ACME*, and *Poliester*. She is adjunct professor at the School of the Arts at Columbia University, a visiting faculty member at the Center for Curatorial Studies, Bard College, and has been a member of the faculty at Yale University.

**Kathy Halbreich** has served as director of the Walker Art Center, Minneapolis, Minnesota, since 1991. Prior to that, she was the founding curator of the Department of Contemporary Art at the Museum of Fine Arts, Boston, from 1988 to 1991, and director of the Albert and Vera List Visual Arts Center at the Massachusetts Institute of Technology, Cambridge, Massachusetts, from 1976 to 1986. At M.I.T, she worked with architect I. M. Pei and artists Scott Burton, Richard Fleischner,

and Kenneth Noland in designing the List Visual Arts Center. She recently cocurated the retrospective exhibition "Bruce Nauman," which traveled to many venues throughout the United States and Europe. She organized, with Walker film-video curator Bruce Jenkins, "Bordering on Fiction: Chantal Ackerman's 'D'Est,'" the first museum exhibition of the Belgian film director, which toured nationally and internationally. Kathy Halbreich has served as a curatorial consultant for the Carnegie International (1988) and as commissioner for the North American region, First Kwangju Biennale (1995). She is on the board of Twin Cities Public Television, St. Paul, and the Greater Minneapolis Conventions and Visitors Association. She has also been on the boards of the Andy Warhol Foundation for the Visual Arts, New York, and the International Selection Committee for Documenta 10, Kassel, Germany.

**Dave Hickey** is a freelance writer of fiction and cultural criticism, a curator, and an educator. He has been executive editor of *Art in America* and a contributing editor to *The Village Voice*, and has written for many major American cultural publications, including *Rolling Stone, ArtNews, Artforum, Interview, Harper's Magazine, Vanity Fair, The New York Times*, and *The Los Angeles Times*. His collection of short fiction, *Prior Convictions*, was published by the SMU Press. His critical essays have been collected in two volumes, published by Art Issues Press: *The Invisible Dragon: Four Essays on Beauty* (1993) and *Air Guitar, Essays on Art and Democracy* (1998). His most recent book, *Stardumb* (Artspace Press, 1999), is a collection of stories, with drawings by artist John DeFazio. Dave Hickey has written numerous exhibition catalog monographs on contemporary artists, such as Ann Hamilton, Lari Pittman, Richard Serra, Robert Gober, Edward Ruscha, Andy Warhol, Vija Celmins, and Luis Jimenez. He has lectured at many universities and museums, among them Harvard, Yale, Princeton, Cornell, the University of Texas at Austin, Art Center, Pasadena, the Museum of Modern Art, the Whitney Museum of American Art, the Dia Center for the Arts, and the Walker Art Center. At present, Hickey holds the position of Professor of Art Criticism and Theory at the University of Nevada, Las Vegas. He is curator of SITE, Santa Fe's Fourth International Biennial (2001).

**Hans-Ulrich Obrist** is curator of the Musée d'Art Moderne de la Ville de Paris, where he directs the program *Migrateurs*. This project series features individual artists—Jeremy Deller, Douglas Gordon, Liza May Post, Sarah Sze, and Rirkrit Tiravanija, among others—who install work in the varied spaces of the museum. He founded the Museum Robert Walser, a migratory museum, in 1993, and the Nano Museum, in 1996. Since 1997, he has worked as editor in chief of *Point d'Ironie*, published by agnes b. He has curated solo exhibitions of such artists as Christian Boltanski, Gerhard Richter, Nietsche Haus, and Sils Maria. Among his thematic exhibitions are "The Broken Mirror"; "Life/Live"; "Do It"; "Cities on the Move"; and "Laboratorium". Recent projects include "Retrace Your Steps: Remember Tomorrow," at the Sir John Soane Museum, London, and "Rumor City," which traveled to Fri Art Fribourg and Mutations, Arc en Reve, Bordeaux. Hans-Ulrich Obrist has edited the writings of such artists as Gerhard Richter, Louise Bourgeois, Gilbert & George, Maria Lassnig, and Leon Golub, as well as a series of artists' books by Gabriel Orozco, Gerhard Richter, and Carsten Hoeller. He is one of the curators of Seoul Media City, South Korea (2000).

**Mari-Carmen Ramirez** is curator of Latin American Art at the Museum of Fine Arts, Houston. She was the curator of Latin American Art, Jack S. Blanton Museum of Art, University of Texas, Austin, from 1989 to 2000. Prior to that, she was director of the Museum of Anthropology, History, and Art at the University of Puerto Rico, Rio Piedras. She has organized numerous exhibitions, including "Encounters/Displacements: Alfredo Jaar, Luis Camnitzer, Cildo Meireles" (with Beverly Adams); "David Alfaro Siqueiros," featured in the XXIV Bienal de São Paulo; "Cantos Paralelos: Visual Parody in Contemporary Argentinean Art," which toured throughout

the southwestern United States and to Argentina and Colombia; and the Latin American section of "Global Conceptualism: Points of Origin." Other projects include "Medio Siglo Sin Lugar (1918–1968)," which opened in Spain, in December 2000; an anthology of critical essays, *Representing Latin American/Latino Art in the New Millenium: Curatorial Issues and Propositions*, for which she is editor; and *Beyond Identity: Globalization and Latin American Art*, coedited with Luis Camnitzer. Mari-Carmen Ramirez is an adjunct lecturer in the art department at the University of Texas, Austin, and has been a visiting faculty member at the Center for Curatorial Studies, Bard College. She has received a Getty Curatorial Residence Fellowship and a Peter Norton Family Foundation Award for Curatorial Excellence.

**Ned Rifkin** has been director of the Menil Collection and Foundation, Houston, since February 2000. Before that, he was Nancy and Holcombe T. Green, Jr., Director of the High Museum of Art, Atlanta, 1991–99, and chief curator of the Hirshhorn Museum and Sculpture Garden of the Smithsonian Institution, in Washington, D.C., 1986–1991. He has also been curator of contemporary art at the Corcoran Gallery, Washington D.C., and curator and assistant director at the New Museum of Contemporary Art, New York. His doctoral dissertation, written for the University of Michigan's history-of-art program, *Antonioni's Visual Language*, and later published as a book, was the first history-of-art thesis focusing on a major filmmaker as an artist. His major exhibition catalogs include *Sean Scully: Twenty Years, 1976–1995*; *Robert Moskowitz*; and *Leon Golub*. Ned Rifkin has lectured internationally and published extensively on contemporary art, film history, and aesthetics, as well as other subjects. He served as one of the co-organizers of the 1984 American pavilion at the Venice Biennale, "Paradise Lost/Paradise Regained." He serves on several national committees, including the Art Advisory Committee for the Internal Revenue Service, the board of trustees of the Association of Art Museum Directors, and the board of directors of the American Association of Museums. He has cochaired several National Endowment for the Arts panels, and was an original member of the Federal Advisory Committee on International Exhibitions.

**Paul Schimmel** has served as chief curator of the Museum of Contemporary Art, Los Angeles, since 1990. Prior to that, he was chief curator/curator of exhibitions and collections, Newport Harbor Art Museum, Newport Beach, California. He has organized many exhibitions, including "Helter Skelter: Los Angeles Art in the 1990s"; "Hand-Painted Pop: American Art in Transition, 1955–62"; "Sigmar Polke Photoworks: When Pictures Vanish"; "Robert Gober"; "Out of Actions: Between Performance and the Object, 1949–1979"; and "Charles Ray". Major publications accompanied each of these shows. He initiated the Focus series at MOCA, a series of small, one-person exhibitions presenting the work of such artists as Arshile Gorky, Jennifer Pastor, Franz West, and Richard Wilson. He recently organized "Public Offerings," which looks at the formative works of artists who have graduated from important art-school programs in the U.S., Europe, and Japan during the nineties. Paul Schimmel has lectured in many important art institutions throughout the world—Kanazawa Museum of Modern Art, Japan; Royal College of Art, London; J. Paul Getty Museum, Los Angeles; and Centre Georges Pompidou, Paris. He has served as a National Endowment for the Arts panelist.

**Nicholas Serota** has been director of the Tate, London, since 1988. Prior to that, he was director of the Whitechapel Art Gallery, 1976–88, and the Museum of Modern Art, Oxford, 1973–76. He also has been exhibitions' organizer for the Arts Council of Great Britain. He studied History of Art at Cambridge University and at the Courtauld Institute, London, where he completed the thesis "Turner's Visits to Switzerland." At Whitechapel, he launched a community-outreach program to attract new audiences and organized important exhibitions on such artists as George Baselitz, Richard Long, Carl Andre, and Max Beckman. In 1981, he curated "A New Spirit in Painting" at the Royal Academy. His Walter Neurath Lecture, *Interpretation or Experience: The Dilemma of*

*Museums of Modern Art*, was published in the spring of 1997. At the Tate, he is recognized for his novel rotation and installation of the permanent collection, juxtaposing new and old, traditional and avant-garde art. He revived the Turner Prize and raised the profile of contemporary art in England. Recently, he orchestrated the fund-raising, planning, and construction of the Tate Modern, which opened in May of last year. Nicholas Serota has been a member of the Visual Arts Advisory Committee of the British Council, a trustee of the Architecture Foundation, and is currently a commissioner on the Commission for Architecture and the Built Environment, London.

**Robert Storr** is an artist, critic, and senior curator in the Department of Painting and Sculpture at the Museum of Modern Art, New York. He has curated many exhibitions at the Modern, including "Making Choices"; "Tony Smith: Architect, Painter, Sculptor"; "Chuck Close"; "On the Edge: Contemporary Art from the Werner and Elaine Dannheisser Collection"; "Deformations: Aspects of the Modern Grotesque"; and "Dislocations". He has also organized a number of smaller-scale Projects exhibitions, with Art Spiegelman, Moira Dryer, Ann Hamilton, Tom Friedman, Georg Herold, and Markus Oehlen, among others. In addition to the catalogs and brochures published in conjunction with these exhibitions, he is the author of *Philip Guston* (Abbeville, 1986), *Chuck Close* (Rizzoli, 1987), and *Intimate Geometries: The Work and Life of Louise Bourgeois*. Robert Storr has published numerous articles, interviews, and exhibition reviews for *The Washington Post* and *Art in America*, *Art/Press* (Paris), *The New Art Examiner*, *Parkett*, and other art journals. He has been a visiting artist and critic at the School of the Art Institute of Chicago; Maryland Institute, College of Art, Baltimore; Rhode Island School of Design, Providence; Royal College of Art, London; and the School of Art, Yale University, among other institutions. He is a board member of or advisor to a number of foundations, including the Marie Walsh Sharpe Foundation, the MacDowell Colony, Skowhegan School of Painting and Sculpture, Louis Comfort Tiffany Foundation, and Yaddo.

# SYMPOSIUM ATTENDEES

**Marcia Acita,** Center for Curatorial Studies, Bard College, Annandale-on-Hudson, NY
**Bill Adair,** Rosenbach Museum and Library, Philadelphia, PA
**Elizabeth Anderson,** Philadelphia Museum of Art, Philadelphia, PA
**Sarah Andress,** Independent Curators International, New York, NY
**Warren Angle,** Samuel S. Fleisher Art Memorial, Philadelphia, PA
**Richard Armstrong,** Carnegie Museum of Art, Pittsburgh, PA
**Penny Balkin Bach,** Fairmount Park Art Association, Philadelphia, PA
**Nancy Miller Batty,** Delaware Art Museum, Wilmington, DE
**Nicholas Baume,** Wadsworth Atheneum, Hartford, CT
**Nancy Berman,** Skirball Cultural Center, Los Angeles, CA
**Jonathan Binstock,** Pennsylvania Academy of the Fine Arts, Philadelphia, PA
**Peter Boswell,** Miami Art Museum, Miami, FL
**Gerard Brown,** Independent curator, Chicago, IL
**Laura Burnham,** Abington Arts Center, Jenkintown, PA
**Susan Cahan,** Peter Norton Family Foundation, Santa Monica, CA
**Kimberly Camp,** Barnes Foundation, Philadelphia, PA
**Kristin Chambers,** Cleveland Center for Contemporary Art, Cleveland, OH
**David Chan,** Center for Curatorial Studies, Bard College, Annandale-on-Hudson, NY
**Judith Cizek,** Delaware Art Museum, Wilmington, DE
**Jimmy Clark,** The Clay Studio, Philadelphia, PA
**Cassandra Coblentz,** Center for Curatorial Studies, Bard College, Annandale-on-Hudson, NY
**Miguel-Angel Corzo,** University of the Arts, Philadelphia, PA
**Julie Courtney,** Main Line Art Center, Philadelphia, PA
**Amada Cruz,** Center for Curatorial Studies, Bard College, Annandale-on-Hudson, NY
**Dean Daderko,** Independent curator, New York, NY
**Kimberly Davenport,** Rice Art Gallery, Houston, TX
**Suzanne Delehanty,** Miami Art Museum, Miami, FL
**Molly Dougherty,** Moore College of Art Galleries, Philadelphia, PA
**Leah Douglas,** Philadelphia International Airport, Philadelphia, PA
**Derick Dreher,** Rosenbach Museum and Library, Philadelphia, PA
**Kathy Edwards,** University of Iowa Museum of Art, Iowa City, IA
**Kristen Evangelista,** Center for Curatorial Studies, Bard College, Annandale-on-Hudson, NY
**Roberta Fallon,** *Philadelphia Weekly*, Philadelphia, PA
**Alison Ferris,** Bowdoin College Museum of Art, Brunswick, ME
**Christine Filippone,** The Print Center, Philadelphia, PA
**Elizabeth Finch,** The Drawing Center, New York, NY
**Sandra Firmin,** Center for Curatorial Studies, Bard College, Annandale-on-Hudson, NY
**Elizabeth Fisher,** Center for Curatorial Studies, Bard College, Annandale-on-Hudson, NY
**Shannon Fitzgerald,** Forum for Contemporary Art, St. Louis, MO
**Peter Fleissig,** Independent curator, New York, NY
**Lucy Flint-Gohlke,** Davis Museum and Cultural Center, Wellesley College, Wellesley, MA
**Jeremy Fowler,** Davis Museum and Cultural Center, Wellesley College, Wellesley, MA
**Judy Fox,** Davis Museum and Cultural Center, Wellesley College, Wellesley, MA
**Melissa Franklin,** Pew Fellowships in the Arts, Philadelphia, PA
**Marian Godfrey,** The Pew Charitable Trusts, Philadelphia, PA
**Claudia Gould,** Institute of Contemporary Art, Philadelphia, PA
**Jennifer Gray,** Center for Curatorial Studies, Bard College, Annandale-on-Hudson, NY
**Jennifer Gross,** Yale University Art Gallery, New Haven, CT
**Judith Guston,** Rosenbach Museum and Library, Philadelphia, PA
**Paul Ha,** White Columns, New York, NY
**Stephanie Hanor,** Blanton Museum of Art, Austin, TX
**Saralyn Reece Hardy,** National Endowment for the Arts, Washington, DC
**Cheryl Harper,** Borowsky Gallery at the Gershman Y, Philadelphia, PA

**Tina Harrison,** Blanton Museum of Art, Austin, TX
**Sofia Hernandez,** Americas Society, New York, NY
**Irene Hoffman,** Cranbrook Art Museum, Bloomfield Hills, MI
**Stuart Horodner,** Bucknell Art Gallery, Lewisburg, PA
**Chrissie Iles,** Whitney Museum of American Art, New York, NY
**Luiza Interlenghi,** Center for Curatorial Studies, Bard College, Annandale-on-Hudson, NY
**Marjory Jacobson,** Independent curator, Philadelphia, PA
**Hilary Jay,** Paley Design Center, Philadelphia, PA
**Toby Kamps,** Museum of Contemporary Art, San Diego, La Jolla, CA
**Janet Kaplan,** Moore College of Art/*Art Journal*, Philadelphia, PA
**Susannah Koerber,** Art Museum of Western Virginia, Roanoke, VA
**Michael Komanecky,** Phoenix Art Museum, Phoenix, AZ
**Britta Konau,** National Museum of Women in the Arts, Washington DC
**Anne M. Lampe,** Whitney Museum of American Art, New York, NY
**Catherine Lampert,** Whitechapel Art Gallery, London, UK
**Albert LeCoff,** Wood Turning Center, Philadelphia, PA
**Dermis Leon,** Center for Curatorial Studies, Bard College, Annandale-on-Hudson, NY
**Susan Leonard,** Center for Curatorial Studies, Bard College, Annandale-on-Hudson, NY
**Adam Lerner,** Contemporary Museum, Baltimore, MD
**Kelly Lindner,** Center for Curatorial Studies, Bard College, Annandale-on-Hudson, NY
**Heather Lineberry,** Arizona State University Art Museum, Tempe, AZ
**Nancy Maguire,** Stedman Gallery/Rutgers Camden, Camden, NJ
**Dennis McFadden,** Davis Museum and Cultural Center, Wellesley College, Wellesley, MA
**Lisa Melandri,** Moore College of Art Galleries, Philadelphia, PA
**Lori Mertes,** Miami Art Museum, Miami, FL
**Charles Moleski,** Fairmount Park Art Association, Philadelphia, PA
**Jessica Morgan,** Institute of Contemporary Art, Boston, MA
**Dorothy Moss,** Corcoran Gallery of Art, Washington, DC
**Marsha Moss,** Independent curator, Philadelphia, PA
**Patrick Murphy**, Royal Hibernian Academy, Dublin, IR
**Terry Myers,** *New Art Examiner*, Los Angeles, CA
**Ellen Napier,** Fabric Workshop and Museum, Philadelphia, PA
**Eileen Neff,** Independent curator, Philadelphia, PA
**Naomi Nelson,** African American Museum, Philadelphia, PA
**Victoria Noorthoorn**, The Drawing Center, New York, NY
**Linda Norden,** Fogg Art Museum, Harvard University, Cambridge, MA
**Linda Park,** Center for Curatorial Studies, Bard College, Annandale-on-Hudson, NY
**Anne Pasternak,** Creative Time, New York, NY
**Brian Peterson,** James A. Michener Art Museum, Doylestown, PA
**Ann Philbin,** UCLA Hammer Museum, Los Angeles, CA
**Peter Plagens,** *Newsweek*, New York, NY
**Carina Plath,** Center for Curatorial Studies, Bard College, Annandale-on-Hudson, NY
**Raphaela Platow,** Contemporary Art Museum, Raleigh, NC
**Jeanne C. Pond,** Independent curator, Philadelphia, PA
**Jenelle Porter,** Artists Space, New York, NY
**Armelle Pradalier,** Dia Center for the Arts, New York, NY
**Sue Ann Prince,** University of Pennsylvania, Philadelphia, PA
**Renny Pritikin,** Yerba Buena Center for the Arts, San Francisco, CA
**J. Fiona Ragheb,** Guggenheim Museum, New York, NY
**Gabriela Rangel,** Center for Curatorial Studies, Bard College, Annandale-on-Hudson, NY
**Jeffrey R. Ray,** Atwater Kent Museum, Philadelphia, PA
**Tara Reddy,** Seattle Art Museum, Seattle, WA
**Thomas F. Reynolds,** Cooper-Hewitt Design Museum, New York, NY
**Danielle Rice**, Philadelphia Museum of Art, Philadelphia, PA
**Sarah Robins,** Museum of Modern Art, New York, NY
**Julie Rodrigues,** Museum of Contemporary Art, Chicago, IL
**Susan Rosenberg,** Philadelphia Museum of Art, Philadelphia, PA
**Amy Rosenblum,** Independent curator, New York, NY
**Ellen Rosenholtz,** Painted Bride Art Center, Philadelphia, PA
**Greg Rowe,** The Pew Charitable Trusts, Philadelphia, PA
**Matthew B. Rowley,** Please Touch Museum, Philadelphia, PA

**Sid Sachs,** Rosenwald-Wolf Gallery, University of the Arts, Philadelphia, PA
**Ellen Salpeter,** Thread Waxing Space, New York, NY
**Jerry Saltz,** *Village Voice,* New York, NY
**Gary Sangster,** Contemporary Museum, Baltimore, MD
**Dan Schimmel,** Esther M. Klein Art Gallery, Philadelphia, PA
**Amy Schlegel,** Philadelphia Art Alliance, Philadelphia, PA
**Sheri Lyn Sheppard,** Center for Curatorial Studies, Bard College, Annandale-on-Hudson, NY
**Susan Shifrin,** Swarthmore College, Swarthmore, PA
**Innis H. Shoemaker,** Philadelphia Museum of Art, PA
**Kim Simon,** Center for Curatorial Studies, Bard College, Annandale-on-Hudson, NY
**Roberta Smith,** *New York Times,* New York, NY
**Anne Collins Smith,** Davis Museum and Cultural Center, Wellesley College, Wellesley, MA
**Erika Jaeger Smith,** James A. Michener Art Museum, Doylestown, PA
**Vesela Sretenovic,** List Art Center, Brown University, Providence, RI
**Judith Stein,** Independent curator, Philadelphia, PA
**Judith Tannenbaum,** Rhode Island School of Design Museum, Providence, RI
**Michael Taylor,** Philadelphia Museum of Art, Philadelphia, PA
**Susan M. Taylor,** The Art Museum, Princeton University, Princeton, NJ
**Ann Temkin,** Philadelphia Museum of Art, Philadelphia, PA
**Vesna Todorovic,** Independent curator, Philadelphia, PA
**Goran Tomcic,** Allen Memorial Art Museum, Oberlin College, Oberlin, OH
**Richard Torchia,** Beaver College Art Gallery, Glenside, PA
**Tricia Van Eck,** Museum of Contemporary Art, Chicago, IL
**Jacqueline van Rhyn,** The Print Center, Philadelphia, PA
**Katherine Ware,** Philadelphia Museum of Art, Philadelphia, PA
**David Warner,** *City Paper,* Philadelphia, PA
**Mel Watkin,** Forum for Contemporary Art, St. Louis, MO
**Mary Ann Wilkinson,** Detroit Institute of Arts, Detroit, MI
**Jill Winder,** Center for Curatorial Studies, Bard College, Annandale-on-Hudson, NY
**Lydia Yee,** Bronx Museum of Art, Bronx, NY
**Dede Young,** Delaware Center for the Contemporary Arts, Wilmington, DE
**Sylvia Yount,** Pennsylvania Academy of the Fine Arts, Philadelphia, PA
**Marilyn Zeitlin,** Arizona State University Art Museum, Tempe, AZ
**Amanda Zucker,** Corcoran Gallery of Art, Washington, DC

# PHILADELPHIA EXHIBITIONS INITIATIVE GRANTEES/1998–2001

Since its founding in 1997, the Philadelphia Exhibitions Initiative has awarded more than $3.1 million, through a highly competitive panel process, to Philadelphia-area organizations to encourage projects of international scope and significance. The following lists grantees to date, the year of their award, short project descriptions, and individual grant amounts. For more information, contact PEI at 215-985-1254.

### Beaver College Art Gallery
*Period Room: A Project by Amy Hauft* (1998)
A site-specific installation consisting of a horizontal caned plane with pathways and seats woven into the structure throughout the gallery, and incorporating a "phantom exhibition" of historic caned chairs, designated by a printed multiple in area collections. —$46,750.

### Beaver College Art Gallery
*The Sea and the Sky* (1999)
A thematic exhibition of regional and international artists who concentrate on the subject of sea and sky within a broad range of media and format. The project is a collaboration between Beaver College Art Gallery and the Royal Hibernian Academy, Gallagher Gallery, Dublin, Ireland. —$72,228.

### Brandywine River Museum
*Milk and Eggs: The Revival of Tempera Painting in America, 1930–1950* (1999)
A thematic exhibition that will define, analyze, and present the phenomenon of tempera painting's rebirth in America. —$100,000.

### Chester Springs Studio
*Reenactment/Rapprochement* (1998)
An exhibition incorporating performances and installations by Eleanor Antin, Mike Bidlo, Thomas Dan, Tom Marioni, Stuart Netsky, Alan Scarritt, Suzanne Wheeling, and William Williams—artists who mine their own persona, a specific history, or re-create their past. —$77,250.

### The Clay Studio
*River* (1999)
A new, large-scale, ceramic and mixed-media installation dealing with ecological and social issues affecting the Delaware River, by Japanese-born artist Sadashi Inuzuka. —$48,500.

### The Fabric Workshop and Museum
*Jorge Pardo* (1998)
A temporary, site-specific installation consisting of a video lounge–café and transformation of the museum entrance. —$91,650.

### The Fabric Workshop and Museum
*Doug Aitken* (2000)
A new architectural environment consisting of linked, multiple fabric spaces with original projected video images, by Los Angeles–based artist Doug Aitken. —$176,200.

### Fairmount Park Art Association
*New Land Marks: public art, community, and the meaning of place* (1999)
A synoptic exhibition of proposals for new works of public art by twenty-three artists, architects, landscape architects, and writers who worked with eighteen community organizations throughout Philadelphia. A "transportable" preview show traveled to community locations for six months prior to the opening of a major exhibition at the Pennsylvania Academy of the Fine Arts. —$200,000.

### Foundation for Today's Art—Nexus
*Context* (1998)
A multipartite program consisting of ten temporary public installations by artists Sarah Biemiller, Mei-ling Hom, Laura Hutton, Elizabeth Leister, Sue Mark, Jane Marsching, James Mills, and Jenny Shanker, among others, and a gallery exhibition. Presented as part of the 1998 Fringe Festival. —$33,525.

### Goldie Paley Gallery, Moore College of Art and Design
*La Futurista: Benedetta Cappa Marinetti, 1917-1944* (1998)
An exhibition exploring the career of the virtually unknown Italian woman futurist. —$114,772.

### Goldie Paley Gallery, Moore College of Art and Design
*Valie Export: Ob/De+Con(Struction)* (1999)
The first major American exhibition to examine the work of the Austrian performance and multimedia artist who continues to break boundaries and develop prototypes. Part of the Moore International Discovery Series. —$162,645.

### Institute of Contemporary Art/Samuel S. Fleisher
### Art Memorial/Mural Arts Program
*Wall Power* (1999)
A collaborative project among three institutions that explored the artistic, social, and political impact of murals and placed them in a broader historical and cultural context. The exhibition featured installations, wall paintings, and outdoor billboards by graffiti artists Barry McGee, Stephen Powers, and Todd James; large-format photographs by conceptual artist Joseph Bartscherer; an historical survey of mural art in Philadelphia; and tours of area murals. —$189,550.

### Institute of Contemporary Art
*Architecture and Design Series: #3 Karim and Hani Rashid, Lise Anne Couture; #4 Greg Lynn* (2001)
A commissioned site-specific installation merging architecture and applied arts, collaboratively created by Karim and Hani Rashid and Lise Anne Couture, and "Intricacy," guest-curated by Greg Lynn, reflecting technical and visual computer technologies emerging across design and production disciplines. —$180,000

**James A. Michener Museum of Art**
*George Nakashima and the Modernist Moment* (2000)
An exhibition resituating the work of this internationally recognized designer and craftsman
within the context of the European modernist design tradition, as exemplified by Finn Juhl,
Alexander Noll, Gio Ponti, Carlo Mollini, Charlotte Perriand, and Jean Prouvé. —$139,500.

**The Library Company of Philadelphia for PACSL (Philadelphia Area Consortium
of Special Collections Libraries)**
*Leaves of Gold* (2000)
An exhibition consisting of 115 medieval manuscripts selected from the collections of
eleven collaborating regional libraries and museums, many of which have never been exhibited
or cataloged before. —$167,125.

**Main Line Art Center**
*Points of Departure: Art on the Line* (1998)
A two-and-one-half-year project presenting a series of site-specific installations commissioned
for 30th Street Station and seven train stations along the Main Line, by Dennis Adams,
Susie Brandt, Donald Camp, Maria Elena Gonzalez, Virgil Marti, Tim Rollins + K.O.S., Kay Rosen,
and Richard Torchia. —$200,000.

**Paley Design Center, Philadelphia University**
*What Is Design Today?* (2001)
An exhibition that introduces design to a wide audience using significant contemporary objects
and hands-on experience. The show investigates the intersection of material culture and the
post-industrial and digital ages through six thematic and self-contained displays. —$172,345.

**Philadelphia Folklore Project**
*Folk Arts of Social Change* (1998)
A multidisciplinary exhibition of folk arts that came out of, and have been means for advancing,
social change. —$69,895.

**Philadelphia Museum of Art**
*Museum Studies #4: Rirkrit Tiravanija* and *Museum Studies #5: Gabriel Orozco* (1998)
A CD-ROM by Tiravanija documenting his cross-country journey with four Thai college students to
quintessentially American sites, and an installation of new work by Orozco based on works from
the museum's collection. —$84,500.

**Philadelphia Museum of Art**
*Venturi, Scott Brown and Associates: Architecture and Design* (2000)
The first major retrospective exhibition of the architecture and design of Venturi, Scott Brown and
Associates, encompassing some 250 objects, including a unique installation. —$200,000.

**Philadelphia Museum of Art with Tate Gallery, London**
*Barnett Newman* (2001)
A major retrospective of the work of one of the most significant artists of the abstract
expressionist movement. —$200,000.

**The Print Center**
*Imprint* (2001)
A public art project that uses the flexibility and inherently democratic nature of print media to address issues relevant to contemporary urban life. Artists include Dotty Attie, John Coplans, Susan Fenton, Kerry James Marshall, Virgil Marti, and James Mills. They will create billboards, coffee cups, and magazine inserts. —$181,516.

**Rosenbach Museum and Library**
*Drifting: Nakahama Manjiro's Tale of Discovery* (1999)
An exhibition of one of the museum's most significant illuminated manuscripts, an 1852 account of the experiences of the first Japanese person to visit the United States. —$71,201.

**Rosenwald-Wolf Gallery, The University of the Arts**
*Yvonne Rainer* (2000)
A retrospective examining the work of seminal avant-garde dancer and filmmaker Yvonne Rainer, including photographs, objects, film footage, and video. A biographical video by Charles Atlas will be produced as part of the exhibition. —$154,900.

## ABOUT THE PEW CHARITABLE TRUSTS

The Pew Charitable Trusts support nonprofit activities in the areas of culture, education, the environment, health and human services, public policy and religion. Based in Philadelphia, the Trusts make strategic investments to help organizations and citizens develop practical solutions to difficult problems. In 2000, with approximately $4.9 billion in assets, the Trusts committed over $235 million to 302 nonprofit organizations. The Culture Program seeks to integrate arts and culture more fully into American life. In the Philadelphia region, it supports activities that build stronger bonds between arts institutions and the communities of which they are a part. It also seeks to elevate artistic excellence by recognizing the pressing needs of individual artists and enhancing the cultural community's ability to work together more effectively. On the national stage, the Culture Program seeks to stimulate an informed discussion about the importance of arts and culture by supporting research, advocacy and the pursuit of innovative policies that deepen support for the arts by individuals, organizations and governments. For further information about the Trusts' cultural funding, please visit our website at *www.pewtrusts.com*.

## ABOUT THE UNIVERSITY OF THE ARTS

The University of the Arts is the nation's only university devoted exclusively to education and professional training in design, visual, media, and performing arts. Offering undergraduate and graduate degrees in art education, communication, crafts, dance, design, fine arts, media arts, multimedia, museum education, museum exhibition design, music, theater, and writing, the University prepares its students to assume a wide range of careers in traditional and emerging arts and related fields. For further information about The University of the Arts, call 215.717.6000 or visit our website at *www.uarts.edu*.